The Herbert History of
ART AND ARCHITECTURE

THE
RENAISSANCE

Manfred Wundram

The Herbert Press

Published in Great Britain 1988 by
The Herbert Press Ltd, 46 Northchurch Road, London N1 4EJ

Copyright © Chr. Belser, Stuttgart
English translation © 1972
by George Weidenfeld & Nicolson Ltd, London

Translated by Francisca Garvie

Printed and bound in Hong Kong by South China Printing Co.

A CIP catalogue record for this book is available
from the British Library.

ISBN 0-906969-92-1

CONTENTS

INTRODUCTION

The art of the 15th and 16th centuries in Europe is referred to as "Renaissance," but, like all our stylistic labels, the term is imprecise, and since "renaissance" literally means revival or rebirth, we can also speak of the Carolingian and Ottonian renaissances and of the so-called proto-renaissances in late 11th and early 12th-century Tuscan architecture and in the art of Provence in the 12th century. What links all renaissance movements is a revival of interest in forms from the classical tradition, although, in each case, the direction and, above all, the scope of these classical influences were interpreted differently.

The first problem is to set chronological limits to the Renaissance, one of the great periods of European art. Art historians of the late 19th and early 20th century called the Italian Quattrocento the age of the Early Renaissance, thus placing the beginnings of the Renaissance in the early 15th century south of the Alps; they postulated a time lapse of almost a century before Renaissance concepts reached the North. Albrecht Dürer's visits to Italy in 1494–95 and 1505–7 were milestones in the assimilation of Renaissance forms north of Italy. More recent research in art history has modified this idea and sets the break between the Middle Ages and "modern times" not around 1400 but as early as 1300. Accordingly, it was not the generation of Brunelleschi, Donatello, and Masaccio that brought about the decisive turning point in European art, but the age of Nicola Pisano, Giotto, and Dante. This theory is corroborated by a time-honored source. The first great Italian art historian, Giorgio Vasari, referred to the age of Giotto as the first phase and the early decades of the Quattrocento as the second phase of a *rinascita*, or rebirth of "good art," in his *Lives of the Artists* (*Le Vite de' più eccelenti pittori, scultori ed architetti italiani*), which first appeared in 1550 and was issued in a revised and enlarged edition in 1568.

It is as difficult to fix the end of the Renaissance as it is the beginning. The traditional division into Early, High, and Late Renaissance has met with sharp criticism in our day. While the artists and theorists of the late 16th century saw themselves as the direct successors of the High Renaissance, and in particular of Raphael and Michelangelo, research in

recent decades has shown that the generation working after the High Renaissance and before the Early Baroque created a style distinct enough from Renaissance ideals to be given its own name, Mannerism.

Defining the conceptual basis of the Renaissance is no easier than the question of chronology. The term was first used to refer to a period in art by French scholars of the 19th century; but the word itself goes back to Vasari, who spoke of the *rinascita*. But what was this rebirth of art? The Humanist literature of the late 15th and the 16th centuries has led to the widespread opinion that the influence of classical models initiated this rebirth. However, the notion that classical antiquity was one of the basic inspirations of the Renaissance confuses rather than clarifies our concept of the period, for medieval Tuscan architecture, such as the baptistery in Florence, echoes classical architecture far more than do the first true Renaissance buildings—the early works of Filippo Brunelleschi. In fact, it was from such medieval buildings that Brunelleschi, who thought the Florentine Baptistery was a work of late antiquity, drew his entire repertory of *all'antica* forms. And if we look at Nicola Pisano's pulpit in the baptistery of Pisa, dated 1260 (*Ill. 54*), in the light of its debts to Roman art, it is clear that little from the Quattrocento can be called more "classical." So, in Italy, at least, the influence of antiquity was as pervasive in the Middle Ages as in the Renaissance.

Vasari did not dwell on the classicism of the new age; he defined the driving power behind Renaissance art as a new concern with man and his world. This becomes very clear in his assessment of the bronze *David* by Donatello (*92*): "This figure is so natural in its vivacity and softness that artists find it hardly possible to believe it was not molded on the living form."

It was above all this "discovery of the world and of man," as Jacob Burckhardt entitled Part IV of his *Civilization of the Renaissance in Italy*, that separates the Middle Ages from the Renaissance. Man and his world came to occupy a new place in Creation, and so became worthy of representation to a degree unknown since classical antiquity. Despite the wide use of secular motifs, however, art remained predominantly a product of church commissions, trying now to render visible the harmony and divine order of Creation in terms of our world. It is perhaps significant that the founder of the brilliant Medici era in Florence, Cosimo il Vecchio, should spend the last years of his life in the monastery of S. Marco, which he himself had founded.

We shall attempt to outline the period in all its variety. The illustrations and the text seek to define the concept of the Renaissance, describing the many ways in which this concept took form; in so doing, they reveal as well the polarity that existed, particularly in the 15th century, between art in Italy and north of the Alps. The comparison between North and South will bring out both what distinguishes and what links the two, and perhaps this attempt to show the underlying unity—despite the differences—in the styles of European art between 1400 and 1580 will make the idea of a time lapse less persuasive.

The prelude to the Renaissance in Italy comes with the work of the sculptor Nicola Pisano (d. 1284?). The reliefs of his pulpit (54) in the baptistery of Pisa, completed at almost the same time as the Master of Naumburg's donor figures and choirscreen reliefs in Naumburg Cathedral, show a less stylized conception of New Testament themes than ever before. Interest in classical sarcophagi was the probable cause of the sudden liberation from the hieratical, weightless figures of the Middle Ages. With Nicola came a "humanization" of art, which Giotto, Nicola's true successor, developed further at the beginning of the 14th century. Giotto (c. 1266–1337) is the pivotal figure in the evolution of art from medieval to modern times (142), and he was recognized as such both by his contemporaries (Boccaccio) and by 16th-century theorists (Vasari). He turned away from the *maniera geca* of late medieval painting—that highly refined linear style, sometimes leading to rigidity, in which forms were set against a spaceless and airless gold ground. Giotto's figures, architecture, and landscape acquired a new solidity, and he vividly recounted sacred stories through the emotions of the protagonists. At the same time, Giotto's works are very deliberately constructed.

Giotto was not alone. We find a similar concern with realism in the great flowering of Sienese painting in the first half of the 14th century. The first softening can be seen in the work of Duccio (144), and it is even more evident in that of Simone Martini (145) and his contemporaries Ambrogio (146) and Pietro Lorenzetti.

What we now recognize as "Renaissance" elements are also evident in Tuscan architecture at the time of Giotto. Gothic forms had been adopted from the North beginning with the 13th century, and they were immediately modified. Characteristic of this architecture is a reduction in the multiplicity of formal devices, a new proportion between length, width, and height, and the articulation of the enclosing walls in clearly defined areas perceptible to the eye (S. Croce, Florence).

There were no comparable stylistic developments in the North around 1300 and in the first decades of the 14th century. In architecture, the North cultivated the principles of the French Classic Gothic, with emphasis on ever more ornate and decorative forms; tracery, in particular, flourished (Strasbourg, Freiburg, Oppenheim cathedrals). Sculpture and painting were marked by a reduction in plasticity in favor of brittle surfaces (choir statues, Cologne Cathedral, c. 1317) and panel painting (in Cologne, first half of the 14th century).

Around the mid-14th century, however, a change of style became apparent in the North, too, and it had elements in common with that in the South. In Florence this period is represented by the work of the painter and sculptor Andrea Orcagna (Tabernacle, Orsanmichele, 1359) and the construction of the nave of Florence Cathedral, from 1357 (5); in the North, by the work of the Heinrich Parler workshop (rebuilding of the choir, church of the Holy Cross, Schwäbisch Gmünd, from 1351 [4]). In both North and South, sculptors were concerned with rendering volume at the cost of linear richness (Peter Parler's tombs, Prague Cathedral), and with individual characterization (triforium busts, choir of Prague

Cathedral, 1379–93). In the same way, architecture reveals a new emphasis on solidity and an entirely new accentuation of horizontals.

Toward 1400, at the beginning of the Early Renaissance in the strict sense of the term, North and South again went different ways. Florence became the center of the "rebirth" of the arts; the preliminary steps taken in Giotto's time seem to have been consolidated in every sphere. In both painting and sculpture there were efforts to render the physical volume of figures and objects and to define spatial perspective. Brunelleschi made the final break with medieval architecture by achieving a perfect equilibrium between the three dimensions of stereometric space, creating clearly definable areas and volumes, and borrowing from classical models for individual details (3). The innovations in sculpture came in the first years of the Quattrocento, and it was the great trio of sculptors, Lorenzo Ghiberti, Nanni di Banco, and Donatello, who represented the widest range of new forms. Architecture followed after an interval of about two decades, but painting, at first in the work of a single artist, Masaccio, did not enter the the new age until after 1425. (The same sequence had occurred in the first wave of *rinascita* in the late 13th century, when the work of Nicola Pisano led the way.)

On the surface, the Early Renaissance in Italy had little connection, stylistically or philosophically, with the contemporary flourishing of Late Gothic north of the Alps; but our picture is distorted if we emphasize only the contrasts. As early as the turn of the century, the work of Claus Sluter—here, again, innovations came first in sculpture—showed his commitment to solid, lifelike figures (portrait busts, Chartreuse de Champmol, Dijon), characterization (donor figures on the portal, 1385–93, and prophets on the Well of Moses, 1396–1406, Champmol, Dijon [77], and direct, realistic emotional effects (Pleurants, Tomb of Philip the Bold, Dijon).

But, above all, it was painting in Flanders and southwest Germany that showed a realism directly comparable to that of Masaccio in the early 15th century. The artistic concerns —plastic modeling of figures, perspective effects, three-dimensional space, landscape minutely observed—are closely related, and the chronological parallels are astonishing: Masaccio was at work on his masterpiece, the frescoes in the Brancacci Chapel of S. Maria del Carmine, Florence, in 1427–28. Lucas Moser dated his *Magdalen* Altarpiece (parish church, Tiefenbronn [152]) 1431. (In spite of all the sensational counterarguments that have recently been put forward, the name and date are indubitably correct.) And in 1432 Jan van Eyck completed the *Altarpiece of the Mystic Lamb* (St-Bavon Cathedral, Ghent), begun with his brother Hubert.

Admittedly, there are decisive differences between North and South, despite these similar tendencies. In Florence the new formal problems were immediately assimilated intellectually and systematized. By the second decade of the 15th century, Brunelleschi had worked out the calculation of linear perspective mathematically; other branches of art theory, dealing with proportion, optics, and anatomy, followed very soon. Science and art were united.

By contrast, the Northern artists continued to resolve new problems intuitively. The rational element of Early Renaissance art in Florence has some connections with the influence of classical art, yet we should not overestimate the direct impact of antiquity. It is significant that Brunelleschi, for instance, did not look to ancient Rome for his models, but to the Early Christian basilica; and his wealth of individual forms drawn from classical antiquity was probably not inspired by a knowledge of the original but transmitted by way of the Romanesque buildings of the Tuscan proto-Renaissance. Of the great sculptors of the Early Renaissance, only Nanni di Banco (*53, 80, 81*) made classical antiquity a constituent element of his art. And in painting, Masaccio is hardly distinguishable from Giotto in his assimilation of antiquity. "The driving aim was to rival antiquity rather than to imitate it" (Burckhardt). This sense of rivalry is not peculiar to the Renaissance but is a feature of Italian art as a whole. We need only think of the rich heritage of antique monuments before the eyes of everyone south of the Alps throughout the Middle Ages. Nor should we forget that the Italians are descendants of the Romans if we want to understand the continuity of the influence—whether direct or indirect—of antiquity that characterizes the Middle Ages and the Renaissance.

In architecture, developments in the North seemed entirely unrelated. The major feature was the Late Gothic hall church (*10, 12, 13*). Its precursors date back to the 14th century, and it has been described as one of the most fascinating "achievements in German art" (W. Pinder). These churches—with aisles and nave of the same height, creating unbroken space—have little in common with Gothic architecture except in their use of the pointed arch. Abandoning the set arrangement of the Gothic nave church to gain a unified spatial order in which the individual parts are no longer subordinated but related to each other as equals, with a resulting focus on a large central area, is characteristic of Renaissance architecture. Some features of the great buildings of the North in the early 15th century, therefore, parallel developments in Italy. On the other hand, when we speak of the new art in Italy, we speak of Florence only. The Renaissance barely touched the southern part of the peninsula, and throughout the century innovations reached Rome only through immigrant artists, because of the papal exile in Avignon, while northern Italy became the nucleus of International Gothic in the early 15th century. The greatest Italian Gothic cathedrals —those in Bologna and Milan—were built from the 1390s on, and such masters as Pisanello (*199*) and Gentile da Fabriano were major exponents of the courtly Late Gothic style in painting. The forceful immediacy of the Early Renaissance ideal had little in common with the sinuous and decorative International Gothic, which, north of the Alps, culminated in the work of Master Francke (*153*) and the panel paintings of Cologne (*161*). Social factors undoubtedly influenced both styles. In particular, it is notable that the realist style of the Early Renaissance attracted bourgeois patronage, in Florence as well as in the rich merchant towns of Flanders and the rapidly flourishing trade centers in southern Germany, while International Gothic was supported by court and church. (Apparent exceptions—for in-

stance, the robust art produced on commission from the dukes of Burgundy in Dijon—were nevertheless executed by artists drawn from a bourgeois milieu, in this case from the towns of Flanders.)

In the later 15th century the important ideas developed in the early decades were elaborated. In Italy and in the Netherlands, the artistic problems faced by the great founder generation—the Van Eycks and the Master of Flémalle in the North; Donatello, Brunelleschi, Masaccio, and their contemporaries in the South—were taken up again one by one and resolved with increasing perfection. In the generation born around 1400, Rogier van der Weyden (*163*) was an important influence in painting; from around 1450, his art and that of his successors permeated the entire northern area, and it had a lasting effect on German painting. South of the Alps, Florentine artists whose commissions took them to other towns spread the ideas of the Early Renaissance throughout Italy. Donatello (*73, 79, 82, 88–92, 106*) was particularly important in this dissemination with his activity in Padua from 1443 to 1453; interestingly, his impact was greatest on painters and painting. From the mid-century on, the once pervasive leadership of Florentine art gave way to a fruitful interchange between different artistic currents. Color—how light and distance affect color, for example—had been of only incidental interest to the Florentine artists of the Early Renaissance. In the second half of the 15th century, Piero della Francesca (*155, 165*) combined color experiments with Florentine perspective and Venetian concern with form in light. Painters in Venice itself, particularly Giovanni Bellini (*171*) and the Sicilian-born Antonello da Messina (*174*), perfected an art dominated by "painterly" values—in which color and light rather than a drawn outline defined form—as opposed to the Florentine ideal, to which drawing and modeling were basic. Color harmonies, rather than Florentine harmony of proportion, were paramount to the Venetians. Antonello, especially, played an unusual role in the development of painting in northern Italy. Trained in Naples, where Flemish painters were working at the Aragonese court, he absorbed Northern influences and techniques, including the use of oil paint and attention to detail. These he combined with an Italian amplitude of form, making his art a unique synthesis of two schools, and thus he became one of the most important intermediaries between North and South in the 15th century.

As a whole, in the second half of the century the "grand design," that is, the convincing representation of the human body, space, and landscape, was followed by a devotion to detail in both the North and the South. Line is more suited to definition of detail than large-scale modeling, and frequently in the later 15th century, we find a shift away from plastic modeling and a renewed tendency toward a rich linear style. In the Netherlands this appeared around midcentury—between the Van Eycks and Rogier van der Weyden; in Germany the change becomes very apparent in the workshop of Hans Multscher between the Wurzach Altarpiece of 1437 (eight panels in Staatliche Museen, Berlin) and the Sterzing Altarpiece of 1457–58 (Vipiteno). South of the Alps, we can compare Masaccio to Botticelli and Donatello to Andrea del Verrocchio in this respect; here, again, is another parallel between

North and South. But the new dominance of line, carefully defining detail while putting less emphasis on volume than in early 15th-century art, makes this phase seem less "realistic" and gives an impression of "re-Gothicization."

North and South differed greatly in their approach to detail. While Italy, never far from classical antiquity, sought an objective ideal—the synthesis of many "givens"—always restrained by a certain standard of decorum, the North turned to the subjective and unique, producing highly expressionistic and personal works that were sometimes extreme. That the North, for instance, produced genre scenes with a highly individual and realistic content as well as true-to-life (rather than idealized) portraiture and "pure" landscapes more eagerly than Italy and, in particular, Tuscany illustrates this basic tendency. By contrast, the impression of "nature reduced to the sublime" (Burckhardt), common to all Italian art in spite of its variety, remained the overwhelming influence on the artists who traveled south around 1500.

The High Renaissance can be seen as a fusion and integration of the tendencies explored in the Quattrocento into a new monumental concept. In the years around 1500 the ideal again became the "grand design," following the intuition of Giotto and Masaccio. But just as Masaccio differs from Giotto in his incomparably closer realism, so Raphael (*175, 179*) differs from Masaccio (*150*) by subordinating all the skill in depicting nature gained during the Quattrocento to his over-all conception. The real and the ideal were fused for a moment into a unity such as never existed before or since in European art—only a fleeting moment, spanning little more than a decade. Leonardo da Vinci's *Last Supper* in the refectory of S. Maria delle Grazie, Milan, 1496–97 (*184*), the great *sacre conversazioni* of Giovanni Bellini and Fra Bartolommeo in the first decade of the new century, Raphael's frescoes in the Stanza della Segnatura, the Vatican, 1509–11 (*177*), and Giorgione's *Reclining Venus*, Dresden Gallery, 1505–10, are the paintings that mark the climax of this classical age in European art. They correspond to the early works of Michelangelo (*109*) in the field of sculpture; in architecture, to Bramante's Tempietto (*20, 35*) in the courtyard of S. Pietro in Montorio, Rome, c.1502, his designs for the new St. Peter's beginning in 1506 (*21*), and the pilgrim church of S. Maria della Consolazione, Todi, from 1508 (*17*), conceived under his influence.

Two events occupy a major place in art history in the years around the turn of the century. First, when Bramante (1504), Michelangelo (1505), and Raphael (1508) moved to Rome, Florence, which had been the accepted center of European art since at least 1400, gave up its pre-eminence to Rome. Second, it was not until about 1500—apart from a few earlier isolated contacts that must not be underestimated—that a significant and continued interchange of artistic ideas between the South and North took place, with the North chiefly at the receiving end.

The values of the Renaissance were sustained for a short period only. The integration of the real and the ideal, vigorous life and deliberate composition, spontaneity and intellect, the unusual and the typical, the secular and the sacred, the skillful creation of spatial illusion

on a two-dimensional surface, could not be heightened or developed further. For one moment time seemed to stand still in an ecstatic, supernatural balance. But the slightest vibration could topple this unique equilibrium. And, indeed, it was the High Renaissance masters themselves who led art on to new territories. These masters were Michelangelo, with his fervent attempts to render spiritual tensions visible by means of supremely heightened expressivity of the body (*115, 131*); Raphael, who broke through the flat surface with his bold spatial structures in the Stanza d'Eliodoro (*178*) and the *Transfiguration* (*179*), and ordered his compositions not by a balance of forms but by intensified movement; and Leonardo, in whose later compositions the *sfumato* backgrounds suggest hidden moods and spirits behind appearances as if through a veil (*169*). This great generation of High Renaissance artists opened the door to the Late Renaissance, which is today described as Mannerism. The dates and styles of this late phase are as diverse and ambiguous as the period itself. Like "Renaissance," the term "Mannerism" goes back to Vasari (*186*), who characterized the late style of Michelangelo as having *maniera*. And the work of the mature Michelangelo was undoubtedly one of the main sources of Mannerism. But there is no Mannerist art as such, only a wide spectrum of contemporary "mannerisms." What is common to the artists active between 1520 and 1580 is that their point of departure lay in the High Renaissance, the achievements of which—either singly or in combination—they took up, elaborated, and often pushed to extremes. What also unites them is their tendency to substitute the abnormal for the normal: "unnatural" proportions in the figures, violent foreshortening, color combinations far from the classical canon, dynamic compositions exaggerated by extreme asymmetry, with occasionally an almost autonomous surface rhythm, and a hidden symbolism in the pictorial content (*192, 193, 196*).

This divergence from the ideal model obviously favored the penetration of Mannerist tendencies north of the Alps. The School of Fontainebleau, formed at the court of François I under the direction of Primaticcio and Rosso Fiorentino, brought the formal language of the Late Renaissance to the North, as did the scores of German and Netherlandish artists, including the Netherlandish Romanists, who had been to Italy.

All this not only put in question, but actually destroyed, the balanced world of the High Renaissance. In its place came a view of life defined by extreme tension and excitement, which no doubt also reflected political upheavals, such as the sack of Rome in 1527, and spiritual unrest, due above all to attacks on the authority of the church by the Reformation movement. The manifestations of Mannerism, beyond their more general aspects, can hardly be classified under a single appellation. Sometimes they lead to an academic paralysis of the formal language taken over from the High Renaissance; sometimes, inspired by Michelangelo and Raphael, they lead to feverishly exaggerated movement and overheated action; sometimes they establish a tense interaction between cool detachment and understated mood and atmosphere. Sometimes too, the contrast between "classicist" tendencies and the digression from "nature" is exemplified in a single work, such as Giulio Romano's

Palazzo del Te, Mantua, 1526–c.1534, or, at the end of the period, in the architecture of Palladio. The age of Mannerism, the Late Renaissance, also embraces such artists at Titian (*194*) and Veronese (*195*), who seem to be entirely (Titian) or largely (Veronese) impossible to class in any category of Mannerism.

The role of Mannerism in the history of art does not lie only in the negative part it played in ending the High Renaissance. Mannerism also had the positive value of changing the stability of the High Renaissance into a state of flux, dynamizing it, and opening up a wide new field of creation. The great generation of the Early Baroque, almost exactly a century after the age of Raphael and Michelangelo, was to mold this inheritance into a synthesis diametrically opposed to the High Renaissance.

ARCHITECTURE

As we have mentioned, the whole of Italian medieval architecture shows latent or at times quite open Renaissance tendencies, if we consider Renaissance to mean a survival of or return to models from classical antiquity. The Tuscan proto-Renaissance (c.1100) was responsible for a great number of skillful works using classical vocabulary, on which the architecture of the early 15th century drew. Even more important than these direct returns to individual details from antiquity is the articulation of surfaces in well-proportioned, balanced relationships perceptible to the eye. Two outstanding examples are the façade of S. Miniato al Monte, Florence, and the exterior of the Florentine Baptistery.

Even when under the influence of the Gothic North, whose architectural forms they borrowed, the Italians retained their love of moderation and harmony. Not only did they bring order into the rich and varied Gothic formal repertoire; they also replaced the dominant verticality by more equalized proportions. The resulting effect is not one of conquest over earthbound forces, as the Gothic, but a wide and unaccented space of human dimensions. In 1246, when building began on the Dominican church of S. Maria Novella in Florence, unusually high arcades with arches of wide span were chosen for the nave, so that the three aisles intercommunicated, contrary to Gothic principles. This extended the width of the interior, in contrast to the former Gothic stress on length. The width is further emphasized by the low clerestory with its high, rather small round windows near the vaulting. The various spatial areas are not self-contained, but instead open into one another. This concept was the basis for many future developments. The Franciscan church of S. Croce in Florence, begun in 1294, goes a step further, accenting horizontality with a distinctive cornice, or ornamental molding, that runs the length of the nave between the arcade and the nave walls. The nave walls—the arcades with their rather plain piers and capitals—are nicely balanced by this cornice.

The extension of the nave of Florence Cathedral (5) was planned on the same principles from 1355, under the direction of Francesco Talenti. The huge arcades and the low clerestory

with round windows were taken over from S. Maria Novella and the strong horizontal molding from S. Croce. But these elements were elaborated, creating an interior space that has little resemblance to Gothic architecture. The details—the pillars, capitals, and console cornices—can no longer be considered as vertical or horizontal "guidelines"; they are solid elements. The horizontals are emphasized not only by the cornices but also by the sequence of three rows of projecting leaf moldings on the capitals, giving the optical impression that the nave walls are composed of three vertical units of more or less uniform size. Another example of nascent Renaissance tendencies is the Loggia dei Lanzi (24), Florence, built from 1374 to 1381 by members of the Florence Cathedral workshop. Its pillars and capitals resemble those of the cathedral, but here, instead of elongated, pointed arches that rise up steeply, visually separating the spandrels, we have compact round arches, related to the pillars in both span and radius. The height of the pillars and their distance from each other are more or less equal; thus a square can be drawn between them, and the round arches correspond to approximately half the circle inscribed in the square. Fifty years later Brunelleschi was to formulate relationships between the individual architectural elements as a creative principle.

North of the Alps too, a change of epoch-making importance occurred around the mid-14th century, at about the time of the nave construction in Florence Cathedral. From 1351, probably under the supervision of Heinrich Parler, a new kind of space was created in the choir of the church of the Holy Cross in Schwäbisch Gmünd (4). The three aisles are the same height, and they are joined to a choir with ambulatory that is equally high, thus creating a hitherto unknown unity between nave and choir. The outer walls are divided into two almost equal units by a horizontal cornice, the solidity of which dominates the more delicate vertical wall moldings. The interplay this creates between thrusting and static forces is further stressed by the comparatively low, wide, nearly round windows with round arches on the ground floor. In spite of the difference in detail, the architectural concept is related to that of Florence Cathedral. The true novelty of Parler's creation lies elsewhere, in an interpretation of spatial colume contrary to the Gothic. The space extends unbroken through to the chapels on the ground floor, and the horizontal cornice, with its sharply jutting triangular projections, gives the impression that the walls are vibrating. Heinrich's son Peter, who directed the construction of the choir of St. Vitus's Cathedral, Prague, from 1353, elaborated on his father's idea by creating a triforum zone that actually moves in and out. We will find comparable concerns in the sculpture of Parler's time. As a whole, it is characteristic of the architecture of the Parler workshop that the Gothic concept of the "diaphanous wall" (H. Jantzen) and the creation of spatial foils for the nave are replaced by a unified space whose volume actively defines the spatial boundaries.

In the early 15th century, Florence saw the birth of a new era in European architecture. Significantly, the innovations had their source in a single figure, whose personality and artistic development are well documented, namely, Filippo Brunelleschi (1377–1446). As an

architectural technician, he is known above all for a grandiose achievement in engineering, the completion of the huge dome of Florence Cathedral (from 1420), spanning an enormous space, a two-shelled structure supported by a series of connected ribs. In appearance, however, Brunelleschi here followed plans for the dome, the drum, and the contours of the roof that had existed since the Trecento (again showing the continuity between the 14th and 15th century). Brunelleschi also designed original projects at the same time. In 1419 he planned the loggia of the Spedale degli Innocenti (Foundling Hospital); from 1419 to 1428 the burial chapel of the Medici, the so-called Old Sacristy (3) in S. Lorenzo. Beginning in 1421, Brunelleschi undertook the construction of S. Lorenzo itself (1). The revolutionary features of these works lie neither in the use of classical details, which were no more than a return to Tuscan tradition, nor in the creation of new spatial forms, which largely follow Trecento ideas, but rather in the system of relating the different parts to one another and among one another. In the Old Sacristy, the motifs on the wall containing a small altar room recall those of the triumphal arch; the archway forming the opening of this small room, whose motifs all derive from those of the central area, corresponds to the smaller round-headed niches above the sacristy doors. The windows above the architrave seem to carry the general form of the niches upward toward the vaulting, thus connecting the lateral and upper limits of the space, while the circular plan of the dome and the drum windows are echoed by the roundels in the wall lunettes and in the pendentives. Both the vertical elements and the spherically curved parts of the spatial shell are proportionally interrelated. The essence of this novel conception of architecture is the mathematical relation both of the individual details and of the elements of a clearly articulated whole to one another.

Brunelleschi had a remarkable career. In 1434, when he was entrusted with the construction of S. Spirito, he returned to the schema he had used in S. Lorenzo—a three-aisled, cruciform, flat-roofed basilica with side chapels (2, 6). But the similarity of the plans makes the changed architectural concept all the more clear. The square of the crossing is the unit of measure for the entire plan; the width of the aisles and the depth of the side chapels (equal to the radius of the circles inscribed in the aisle bays) are all subordinated to it. The aisles and chapels extend around the transept and choir, and, according to Brunelleschi's original plan (later modified), they should also have lined the inner wall of the façade. The nave is integrated into a centrally planned space. In section, the upper wall of the nave and the arcades are related in a directly measurable proportion of 1:1. No less important to the over-all spatial effect is the connection between aisles and chapels; the arcade and chapel openings look identical, so that each seems a projection of the other. In the articulation of the walls, flat pilasters are replaced by half-columns in front of the strongly profiled chapel surrounds; the wall is now modeled, as the exterior of the building, with its series of convex vaulted chapels—reflections of the interior space—was originally meant to be. Without any evidence of returning to antique models, Brunelleschi, at S. Spirito, was the first European architect to apply the theories of Vitruvius. His plan follows a unified concept that de-

termines the individual features and directly interrelates them. By contrast, S. Lorenzo clearly has additive character; it is an articulated building that still owes something to the Trecento.

We can only guess at Brunelleschi's role in secular architecture. It is possible that he influenced the style of the Palazzo Medici begun in 1444 by Michelozzo (26). The series of uniform round-headed windows and the use of carefully carved and beveled blocks was already a feature of princely residences in the late Trecento. But what is new is that the rusticated stone of the second and third levels is less articulated and there is a corresponding reduction in the height of the stories. What is also new, besides the use of classical details, is the cornice at the top. This is a prototype for Tuscan domestic building, and it was succeeded by a wealth of variants—of which the most mature example is the Palazzo Strozzi of the very late Quattrocento, with its bold projecting cornice correctly proportioned to the lower part of the building (30).

Another example of the aristocratic town residence, and one more strongly indebted to antiquity, is the Palazzo Rucellai (23), designed by Leon Battista Alberti (1404–72). Alberti covered the façade with a network of horizontals and verticals, using a sequence of classically derived orders: Tuscan on the bottom, then Composite, and finally Corinthian. This arrangement, together with the round-headed windows, clearly shows the influence of Roman antiquity (in particular, the Colosseum). Alberti did not wand bold rustication, because this would not have harmonized with the use of pilasters. Instead, he varied the heights and widths of the blocks to create a highly animated surface.

Alberti's place in the third quarter of the 15th century is analogous to Brunelleschi's in the second. Widely cultured and very talented, he exemplifies the type of the *uomo universale* that was to culminate in the person of Leonardo at the threshold of the High Renaissance. In addition to his practical work, he wrote theoretical treatises, including a revision of Vitruvius. Alberti also exemplifies the dichotomy between conception and execution—the activity of the master mason and that of the designing architect. The work on the Palazzo Rucellai was executed by Bernardo Rossellino; Matteo de' Pasti carried out the conversion of the church of S. Francesco, Rimini (Tempio Malatestiano), designed by Alberti and begun in 1446. Alberti's main work, S. Andrea in Mantua (7, 9), was not begun until 1472, the year of his death. If Brunelleschi had largely built on Tuscan tradition, Alberti turned directly to Roman antiquity. His design for the choir of SS. Annunziata in Florence (1471) is based on the ground plan of the Temple of Minerva Medica in Rome; and the nave of S. Andrea in Mantua (7), spanned by an enormous coffered barrel vault, was inspired by monumental Roman vaulting. The trend toward uniformity that had characterized Brunelleschi's late works increases here in the articulation of space and of the exterior. Compared to the delicate façade of Brunelleschi's Pazzi Chapel (8), built up of additive individual elements, the new animation of Alberti's S. Andrea façade, in which he united stories with the use of the giant order, is all the more clear (9). Exterior and interior interpenetrate to a

far greater degree than in the late work of Brunelleschi. The chief characteristic of the façade, the alternation between tall, barrel-vaulted niches and flat lateral areas, is repeated in the elevation of the nave. Alberti's ideas exerted an influence lasting well beyond the chronological limits of the Renaissance. Neither the church of Il Gesù in Rome (46, 50), begun in 1568, with its rich legacy to the Baroque, nor the nave of St. Peter's are conceivable without the work of Alberti. Alberti's "Roman" architecture found few successors, however, in Florence. Perhaps the Palazzo Pitti, begun in 1458, owes something to his influence. But his impact on Renainassance architecture in Rome was all the greater. The Palazzo della Cancellaria, for instance, clearly shows the effects of his work (25).

A glance at developments in the northern part of the peninsula shows how very much the Early Renaissance, strictly speaking, was confined to Florence. In Milan and Bologna, for instance, the construction of gigantic cathedrals, such as S. Petronio, remained the major projects throughout the century. In Venice, the Late Gothic mendicant order churches of S. Maria dei Frari and SS. Giovanni e Paolo were nearing completion during the first half of the Quattrocento. New buildings, such as the Cà d'Oro (27), begun about 1421, follow the model of the Doges' Palace in the highly decorative articulation of the loggias. The asymmetric composition and the use of color give a "pictorial" effect that seems worlds apart from the solid, plastic architecture of Tuscany. In Lombardy, the Late Gothic love of decoration and ornament continued to assert itself even when Florentine architects were called in. Two examples in Milan are the Ospedale Maggiore, begun in 1456 by Filarete, and the Portinari Chapel, S. Eustorgio, 1462, built by Michelozzo on the model of Brunelleschi's Old Sacristy.

The great achievement in Northern architecture in the 15th century was the further development of the hall church on the basis of innovations by the Parler workshop. The nave of St. Martin's church in Landshut (13)—in progress in 1407 under the direction of Hans von Burghausen—is a large area of equal height, flooded with light, with low side chapels, in which the desire for a uniform space has also determined the vaulting. Instead of groin vaults determined by the bays, a uniform network of ribs defines the upper limit of the space. The hospital church of the Holy Spirit in Landshut (12), begun in 1407 by the same master, takes a significant step further. The plain, high-rising individual forms of St. Martin's here become solid structural elements. The nave and choir form a single entity, and the upper limit of the space fuses with the pillars and walls, for the beginning of the vaulting is not articulated by capitals or abutments. But, above all, the central space is given a completely new interpretation by the round columns set on the longitudinal axis in front of the end windows. This give the impression of a space whose boundaries are no longer dependent on the logical function of the structural elements. This kind of space is far removed from Gothic architecture, as is the mighty exterior with its large unadorned surfaces.

This new interpretation of space and spatial boundaries informs all the major achievements in 15th-century architecture north of the Alps. For instance, in the church of St. Martin in

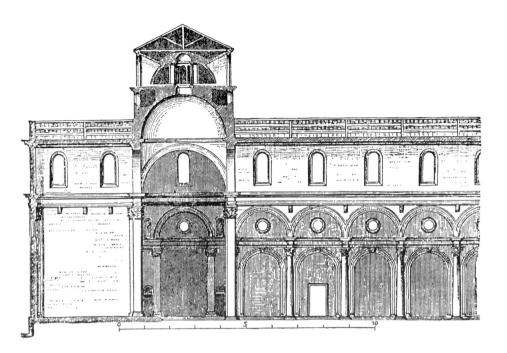

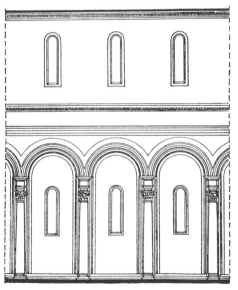

1 S. LORENZO, FLORENCE. Nave elevation.

2 S. SPIRITO, FLORENCE. Nave elevation. Comparison with *1* shows that although the over-all design is similar, the individual details are more closely interrelated in S. Spirito. The height of the upper nave wall is approximately the same as that of the arcades supporting it, the side chapels have the same elevation as the arcades, and the similar dimensions of clerestory windows and aisle windows contribute to the homogeneity of the nave.

Amberg, begun in 1421, the space extends into the side walls, not only because of the addition of side chapels but because above them, between the buttresses, steep, shaftlike galleries reach up to the level of the vault—following the example of the choir of the Franciscan

3 OLD SACRISTY, S. LORENZO, FLORENCE. Built 1419–28 by Filippo Brunelleschi as burial chapel of the Medici, connecting with the southern transept of S. Lorenzo. Bronze doors and terracotta reliefs by Donatello, c. 1440.

4 CHURCH OF THE HOLY CROSS, SCHWÄBISCH GMÜND. Choir. Begun 1351 by Heinrich Parler with a hall-style ambulatory—that is, the aisles are the same height as the nave and extend completely around the choir. Originally a cross vault was planned; the net vaulting now covering the bays was built after the collapse of the choir towers in 1497.

5 FLORENCE CATHEDRAL. The plan for the nave, begun 1296 by Arnolfo di Cambio, was altered in 1355 and gave way to four wide-spanning arcades (two of these are semidetached) and rib vaults. As in Schwäbisch Gmünd (4), the individual features have a marked solidity and the horizontals are stressed heavily.

6 S. SPIRITO, FLORENCE. Begun 1434 by Brunelleschi and incomplete at his death in 1446. This is a return to the type of Early Christian basilican church with flat roof and all'antica details. The various elements are mathematically related to one another and to the whole.

7 S. ANDREA, MANTUA. Begun 1472 after designs by Leon Battista Alberti. Comparison with Brunelleschi (6) clearly shows the influence of ancient Roman vaulting. (The dome, which admits a great flood of light, was executed 1732–82 after designs by Filippo Juvarra.)

8 PAZZI CHAPEL, FLORENCE. Situated in the first cloister of S. Croce. Begun 1430 by Filippo Brunelleschi.

9 S. ANDREA, MANTUA. West façade. The wall features reflect the articulation of the interior.

10 ST. GEORGE, DINKELSBÜHL. Built 1448–92 by Nikolaus Eseler of Alzey. The divisive function of the arcade columns is further reduced by the lack of emphasis on the solidity of form (see also the octagonal and round columns in the two churches of Landshut, 12, 13).

11 STRASBOURG CATHEDRAL. Spire. Completed in 1439 by Johann Hültz of Cologne.

12 HOSPITAL CHURCH OF THE HOLY SPIRIT, LANDSHUT. Begun 1407 by Hans von Burghausen, completed 1461. Continuous space is suggested by the central column in front of the eastern choir window.

13 ST. MARTIN, LANDSHUT. Begun about 1385; Hans von Burghausen named master builder in 1389; nave begun 1407; vaulting completed 1459. The interior appears as an uninterrupted spatial shell; the arcades are united with the vault by their extremely high arches and the absence of capitals, and the bays are not clearly demarcated by the configuration of the network of ribs on the vaulting.

14 CERTOSA, PAVIA. Façade. Begun 1476. Ground floor decoration mainly by Giovanni Antonio Amadeo. The wealth of colorful decorativ work, with a number of motifs borrowed from antiquity, conceals the clarity of the architectural articulation.

15 S. MARIA DEI MIRACOLI, VENICE. Built 1481–89 by Pietro Lombardi and his sons Tullio and Antonio. With its strong color effects, a prime example of typically Venetian "pictorial" architecture.

16 S. MARIA DELLE CARCERI, PRATO. Built 1485–91 by Giuliano da Sangallo. The building is composed of clearly defined, individual geometric solids.

17 S. MARIA DELLA CONSOLAZIONE, TODI. Begun 1508 by Cola di Matteuccio, under the influence of Bramante. In contrast to 16, a uniformly articulated whole.

18 S. MARIA PRESSO S. SATIRO, MILAN. Begun c. 1480 by Bramante perhaps inspired by ancient Roman vaulted buildings, which he may have learned about from Alberti. The effect of depth in the choir is created by shallow forms treated perspectively.

3

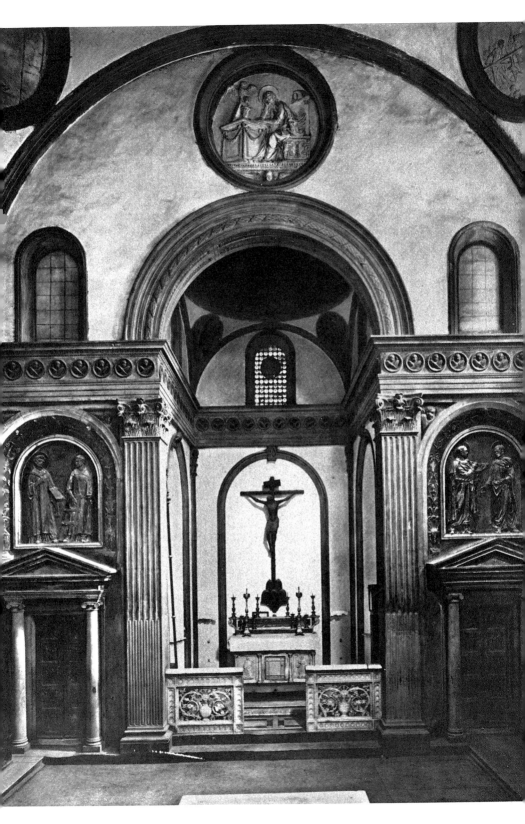

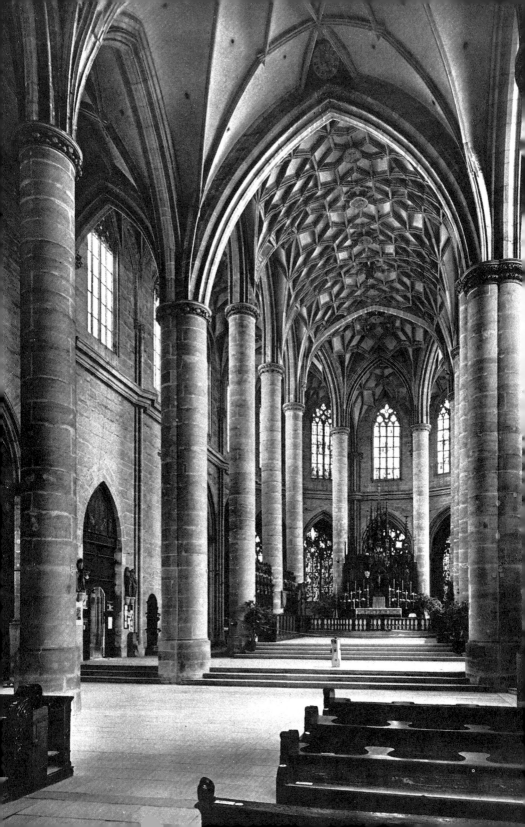

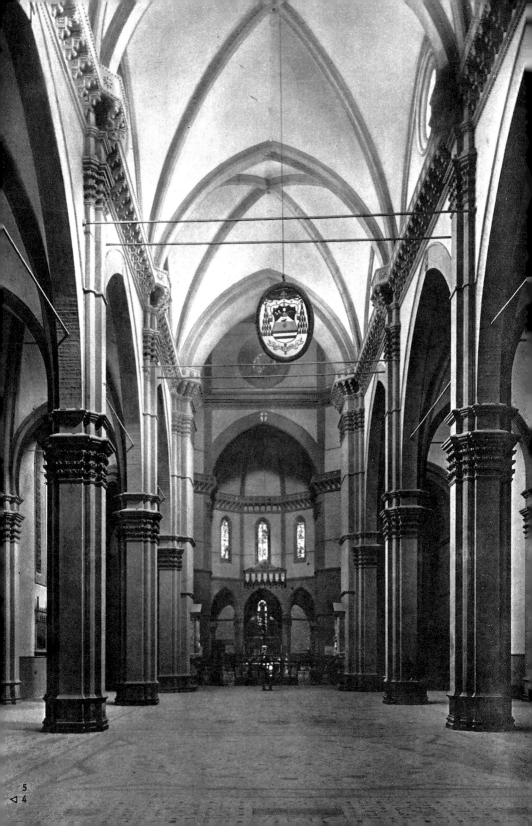

△ 6 ▽ 8 △ 7 ▽ 9

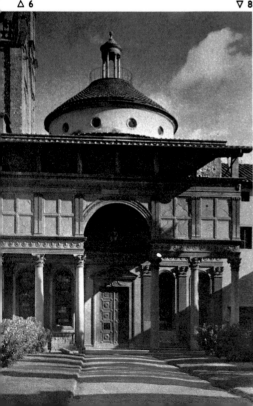

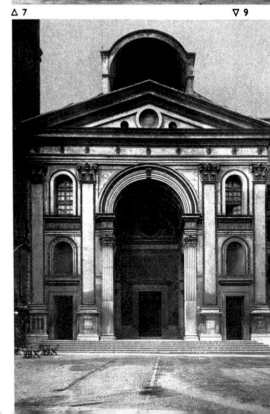

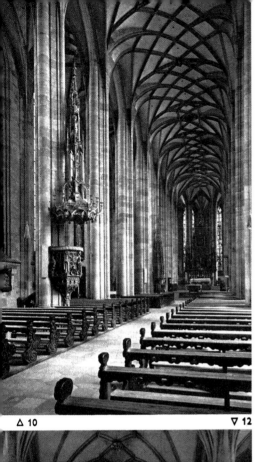

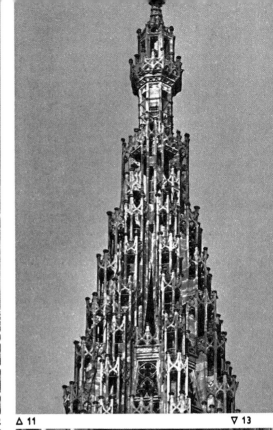

△ 10 ▽ 12 △ 11 ▽ 13

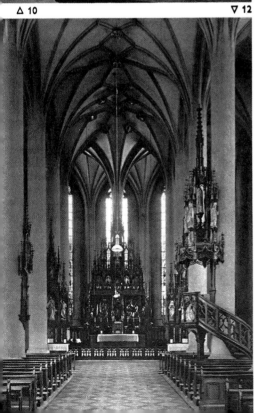

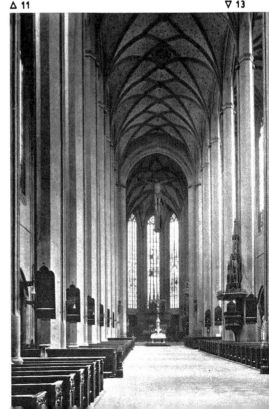

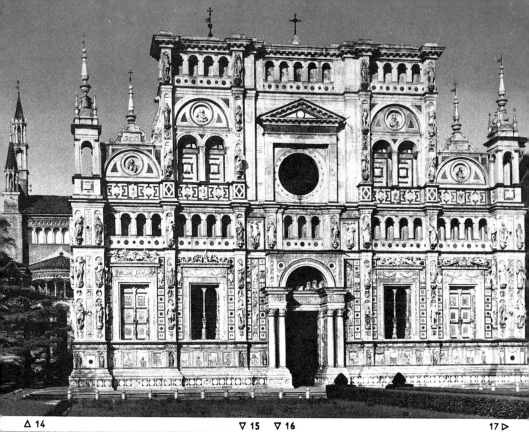

△ 14

▽ 15 ▽ 16 17 ▷

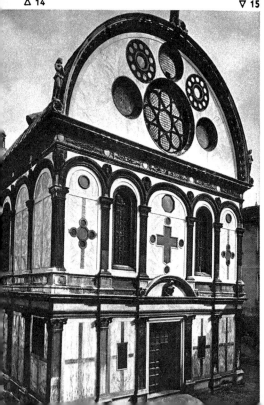

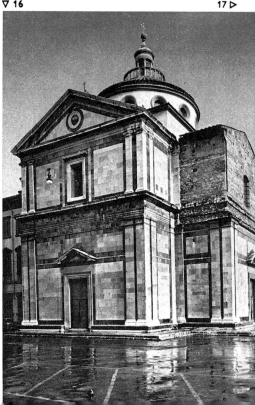

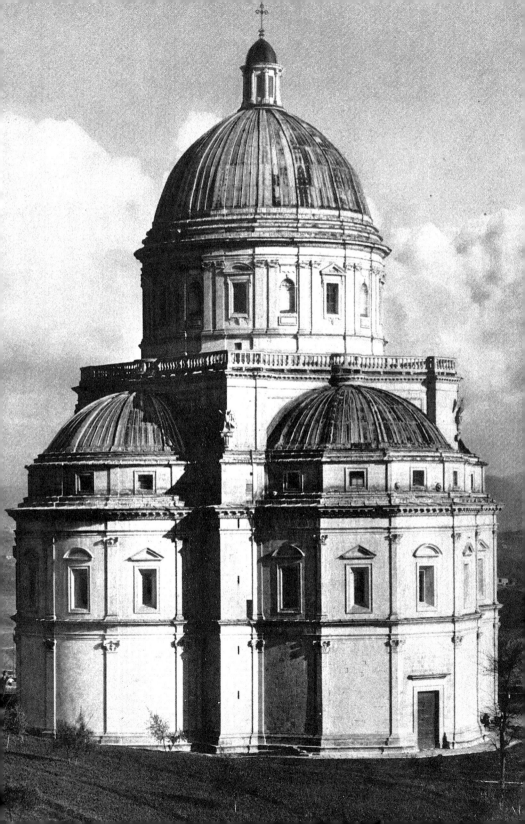

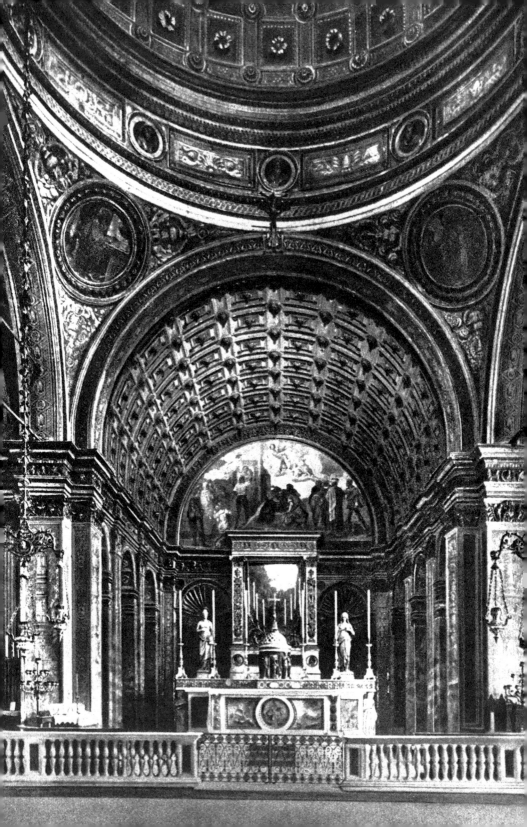

19

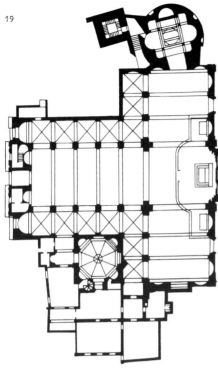

20

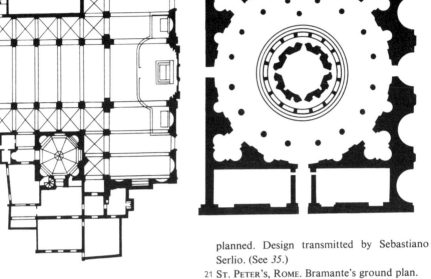

planned. Design transmitted by Sebastiano
Serlio. (See *35.*)

21 St. Peter's, Rome. Bramante's ground plan.

22 St. Peter's, Rome. Michelangelo's ground
plan.

19 S. Maria presso S. Satiro, Milan. The ground
plan makes it clear that the impression that the
three arms are equal is achieved solely by
illusionistic perspective. (See *18.*)

20 S. Pietro in Montorio, Rome. Ground plan of
Bramante's Tempietto with the peristyle he

22

21

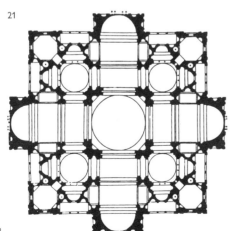

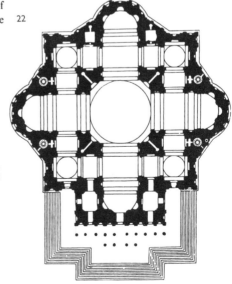

◁ 18

church in Salzburg, another novel creation by Hans von Burghausen. This preoccupation with problems of openness and solidity also affected Northern architecture in the 15th century, even down to the details. In 1392, when Ulrich von Ensingen took over the construction of Ulm Cathedral, he did not give access to the ground floor of the tower through a portal in the wall, but instead created a deep, shadowy recess behind a triple arcade that was level with the front wall. Johann Hültz, who completed the spire of Strasbourg Cathedral in 1439, also had new ideas (11). Instead of areas of tracery, such as the Master of Freiburg Cathedral had designed more than a century before, he dissolved the pyramid into a multitude of small polygons, which allowed the outer space to penetrate at the same that it "interlocked" with the surrounding space. Secular architecture shows evidence of the most divergent tendencies. While, for instance, the Gürzenich in Cologne (28) expresses a Renaissance "mood" in the balanced order of horizontals and verticals and the clearly symmetrical composition, a building such as the Town Hall in Louvain (29) derives from very late Gothic church architecture, with its love of exuberant decoration.

Toward the end of the Quattrocento in Italy, all the ideas put forth in the course of the century began to crystallize. The impetus no longer came from Tuscany alone but also from northern Italy. The Villa Medici in Poggio a Caiano, near Prato (32), 1480–85, was built after designs by Giuliano da Sangallo; from 1485 to 1491 the same master constructed the church of S. Maria delle Carceri in Prato (16). Both buildings give the impression of mathematically calculated stereometric forms. Architecture no longer consists primarily in the articulation of well-proportioned areas but in a combination of simple three-dimensional geometric forms: cube, square, cylinder. The developments introduced in the late work of Brunelleschi and carried on in Alberti's designs for S. Andrea in Mantua now approached their high point. The architecture of ancient Rome, which Alberti had revived, served as an important source of inspiration, particularly for vaulting. The central plan became more frequently used for church architecture. S. Maria delle Carceri (16) is based on the Greek cross; four low, rectangular arms of identical size are set around a square, domed central space, and their barrel vaults are a visual preparation for the central dome. The tendency to give the space a focal center, already clearly apparent in Brunelleschi's S. Spirito (2, 6) and Alberti's S. Andrea (7), is now established as the main theme of the building. The harmonious and self-contained central plan, which can be comprehended fully only when the visitor walks around it—that is, in motion—may be described as the leitmotif of the High Renaissance. It preoccupied painters as well as architects (see 175). A striking number of variations on the centrally planned building can be seen in frescoes and panel paintings in the decades around the end of the 15th century. Leonardo also worked on designs for central-plan buildings again and again.

Donato Bramante (1444–1514) was the same age as Giuliano da Sangallo. Trained in Urbino, where he was strongly influenced by the ideas of Alberti and Piero della Francesca, Bramante moved to Milan in 1476. This date marks the true beginning of the Renaissance

in northwestern Italy. Toward 1480, Bramante undertook the extension of the church of S. Maria presso S. Satiro in Milan (18, 19). His design for the choir is reminiscent of the church of S. Maria delle Carceri (16); transepts surmounted by barrel vaults lead to the central domed space. However, he was unable to build a true centrally planned church, for there was already a nave in existence. But the transepts and choir are perfect examples of central-plan elements, in this case achieved through bold perspective illusion. Since the site allowed no room for an eastern arm, Bramante created the illusion of a choir area projecting to the east with greatly foreshortened lateral blind arcades and heavy, coffered vaulting. Alberti's ideas may have influenced this "Roman" concept, and works from the sister arts, such as Piero della Francesca's *Montefeltre Madonna* or Donatello's reliefs (90), perhaps inspired the use of "pictorial" features. As a whole, it was characteristic of Bramante, who was also trained as a painter, to relieve the monumental architectural structure by means of decorative additions. The huge choir tribune of S. Maria delle Grazie, Milan, begun in 1492, is an even clearer example than S. Maria presso S. Satiro; it combines a grandiose conception with the characteristic love of decoration of the Lombard Quattrocento.

After 1500, Bramante worked in Rome; Giuliano da Sangallo also ended his career in the service of the popes. The city of Rome acted as a catalyst, providing the atmosphere in which forces from abroad fused and matured, based on the classical tradition. Bramante's Tempietto in the courtyard of S. Pietro in Montorio, Rome, c. 1502 (20, 35), is one of the most perfect examples of High Renaissance architecture and is a refined version of Bramante's Lombard style. It is a pure centrally planned church, a structure of wonderfully harmonious proportions comparable in its unified effect to sculpture. The "additive" approach (S. Maria delle Carceri, Prato [16]) has been abandoned. Bramante's design also included a circular peristyle (never executed), with columns radially related to those of the Tempietto, so that the building would have fused with its surroundings. In 1506 Bramante was entrusted with rebuilding St. Peter's (21). This holiest of Catholic churches was also to be built on a purely central plan, a richly articulated structure matching the importance of the project, with varied spatial divisions, which, according to the ground plan, were all part of a unifying square. Bramante's project, which was still in its initial stages at the master's death in 1514, was altered by his successors—who included Raphael, Baldassare Peruzzi, and Antonio Sangallo the Younger. Beginning in 1547, Michelangelo, with his sculptor's attitude, made it more plastic and condensed the details (22). Of the great churches that were actually built, the spirit of the High Renaissance can be seen at its best in S. Maria della Consolazione, Todi, designed by one of Bramante's circle (17). In principle, it is like S. Maria delle Carceri (16), with a dome surmounting a Greek-cross plan; and this comparison with the earlier building makes very apparent the progress in the search for unity characteristic of the High Renaissance. The structure is no longer made up of autonomous cubic forms; instead, the central space and the arms of the cross fuse, thanks to the way the half-cylinders and half-domes lead into the dominant central dome.

23 PALAZZO RUCELLAI, FLORENCE. Begun 1446 after designs by Leon Battista Alberti. Executed by Bernardo Rossellino. In his architectural career, Alberti represented the dichotomy between designer and builder.

24 LOGGIA DEI LANZI, FLORENCE. Built 1374–81 by Benci di Cione and Simone di Francesco Talenti for public civic ceremonies. The Loggia was given the epithet "dei Lanzi" in the 16th century when the lansquenet bodyguard was housed there. Life-size seated figures of the Virtues in the spandrels by Giovanni d'Ambrogio, Giovanni di Francesco Fetti, and Jacopo di Piero Guidi, 1384–91.

25 PALAZZO DELLA CANCELLERIA, ROME. Courtyard. Begun 1483 as private residence of Cardinal Raffaello Riario, but owned since the early 16th century by the Curia, who used it as an administrative building (hence the present name). The architect of this epoch-making Roman Renaissance building is unknown, but he was probably much influenced by Alberti.

26 PALAZZO MEDICI, FLORENCE. Built 1444–c.1460 by Michelozzo. In 1517 Michelangelo filled in the open arches at the corner with windows. In 1715 the long side was extended by seven windows, seriously upsetting the proportion.

27 CÀ D'ORO, VENICE. Built c.1421–c.1440 by Bartolommeo Buon (or Bon). The façade, borrowing loggia motifs from the Doges' Palace, is determined by the playful asymmetry of open and closed surfaces.

28 GÜRZENICH, COLOGNE. Built 1441–47, probably by Johann von Bueren, as a banqueting house; later used as a warehouse.

29 TOWN HALL, LOUVAIN. Built 1448–63 by Mathias de Laeyens. The effect is of a reliquary shrine on a monumental scale.

30 PALAZZO STROZZI, FLORENCE. Begun 1489, cornice over the façade completed 1500. The first design by Antonio da Sangallo the Elder, building by Benedetto da Maiano. The forceful projecting cornice is by Simone del Pollaiuolo, called Cronaca.

31 PALAZZO VENDRAMIN-CALERGI, VENICE. Begun c.1500 by Mauro Coducci. The combination of columns set in front of the wall and strongly marked horizontals is a return to Alberti's ideas; at the same time, it gives the façade a plastic articulation and solidity new to Venice and heralds the High Renaissance.

32 VILLA MEDICI, POGGIO A CAIANO. Built 1480–85 after designs by Giuliano da Sangallo. The portico "is perhaps the first strictly classical creation of the Renaissance; it anticipates the designs and buildings of Palladio decades later" (H. Decker).

33 CHAPEL OF HENRY VII, WESTMINSTER ABBEY, LONDON. 1502–20. The delight in varied decorative effects, characteristic of English architecture since the huge Norman buildings of c.1100, reached its high point in the Perpendicular Style of the late 15th and early 16th century. The stone vaulting with pendant bosses derives from the wooden roofs of the great halls of English castles.

34 FUGGER CHAPEL, ST. ANNE, AUGSBURG. 1509–18. One of the earliest and most important examples of the German Renaissance, with its hall-like space, large round arches in the Renaissance manner, and the Italian-inspired décor, executed by Hans Daucher, Sebastian Loscher, and Jörg Breu.

35 TEMPIETTO, S. PIETRO IN MONTORIO, ROME. Built c.1502 by Bramante. (See 20.)

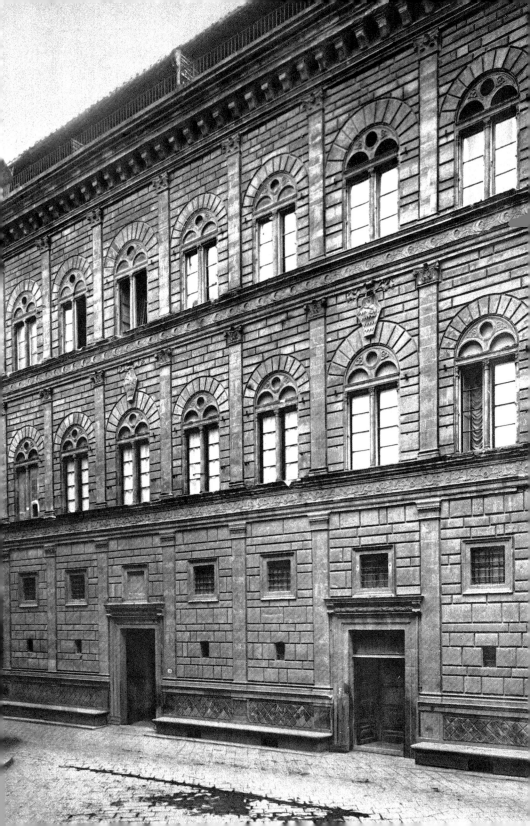

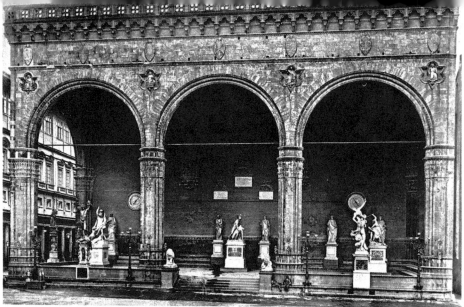

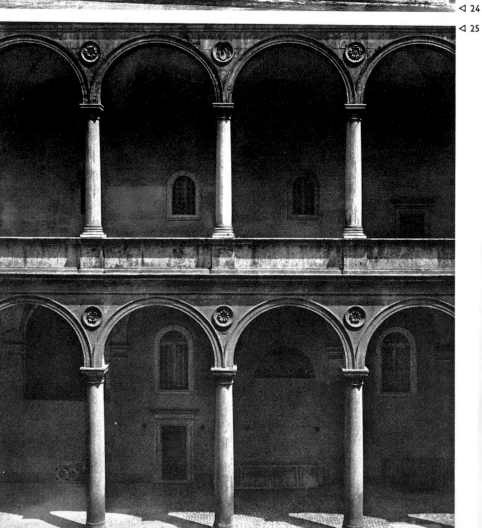

◁ 24

◁ 25

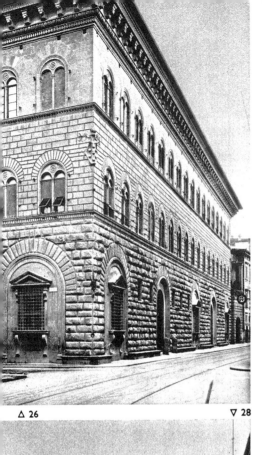

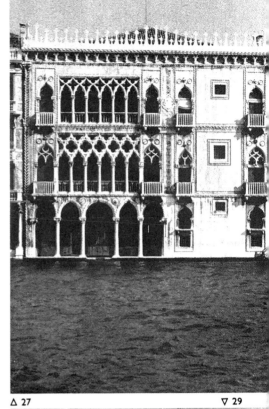

△ 26
▽ 28
△ 27
▽ 29

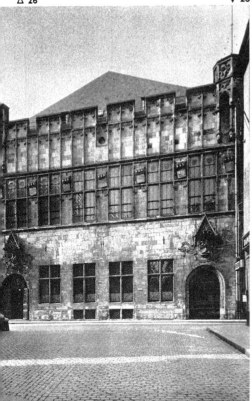

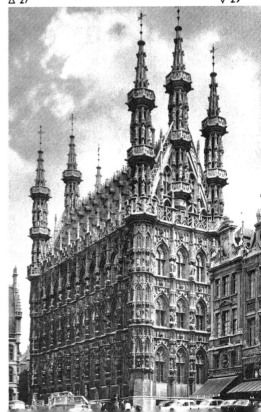

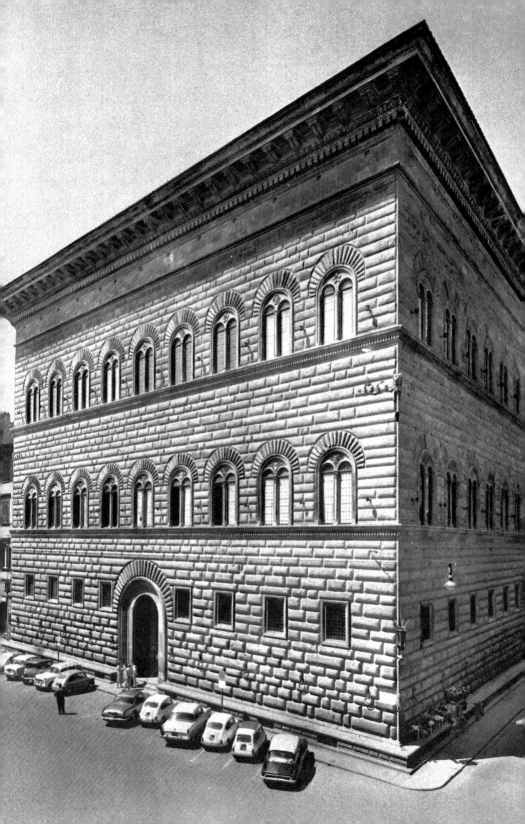

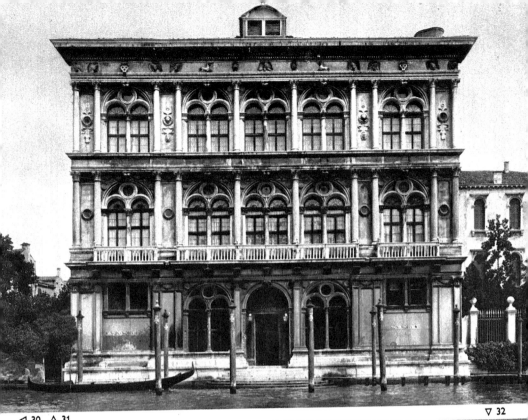

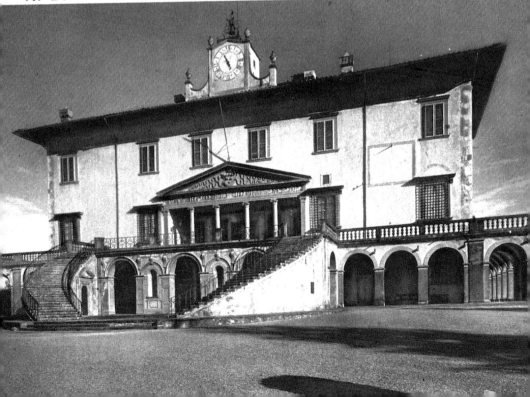

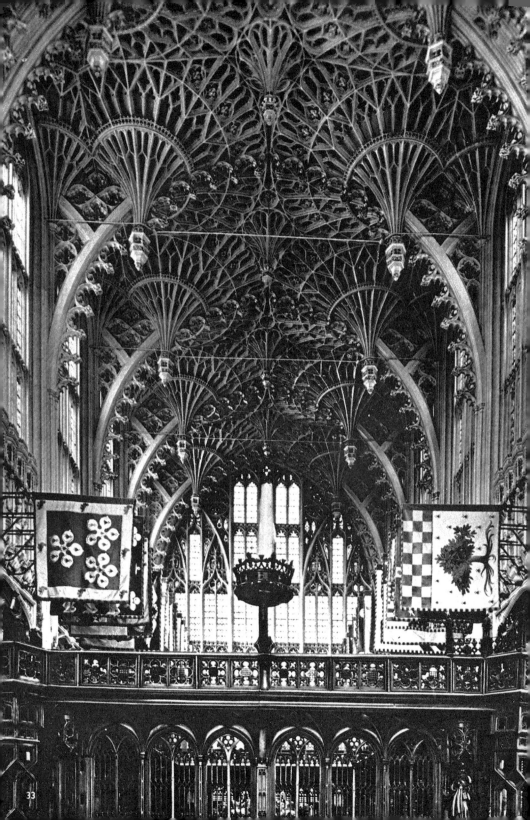

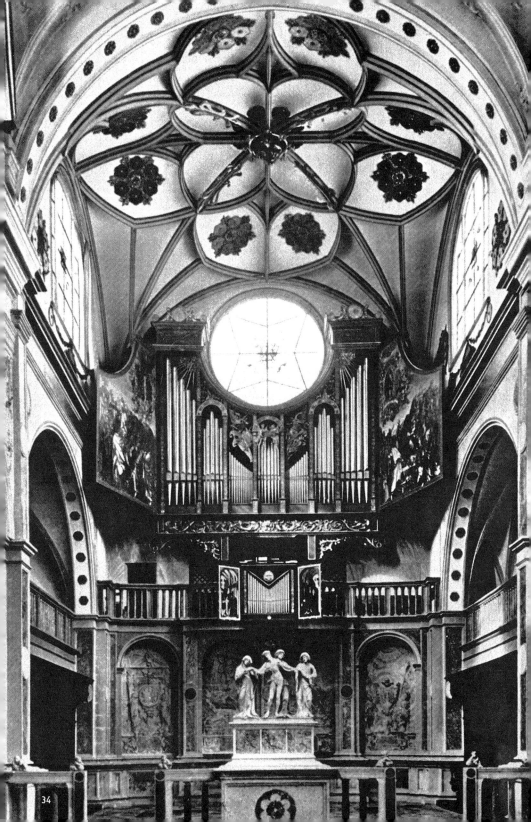

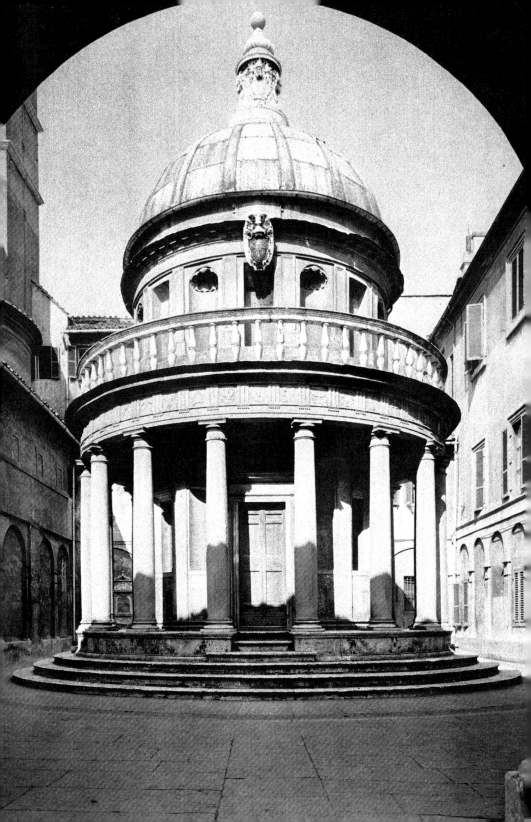

In northern Italy in the late 15th century, the interest in Renaissance forms mingled with a love of exuberant decoration. A representative example is the façade of the Certosa near Pavia, which was begun in 1476 and continued far into the Cinquecento (*14*). At the same time, Venice was developing its own special Renaissance style. From 1481 to 1489, Pietro Lombardi built the church of S. Maria dei Miracoli (*15*). The form of the barrel-vaulted rectangular space is clearly reflected in the exterior. The walls are encrusted with marble in perfect proportions. The harmony between the clearly outlined surface decoration and the architectural mass with the colorful effect of the marble paneling and architectural elements is an example of the painterly values typical of all Venetian architecture. Toward the turn of the century, Mauro Coducci created the "classic" Venetian Renaissance façade with the Palazzo Vendramin-Calergi (*31*). The structure, with its surface of horizontals and verticals, inspired by Alberti, shows a sense of solid form and systematized composition new to Venice. But, at the same time, the bold disruption of the almost square facade and the rhythmic grouping of the central loggia with its lateral wings (alternately closed, open, closed) follows the older tradition of Venetian palace architecture.

This balance of elements, the perfect harmony between the parts, and the logic of the organic articulation dominated the artistic scene for only a short while. From about 1520, the values of the High Renaissance came sharply into question. And the revolt against the idealized world picture of the early Cinquecento began in the circles of those same artists who had been its leaders. In 1525, Raphael's closest collaborator, Giulio Romano, began the Palazzo del Tè (*39*), before the gates of Mantua, consciously contrasting classical and anticlassical tendencies in the architecture and decoration. But, above all, it was Michelangelo himself who replaced the equilibrium between motion and repose by a more dynamic architecture. In the anteroom to the Biblioteca Laurenziana in Florence (*37*), for which he made the first sketches in 1524, there is no dialogue between surfaces and architectural elements, for the columns are recessed into the wall. The entire area is a field of cross forces. The traditional interplay between supporting and supported elements is absent, giving way to the ambiguity and interchangeable motifs that would become an important feature of Mannerist architecture.

The High Renaissance remained a source of inspiration for the entire Cinquecento, but its formal language was reinterpreted in the most varied ways. Exaggerated movement and at times violent contrasts are the tendencies that link the diffuse new vocabulary. The Palazzo Massimo alle Colonne in Rome (1532–36), by Baldassare Peruzzi, for instance, has a huge rusticated façade (*42*), but its monumentality is then played down by the curve of the building, following the line of the street, and by the animated, rather contorted window framings. The thin, flat aspect of the façade contrasts with the deep recesses of the loggia and the shadows created by the forceful window architraves, and also with the cornice, oddly broken up by the window sills, between the two lower stories. Instead of dividing up the levels equally, Peruzzi set two mezzanine floors above two complete stories. When Vasari was

◁ 35

41

commissioned to build the Uffizi in Florence (*38*) in 1560, he created an abruptly fore-shortened architectural vista, closely related to contemporary phenomena in painting. Significantly, it was conceived not as a plastic structure reflecting movement, but as an open loggia with a view into indefinable distances. At the same time, Bartolommeo Ammanati created a strict system of bays in the courtyard of the Palazzo Pitti (*41*), which he ironically based on the sequence of classical orders with alternating projecting and recessed layers of rustication; a most unusual effect is his encasing of the columns in broken pilasters, as though in armor.

Toward 1500, the influx of Renaissance forms to the North gathered force. But the requisite conditions for High Renaissance architecture were absent north of the Alps. A "mature" style cannot be transplanted elsewhere simply by the transmission of individual forms. And when Italian artists were summoned to the North, the age of Mannerism had already begun. The North was more susceptible to the Mannerist interpretation of Renaissance forms—or at least to one side of Mannerism. A multiplicity of forms, exuberant decoration, sometimes to the extent of breaking up every surface, no obvious attempt at regularity—all this links with the tendencies of Northern Late Gothic. There was a great deal of latitude for elaborating the new forms. In Germany and the Netherlands, the detail borrowed from the Renaissance was predominant, and sometimes it smothered entire areas and architectural elements—the spire of St. Kilian's Church, Heilbronn, 1513–29, by Hans Schweiner; the chancellery, Bruges, 1535–37; the Ottheinrich Wing, Heidelberg Castle (*52*), c.1556–c.1559. But in France, a definite "ratio" determined the design of the major buildings, such as the earliest parts of the Château de Chambord (*43*), begun 1519, or the façade of the Louvre, 1546–55, by Pierre Lescot (another, later version of which is shown in *44*). And even in the southern Netherlands, we find works successfully combining the love of detail and multiplicity with a grand over-all design, such as the Town Hall, Antwerp (*45*), built 1561–65 by Cornelis Floris, a work that can bear comparison with the best Italian architecture of the century.

In terms of the future, architecture in the age of Mannerism played a major part historically by overcoming the static in favor of the movemented and by imbuing surfaces and structural elements, and their interplay, with tension. The next step in Western art would be the assembly of these forces and their systematization in a new and highly dynamic concept characterizing the Baroque. Two major figures prepared the ground for the great style to come: Andrea Palladio (1508–80), born in Vicenza, and Giacomo Barozzi da Vignola (1507–73), also from the north of Italy. Palladio is the most striking representative of the classicist side of 16th-century architecture. His façade of Il Redentore, Venice (*49*), is clearly constructed from elements of antique temples, although it also has some very "modern" features, such as articulation with a giant order and the powerful plastic modeling of the wall. The Villa Rotonda, near Vicenza (*36, 48*), is a symmetrical, centrally planned building of perfect harmony in the exterior and ground plan. Yet it is here that the ambivalence of

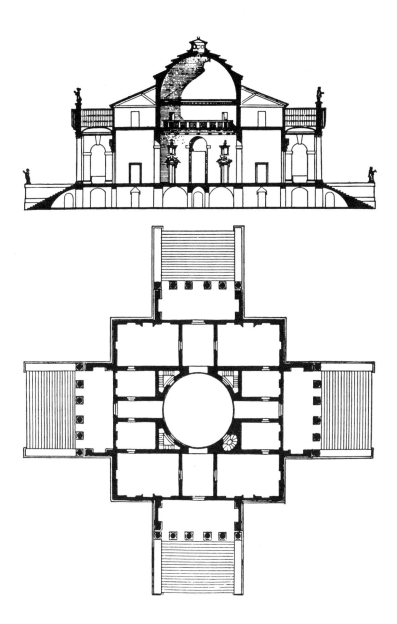

36 VILLA ROTONDA, NEAR VICENZA. Section and ground plan. Designed 1551 by Andrea Palladio.

Mannerist art suddenly becomes apparent again. For the interior, the domed central space, is not the focal point of the whole; rather, it is a dark, almost unlit room from which run four corridors that seem to suck the visitor outward as though through light shafts. The classicizing elements of Palladio's work, together with his way of breaking up the walls into

several levels of relief, exerted a lasting influence on European architecture in the 17th and 18th centuries.

The Roman church of the new Jesuit Order, Il Gesù (46, 50), was built from 1568 to 1584 after Vignola's plans, at the time Palladio was engaged on his late works. In principle, it refers back to Alberti's plan for S. Andrea in Mantua (7, 9), while the restless articulation of the walls and the irregular lighting are indebted to Mannerism. But with its completely unified space and the light-flooded dome, which seems to draw the visitor inward, as do the uninterrupted horizontals of the main nave cornice, Il Gesù stands on the threshold of the Baroque.

37 BIBLIOTECA LAURENZIANA, S. LORENZO, FLO-
RENCE. Anteroom. Michelangelo's first de-
signs date from 1524. In 1557 he delivered a
clay model that was executed toward 1560 by
Ammanati.

38 UFFIZI, FLORENCE. Begun 1560 by Giorgio
Vasari as administrative building of the Tuscan
Grand Duchy; completed 1580. The top storey
was from the beginning intended to house the
Medici art collections.

39 PALAZZO DEL TÈ, MANTUA. Entrance to the
main courtyard. Built 1525–35 by Giulio
Romano. This pupil of Raphael also executed
the frescoes in the Hall of the Giants in the
palace.

40 THE HALL (KINGSTON HOUSE), BRADFORD-ON-
AVON. 1580. The Tudor Style, the period in
English architecture between c. 1530 and the
early 17th century, combines elements of Late
Gothic with the influence of the Italian
Renaissance.

41 PALAZZO PITTI, FLORENCE. Courtyard. Begun
1560 by Bartolommeo Ammanati.

42 PALAZZO MASSIMO ALLE COLONNE, ROME. Built
1532–36 by Baldassare Peruzzi.

43 CHÂTEAU DE CHAMBORD. Begun 1519 for
François I. The shell was nearly complete in
1538.

44 LOUVRE, PARIS. Courtyard. Façade built
1546–65 by Pierre Lescot; sculpture by Jean
Goujon, c. 1549 (restored 19th century).

45 TOWN HALL, ANTWERP. Built 1561–65 by
Cornelis Floris, his principal work.

46 IL GESÙ, ROME. Begun 1568 by Vignola and
finished according to plan after his death in
1573. (See 50.) Façade c. 1580 by Giacomo della
Porta. Consecrated 1584. The High Baroque
interior was completed in 1685.

47 ST. MICHAEL, MUNICH. Begun 1583; choir
rebuilt and enlarged 1590 after collapse of the
choir tower. Probably Wendel Dietrich, who
was responsible for the decoration, Friedrich
Sustris, and the overseer Wolfgang Miller all
participated in the planning. The interior shows
the influence of Il Gesù in Rome (46) and ele-
ments from Late Gothic tradition (pilaster
church with galleries) with multi-partite stucco
decoration.

48 VILLA ROTONDA, NEAR VICENZA. Designed 1551
by Andrea Palladio. Work not completed until
1580 under the direction of Vicenzo Scamozzi.
(See 36.)

49 IL REDENTORE, VENICE. Built 1577–92 after
designs by Andrea Palladio.

37

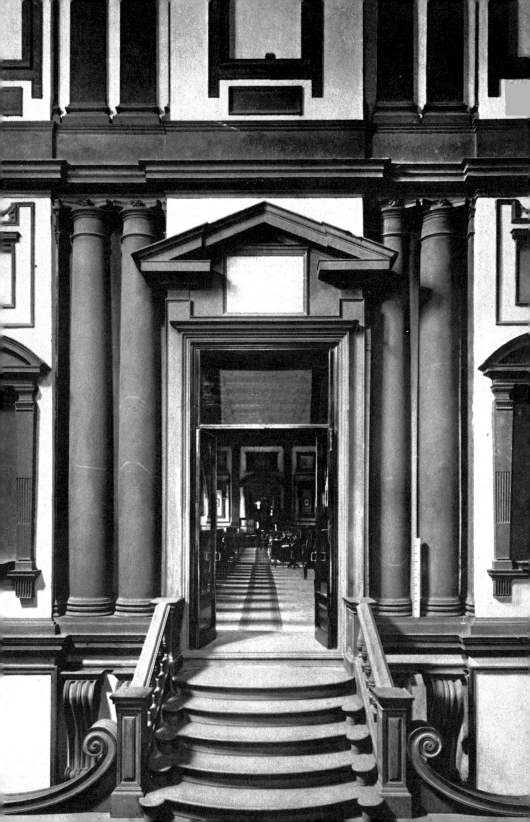

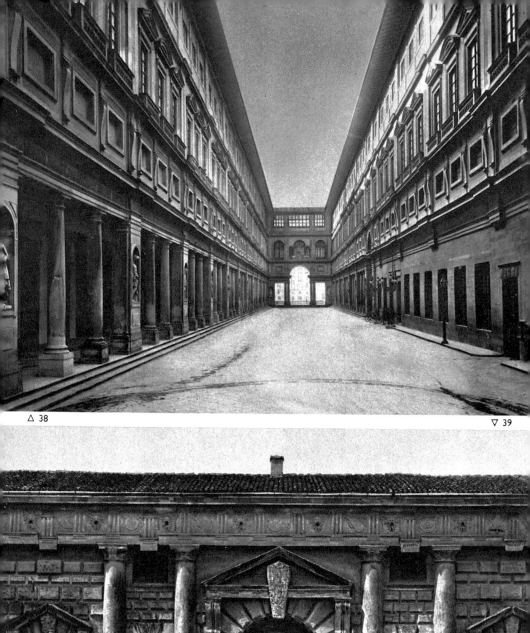

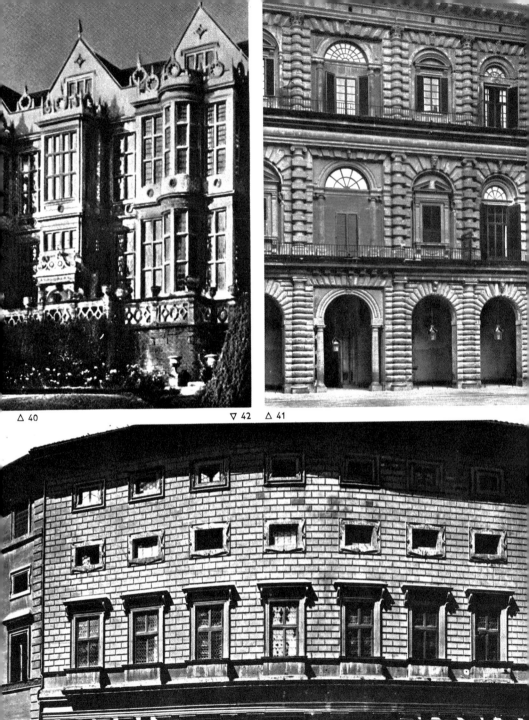

△ 40 ▽ 42 △ 41

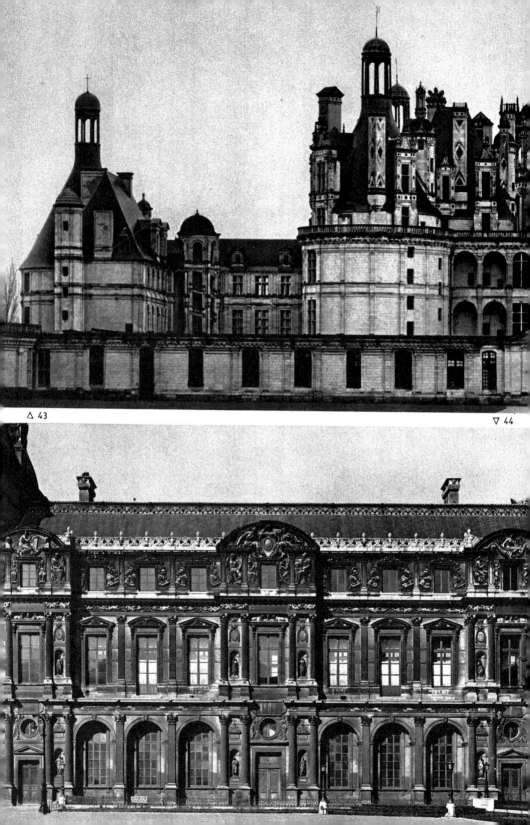

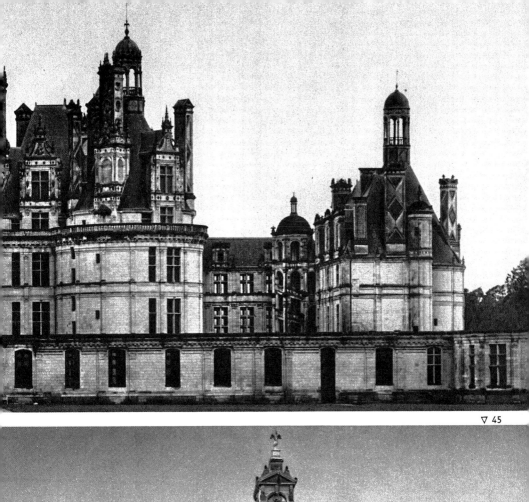

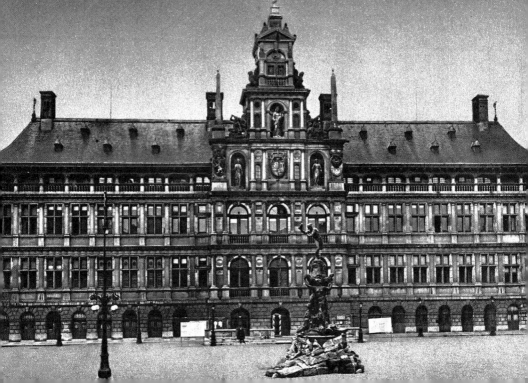

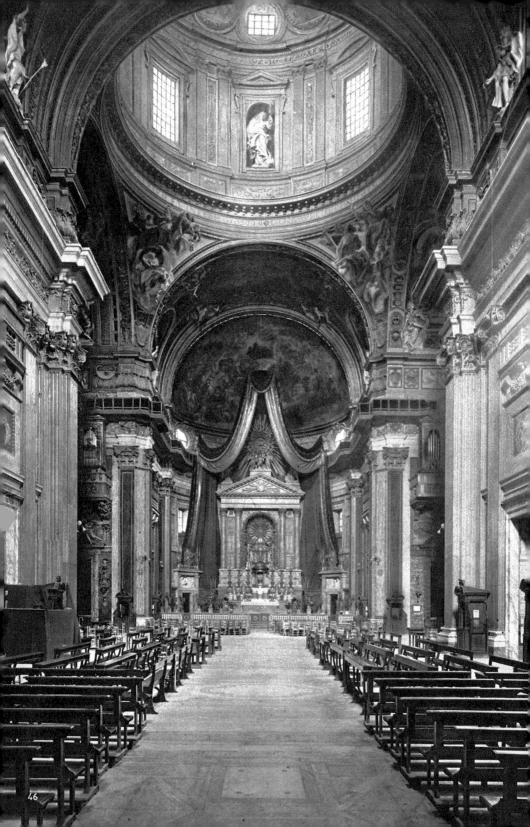

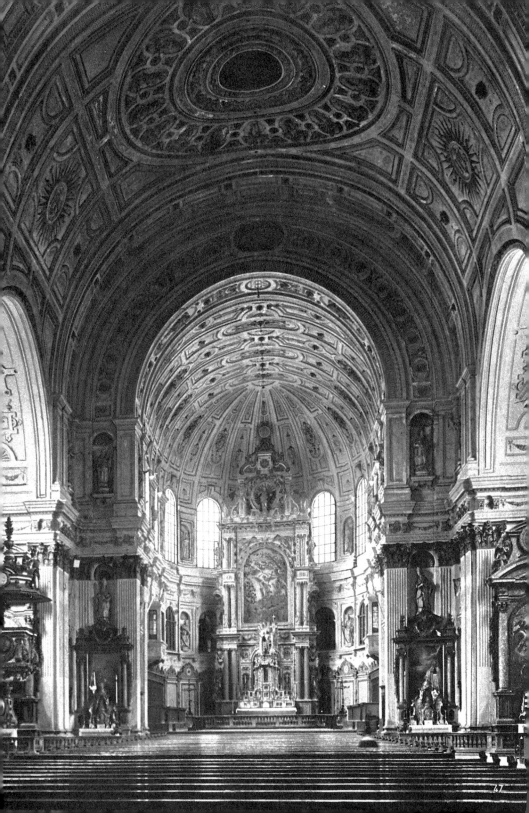

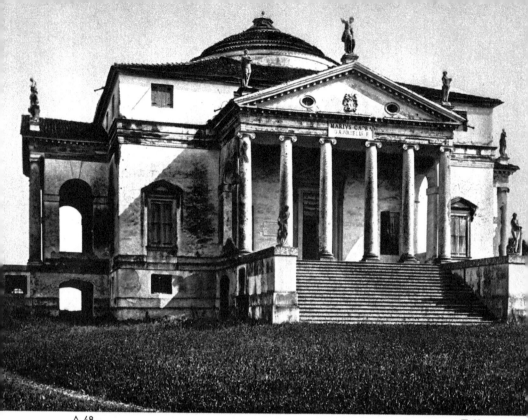

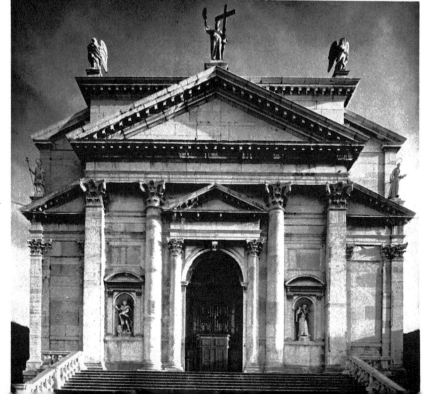

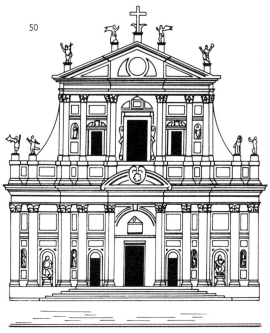

50 IL GESÙ, ROME. Design for the façade by Vignola. (See *46*.)

51 ST. MICHAEL, MUNICH. Façade. Compared to Vignola's design for Il Gesù (*50*), the details here are markedly autonomous. Vignola's designs are characterized by a dynamic cohesion of horizontals and verticals and clear differentiation between the several relief levels of the façade.

52 OTTHEINRICH WING, HEIDELBERG CASTLE. Center of the façade. c.1556–c.1559. Italian and Netherlandish influences combine in the clearly marked coordinate system of articulation and the abundant decoration that veils the surfaces and reduces the articulating power of the structural elements.

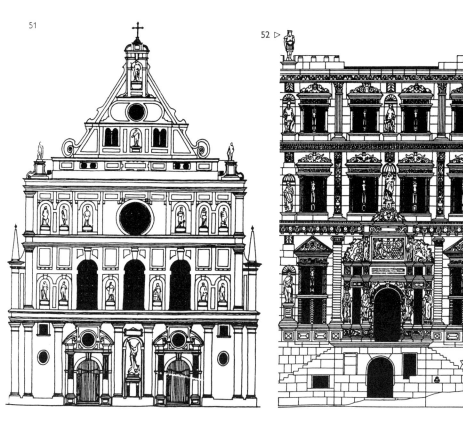

The pulpit by Nicola Pisano in the baptistery of Pisa (54), completed in 1260, can be described as the earliest work of European Renaissance sculpture. The break with artistic tradition is nowhere so overwhelmingly apparent as in the reliefs and statues on this pulpit. The importance given to the figures, as compared to the architectural background, is already unusual. But the major significance of this work is the corporeal aspect of the figures. They are no longer articulated schematically; rather, their solidity derives from their movements and attitudes. Similarly, these reliefs no longer show equal rows of heads and symmetrically arranged gestures; unity is derived from each scene or grouping itself. The only parallels conceived in a similar spirit in 13th-century sculpture are the screen reliefs created shortly before by the Master of Naumburg (c. 1245–50; Naumburg Cathedral). The basic difference here, however, is that the new, "natural" appearance of Nicola's figures was not primarily the result of the experience of nature but came from his studies of antique sarcophagi. By using antique models, some of which can still be identified, Nicola sharpened his eye for reality. His best and most striking achievement is the *Personification of Fortitude as Hercules* (56).

It would seem at first sight as though the Renaissance had begun with a grandiose prelude. But Pisano—a modern artist insofar as his ascertained works reveal a dynamic personal development—moved far from the ideals of his youth in his later works, above all in the pulpit of Siena Cathedral. Here, the narrative is enriched at the cost of the monumental effect of the figures; line occupies as great a place as volume; and antiquity serves as the model not so much for individual figures as for the relief style as a whole, with its manifold effects of light and shade. This unmistakable tendency toward "Gothic" forms is carried further in the work of Nicola's son Giovanni Pisano, whose *Nativity* relief on the pulpit of S. Andrea, Pistoia (55), completed in 1301, is diametrically opposed to the Pisan pulpit of his father. The composition is made up of circling lines; the figures are so violently animated as to endanger their organic coherence; light and shade destroy the continuity of the relief

levels and heighten the emotion of the scene. Giovanni's *Personification of Fortitude as Hercules* on the pulpit of Pisa Cathedral (*57*), made shortly before his death, is an example of one of the most astonishing changes in the whole of European art. The bold breakthrough in the mid-13th century to a new understanding of the organic structure of the body has here plunged back into an incorporeal linear style; the "expressive" content of the figures is no longer directly visible in the individual forms but resides in the linear style of the work as a whole. The development in the North that led from the Naumburg donor figures to such works as the choir apostles in Cologne Cathedral (c. 1317) is quite comparable in principle.

The work of the other major disciple of Nicola, Arnolfo di Cambio (c. 1245–c. 1301), shows just how much Giovanni Pisano's Gothicism was representative of the times: Arnolfo raised the classicizing tendencies of his master to a stylistic principle, but his late works, which he and his workshop produced after he was made director of the reconstruction of Florence Cathedral in 1296, had very little influence (*64, 65*).

53 NANNI DI BANCO, ASSUMPTION OF THE VIRGIN AND THE GIFT OF HER GIRDLE TO ST. THOMAS. Commissioned in 1414, incomplete at the death of Nanni di Banco, 1421. Porta della Mandorla, Florence Cathedral. The belt that originally linked the hands of the two main figures was made of leather. The presumably chronological execution, starting from below, of the ten marble reliefs making up the composition shows an increasing mastery over complex movement and differentiated relief levels. The composition and the figures of the angels had a great influence on painting and sculpture in the late Quattrocento.

54 NICOLA PISANO, NATIVITY. Signed and dated 1260. Pulpit of Pisa Baptistery. Some of the figures are clearly indebted to antique sarcophagi.

55 GIOVANNI PISANO, NATIVITY. Signed and completed 1301, according to the inscription. Pulpit of S. Andrea, Pistoia. The solidity of Nicola's work (*54*) has given way to an animated linear style; the clearly graded relief structure and the play of light and shade suggest a space of indeterminate depth.

56 NICOLA PISANO, PERSONIFICATION OF FORTITUDE AS HERCULES. Completed 1260. Pulpit of Pisa Baptistery. The organically constructed figure is a masterly example of the "balanced" pose—or *contrapposto*—one tensed leg supports the weight and the other leg is relaxed. In terms of the inspiration of antiquity, this is a masterpiece of the "Renaissance."

57 GIOVANNI PISANO, PERSONIFICATION OF FORTITUDE AS HERCULES. Pulpit of Pisa Cathedral. 1302–12. Here again the body is defined largely by line; compared to Nicola's *Hercules* (*56*), Giovanni's statue is planar, the ideal has taken the place of the real.

58 GIOVANNI D'AMBROGIO, HERCULES. 1391–95. Wall of the Porta della Mandorla, north side of Florence Cathedral. It was only toward the end of the century that a few major works showed the inspiration of antique sculpture as vividly as had the work of Nicola Pisano. Compared to Nicola, however, Giovanni lays more stress on detailed modeling.

59 LORENZO GHIBERTI, SAMSON. Completed 1452. Frame of the "Door of Paradise," Florence Baptistery. This statuette also derives from an antique model, possibly owned by Ghiberti (the so-called *Gaddi Torso*, Uffizi). But the fluid contours, the flowing transitions in the modeling of the body muscles, and the resolved

contrasts between the two sides of the body transform the antique inspiration into Ghiberti's own style. (Compare 56–58.)

60 ANDREA PISANO, BAPTISM OF CHRIST. 1330–36. South doors of Florence Baptistery.

61 LORENZO GHIBERTI, BAPTISM OF CHRIST. 1403–24. North doors of Florence Baptistery. The landscape is deeper than in the work of Andrea Pisano. The torsion of the figures, their overlaps, and, above all, the differentiated levels of relief give an impression of depth. The details are more realistic than in Andrea Pisano's panels.

62 CREATION OF ADAM. Sculptor and exact date of execution unknown. Museo dell'Opera del Duomo, Florence. Formerly on the west side of the campanile. The relief is deeper than in Andrea Pisano's bronze door (60), and the figures are more solid.

63 ANDREA ORCAGNA, BIRTH OF THE VIRGIN. Completed 1359. Tabernacle in Orsanmichele, Florence.

64 ARNOLFO DI CAMBIO, S. REPARATA. 1296–1302. Museo dell'Opera del Duomo, Florence. Intended for the façade of the Cathedral.

65 S. REPARATA. Sculptor, date, and purpose unknown. Museo dell'Opera del Duomo, Florence. Although the structural principle is similar to Arnolfo's (64), this master has translated Arnolfo's severe abstract style into melodious, flowing forms.

66, 67 GIOVANNI D'AMBROGIO, ANNUNCIATION. Probably c. 1390. Museo dell'Opera del Duomo, Florence. Intended for the tympanum of the Porta della Mandorla, Florence Cathedral.

68 RESURRECTION AT THE LAST JUDGMENT. Unknown Trecento master. Detail of pier on the right of the façade, Orvieto Cathedral.

69 DONATELLO, ST. GEORGE AND THE DRAGON. After 1417 (date of purchase of marble for the base of the tabernacle of St. George). Orsanmichele, Florence. Prototype of the *rilievo schiacciato* (compressed, "flattened-out relief") created by Donatello. There is no strong modeling even in the foreground, and the deep space is implied by foreshortening and by the constantly shallower relief. The background is merely engraved, giving the illusion of atmospheric effects.

70 MADERN GERTHNER, ADORATION OF THE KINGS.

c. 1425. Tympanum, south portal of the church of Our Lady, Frankfurt. The delight in narrative, the stress on the "beautiful" flow of line, and the attempt to give the background greater depth are very close to the style of Ghiberti's "Door of Paradise" (71). The suggestion of space is increased by the physical distance between the tracery arch and the relief.

71 LORENZO GHIBERTI, DAVID AND GOLIATH. 1425–52. "Door of Paradise," Florence Baptistery.

72 JACOPO DELLA QUERCIA, EXPULSION FROM PARADISE. 1428–38. Frame of Porta Magna, façade of S. Petronio, Bologna. Landscape and architectural details are reduced in favor of monumental figures. Jacopo does not extend the background depth and thus the figures seem more solid.

53

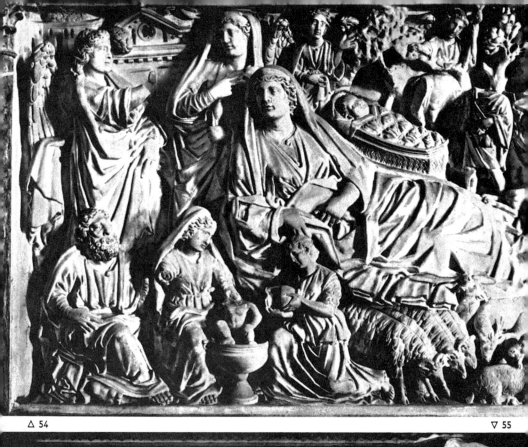

△ 54
▽ 55

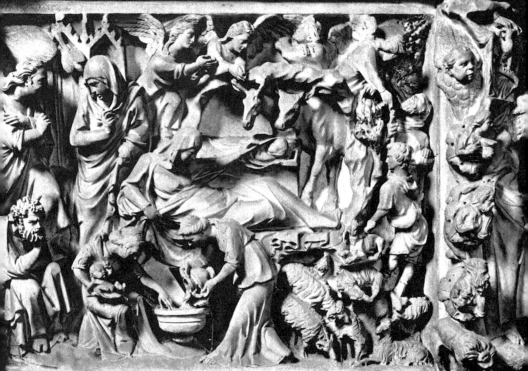

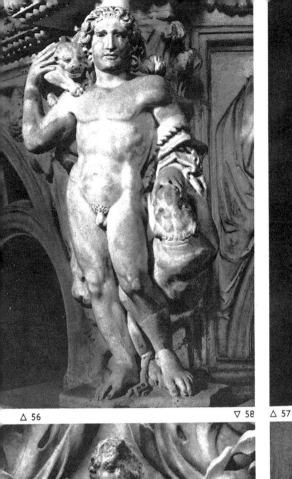

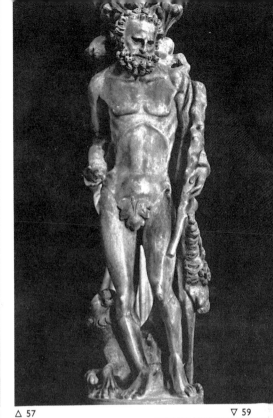

△ 56 ▽ 58 △ 57 ▽ 59

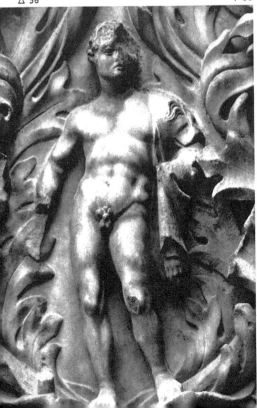

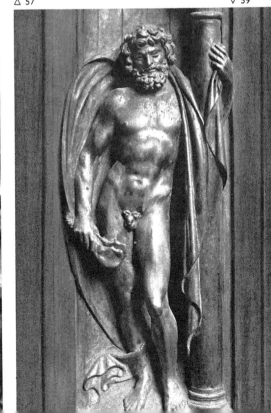

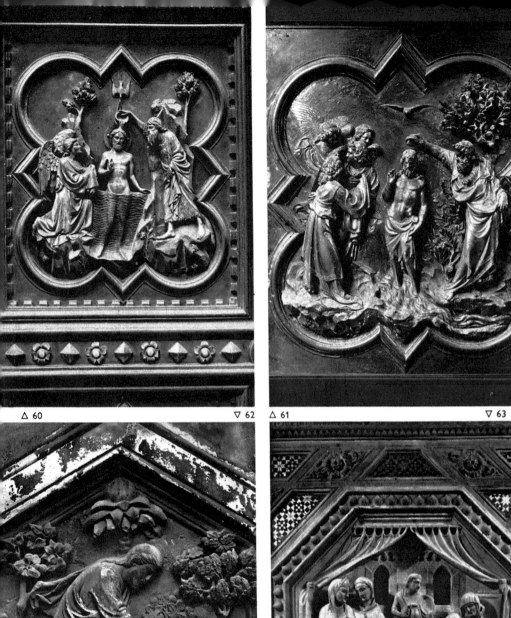

△ 64

66 ▽

△ 65

▽ 67

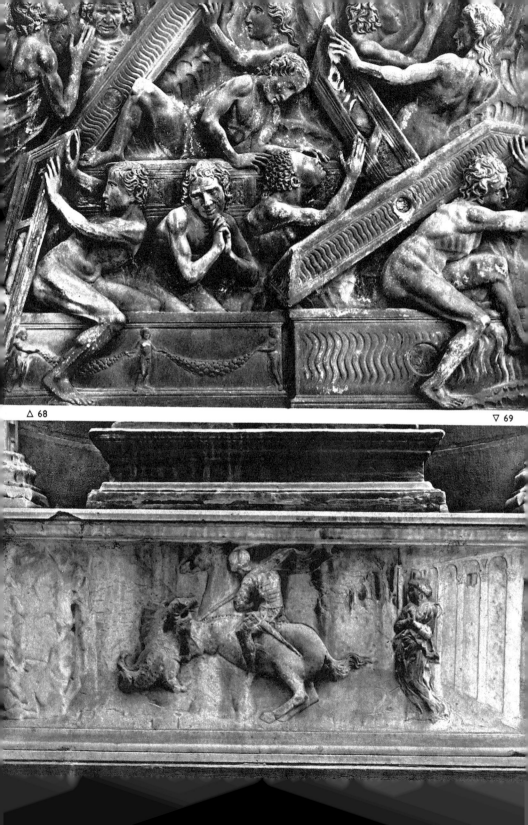

△ 68

▽ 69

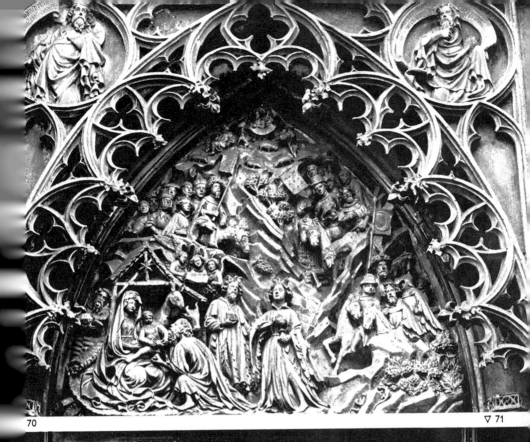

Admittedly, a latent classical tendency permeates the entire output of sculpture in the 14th century south of the Alps. The greatest work between 1300 and 1350 is Andrea Pisano's bronze doors for the Florentine Baptistery (60). Here, a melodic linear style of inexhaustible variety goes hand in hand with clearly articulated figures; the wealth of scenic action is controlled by the delicate clarity of the composition, and the action taking place between the background and an ideal foreground is clearly defined. In time to come, the masters of the Florence Cathedral workshop developed Andrea Pisano's relief style further in the extensive cycle on the campanile (62).

As in architecture, so too in the sculpture of the mid-14th century there were signs of stylistic change, occurring at almost the same time in the North and the South. The painter and sculptor Andrea Orcagna, whose great Tabernacle in Orsanmichele in Florence is dated 1359 (63), based his figures on a new ideal of three-dimensional corporeality, achieved by reducing the wealth of folds that articulate the body. His reliefs show a desire for spatial effects far beyond that of Andrea Pisano. These tendencies increasingly dominated the last decades of the century, when the Florence Cathedral workshop was very active. Significantly, at this time inspiration was again drawn from antique models, and the "balanced" statue—that is, posed with one leg bearing the weight—preoccupied the greatest artists of the time, above all, Giovanni d'Ambrogio. He was very probably the creator both of the *Annunciation* (66, 67), with its astonishing Roman heads, and of the little relief figure of *Hercules* (58) on the wall of the Porta della Mandorla in Florence Cathedral. Here, bridging a gap of four generations, we find the link with Nicola Pisano (compare 56); the animated movement and the modeling of physical details are, of course, evidence of the changed times.

North of the Alps, the Parler workshop, with its almost inestimable influence, initiated a change from the ideal linear style of the first half of the century (74). The voluminous, ample figures on the royal tombs in Prague Cathedral and all their successors, such as the busts in the triforium gallery of Prague Cathedral choir, attempting lifelike portrayal, are just as much precursors of Renaissance sculpture as the contemporary works of Tuscan sculpture, in spite of traditional differences in the organic modeling of details.

The period of preparation came to a close about 1400. The different trends then seemed to come together in a single focal point, in a manner unique in art history. Florence became the birthplace of modern sculpture. The impetus came with the competition for the second bronze doors of the Florence Baptistery, which the twenty-four-year-old Lorenzo Ghiberti won in 1401. The bronze doors were made between 1403 and 1424, and they are now on the north side of the building (61). The external arrangement is similar to Andrea Pisano's earlier doors, but the individual features show bold steps forward. The space is extended by foreshortening and by differentiating the levels of relief; the figures, with their varying movements, are assured; the narrative can unfold much more freely and naturally in this

◁ 72 extended space (compare 60 with 61). This manner of representing space and figures, and

the realism of the narrative, all of which led to more successful solutions during the course of the work, are one aspect of Ghiberti's art; Late Gothic linear beauty and the tendency to idealize are another. In fact, among the many great sculptors of the early 15th century, Ghiberti is the figure who represents the continuity between the two ages most clearly. The problems of representing space and of composition predominate in Ghiberti's second great cycle of reliefs, which adorn the third bronze door of the Baptistery, called the "Door of Paradise," executed between 1425 and 1452 (*59, 71, 76*). Unlike the arrangement of the earlier doors, he now assembled several scenes into each of ten large pictorial areas. The boundaries between sculpture and painting seem to have disappeared, and the tension between the high-relief foregrounds and the almost flat, pictorial background vistas creates a highly detailed and rich relief style that would find clear echoes in European sculpture well beyond the Quattrocento—until the south German relief carving of the 18th century.

An assured handling of physical structure, together with highly decorative draperies, also characterizes the over-life-size statues that Ghiberti, the founder of modern bronze casting, made between 1414 and 1427 for Orsanmichele, Florence (*78*). There is yet another respect in which Ghiberti can be termed a modern artist. Toward the end of his life he, too, wrote about his own work and the history of art; he also studied the theories of proportion and optics, with that wide general awareness typical of the Early Renaissance artist.

While Ghiberti's workshop became the "academy" of modern bronze casting, a new concept of sculpture came into being in the cathedral workshop and in Orsanmichele. Here, Nanni di Banco and Donatello brought to fruition the experiments of the last decades of the Trecento. Nanni (c. 1387–1421) was the marble specialist among the founders of the Italian Early Renaissance. He also turned the most eagerly to antiquity. In the statues he created for Orsanmichele in the second decade, Nanni di Banco revived the type of *contrapposto* ("balanced pose") Roman figure in toga, which had many successors (the earliest is Donatello's *St. Mark*, 1411–20). In his group of the *Quattro Coronati* (*80*), he brilliantly resolved the problem of spatial coherence, linking several life-size figures in a scenic unity in exemplary fashion. In his last great work, the relief of the *Assumption* (*53*) on the tympanum of the Porta della Mandorla in Florence Cathedral, Nanni overcame the static quality of his models and achieved an almost Baroque wealth of movement that renders the hovering mandorla immediately legible. This is a step on the way to Verrocchio's design for the *Forteguerri Cenotaph* in Pistoia.

Nanni forged new paths in everything he undertook—for instance, in the *St. Luke* (*81*), completed in 1412, the earliest monumental seated figure in the 15th century, Nanni produced a form of impressively compact structure, with an *all'antica* philosopher's head whose differentiated modeling has no equals in earlier sculpture. He resolved the spatial problems posed by a seated figure brilliantly, and the treatment of the marble surface is immaculate. Nanni's moderate temperament is very clear if we compare his *St. Luke* with the *St. John* by Donatello (*82*), commissioned at the same time but completed somewhat later. Donatello's

figure is built up of contrasts that anticipate and intensify the emotion of the head. Indeed, Donatello (1386–1466) can be described as the dramatist of Early Renaissance sculpture. He made *contrapposto* structure into a creative principle. The differentiation between the supporting leg and the free leg is heightened to express violent tensions that embrace the entire statue, including gestures and the torsion between the motion of head and shoulders that is so typical of his work. The prototype for this dramatic concept of the figure, which runs through the whole of Donatello's œuvre as a leitmotif, may have been the so-called *Isaiah* in Florence Cathedral. In one bold stroke, Donatello set the pattern for the future.

73 DONATELLO, DAVID AS A YOUTH (?). 1408–9. Florence Cathedral. Created for one of the buttresses of the choir. The over-life-size figure was long considered an early work of Nanni di Banco, but the extremely tense *contrapposto* structure proves it a prototype of the dramatic figurative ideal only Donatello managed to attain in the early Quattrocento.

74 PETER PARLER, ST. WENCESLAS. 1373. Altar in the chapel of St. Wenceslas, Prague Cathedral. The weight of the body contrasts strongly with the shadowy recesses of the cloak. The colored setting is important to the over-all effect.

75 SCHÖNE MADONNA. c.1390. St. John, Thorn. A masterpiece on the *Schöne Madonnen* ("beautiful madonnas") theme, which was a perfect vehicle for the "soft style" north of the Alps. The curve of the figure is linked to the beautiful lines of the richly worked drapery. Note how the folds enclose the space and give the figure volume. The draperies seem substantial in themselves and as though separate from the body. On a console, figure of *Moses with the Tablets of Law*.

76 LORENZO GHIBERTI, JOSHUA. 1425–52. Frame of the "Door of Paradise," Florence Baptistery.

77 CLAUS SLUTER, THE PROPHET DANIEL. 1396–1406. Well of Moses, Chartreuse de Champmol, Dijon. The strong modeling of the figure, its animated movement in space, and the realistic head anticipate the work of Donatello, despite stylistic differences.

78 LORENZO GHIBERTI, ST. JOHN THE BAPTIST. Completed 1414. Orsanmichele, Florence.

Created for the Arte di Calimala, the Florentine Wool Merchants' Guild. First modern monumental bronze statue. The style resembles that of the *Schöne Madonnen* (compare 75); south of the Alps, however, the organic construction of the body can be sensed through the rich folds of drapery.

79 DONATELLO, JEREMIAH. 1427–36. Museo dell' Opera del Duomo, Florence. Intended for one of the niches of the campanile.

80 NANNI DI BANCO, QUATTRO CORONATI. c.1413–16. Orsanmichele, Florence. Created for the Arte dei Maestri di Pietre e Legnami, the Florentine Stoneworkers' Guild, whose patron saints were the four martyrs Castor, Symphorian, Nicostratus, and Simplicius. Of all the monumental sculptures of the Florentine Quattrocento, the *Quattro Coronati* is the most indebted to antiquity. The insertion of four over-life-size figures into one niche links the group in a scenic unity, an artistic aim that points to the future.

81 NANNI DI BANCO, ST. LUKE. 1409–12. Museo dell'Opera del Duomo, Florence. Created for a niche on the ground level of the façade of the cathedral.

82 DONATELLO, ST. JOHN. 1409–15. Museo dell' Opera del Duomo, Florence. Like Nanni di Banco's *St. Luke* (*81*), it originally stood in a niche in the cathedral façade.

83 APOSTLE. c.1400. Clay. Height c.65 cm. Germanisches Museum, Nuremberg. One of a series of single figures. The rich drapery conceals contours of the body. (Compare *81* and *82*.)

84 JACOPINO DA TRADATE, POPE MARTIN V. Com-

pleted 1421. South wall of the choir, Milan Cathedral. Approximately twice life-size. This is a masterpiece of northern Italian "soft style" sculpture. As with the Nuremberg clay apostle (*83*), the drapery is highly decorative, yet the figure is composed with more feeling for human weight, and the form of the body is visible through the drapery. But compared to the Florentine Evangelists (*81, 82*), the main impression is of a Gothic linear fluidity.

85 DONATELLO, CANTORIA. Detail of *88*. Marble. Museo dell'Opera del Duomo, Florence.

86 LUCA DELLA ROBBIA, CANTORIA. Detail of *87*. Museo dell'Opera del Duomo, Florence.

87 LUCA DELLA ROBBIA, CANTORIA. 1431–38. Museo dell'Opera del Duomo, Florence. Created for the cathedral crossing. The panels in the *all'antica* frame are clearly separated from one another. Accordingly, the scenes of music-making angels are centralized, and the lively movement and symmetrical spatial composition are carefully balanced. The marble surface is worked with a mastery unique in Florentine sculpture at the time. Luca stands as the most important pupil of Nanni di Banco, not least in his assimilation of antiquity.

88 DONATELLO, CANTORIA. 1433–39. Museo dell' Opera del Duomo, Florence. Executed as a pendant to Luca della Robbia's *Cantoria* (*86, 87*) for the crossing of the cathedral. As an artist Donatello is diametrically opposed to Luca: The continuous frieze of dancing putti is filled with bacchantic movement, which is enhanced rather than restricted by the rhythm of the columns. In the treatment of detail, expression and movement, rather than beauty of modeling, are primary. This even leads to distortions of the figures. The abundant use of gold mosaic on the columns and for the background heightens the illusion of space.

89 DONATELLO, ANNUNCIATION. c. 1435. S. Croce, Florence. Commissioned by the Cavalcanti family. Comparison with the *Cantoria* (*85, 88*) shows Donatello's artistic range. The depth is reduced in order to bring out the scenic unity of the figures, and the swirling animation of the *Cantoria* is countered by restrained and delicate movement. Donatello also proves himself a master of decorative detail.

90 DONATELLO, THE MIRACLE OF THE UNBELIEVER'S MULE. After 1443. High Altar, S. Antonio Basilica (Santo), Padua. According to the legend, St. Anthony made a mule kneel before the Host as proof of the transubstantiation during the Mass. The ruins of the Basilica of Maxentius obviously influenced the architecture of this tense scene.

91 DONATELLO, CHRIST BEFORE CAIAPHAS AND PILATE. Begun c. 1460 and incomplete at Donatello's death, 1466. Detail from the southern of the two bronze pulpits, S. Lorenzo, Florence. Donatello's last works are marked by the disruption of all the classical canons of form. He negates the boundaries between picture space and real space just as he ignores the caesura between individual scenes and even continues the compositions around corners.

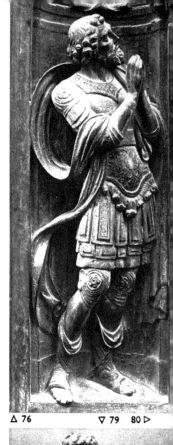

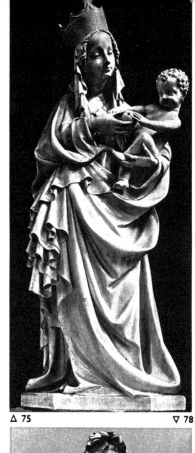

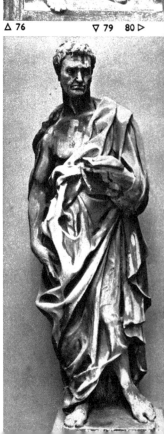

△ 74 ▽ 77 △ 75 ▽ 78 △ 76 ▽ 79 80 ▷

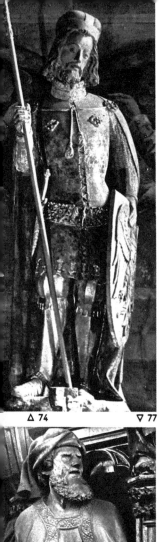

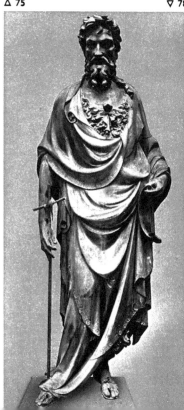

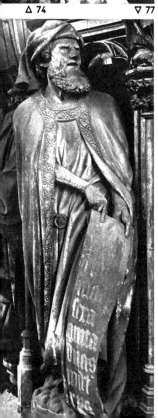

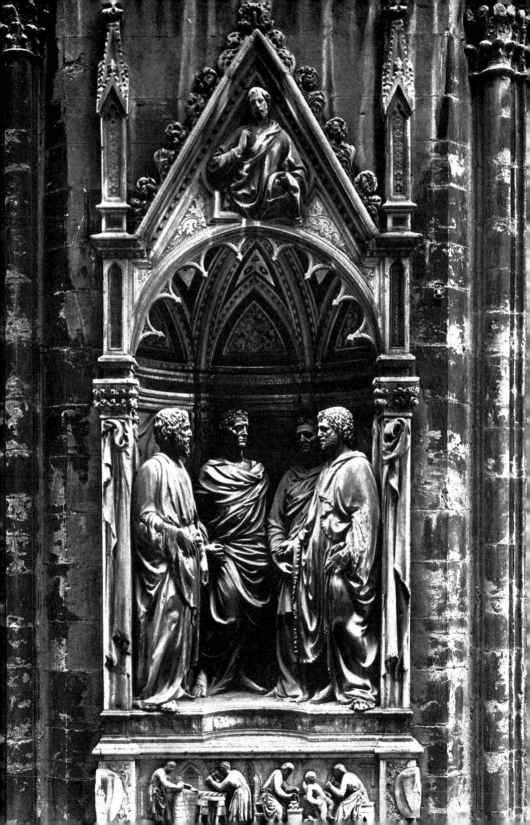

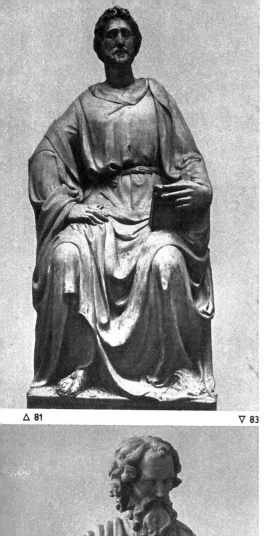

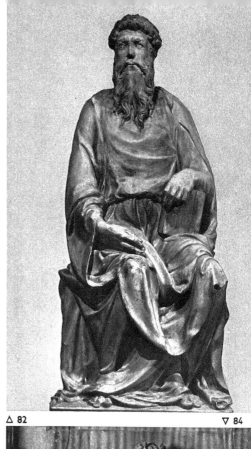

△ 81

△ 82

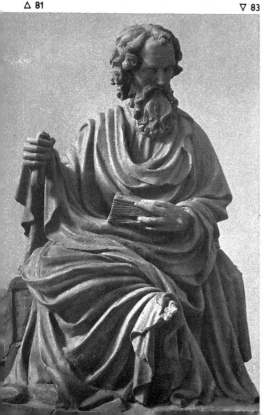

▽ 83

▽ 84

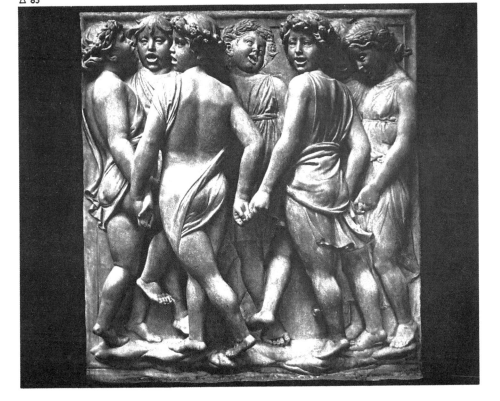

LVDATE DNM IN SCIS ET LAVDATE EVM IN FIRMAMENTO VIRTVTIS EI LAEV IN VIRTVTIBVS EI LAEV SECVNDVM MVLTITVDINEM MAGNITVDINIS EIV

LVDATE EVM IN SONO TVBAE LAVDATE EVM IN PSALTERIO ET CYTHARA LAVDATE EVM IN TIMPAN

ET CHORO LA EV IN CORDIS ET ORGANO LA EV IN CYMBALIS BENE SONANTIBVS LAEV IN CIMBALIS IVBLATIONIS OIS SPS LAVDET DNM

△ 87 ▽ 88 89 ▷

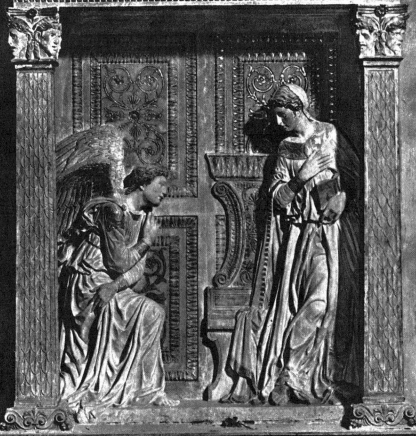

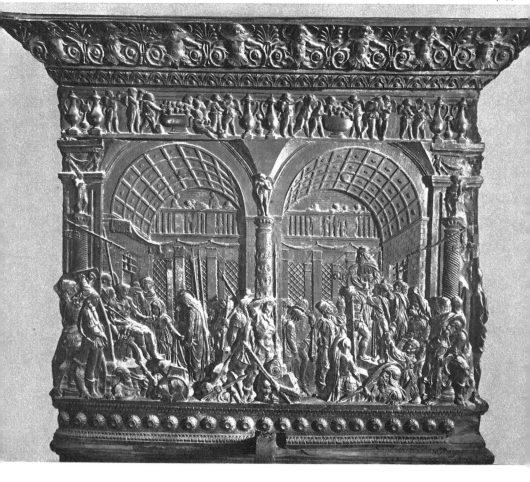

It is impossible to classify Donatello. To describe him as the great realist, as opposed to the classicist Nanni di Banco, which has been customary since the days of Vasari, means distorting the image of both artists. It is enough to point to the bronze *David* (*92*) in the Bargello or the *Annunciation* in S. Croce (*89*) to reveal the idealistic elements in his work. Donatello was as versatile in technique as in expressive range. He worked mainly in marble and bronze, but also in wood and stucco. The outstanding feature of his artistic personality is consistency. He displayed the same decisiveness when he created a new relief style, the *relievo schiacciato* ("flattened out relief") (*69*), as when he developed the *contrapposto* structure of his free-standing figures. Instead of the dualism between high and low relief that marks Ghiberti's style in the "Door of Paradise" (*71*), Donatello modeled his backgrounds in flat relief, and by its gradations he achieved increasingly bold spatial compositions, particularly in the high altar, S. Antonio Basilica, Padua (*90*), and the bronze pulpits in S. Lorenzo, Florence (*91*). Donatello imbued all the modes of sculpture with new spirit. His ten years in Padua also made him the most important founder figure of the northern Italian Renaissance, particularly by his influence on painting.

It would be mistaken to select any one of the three great Florentine sculptors of the early 15th century as the true initiator of the Early Renaissance. It was the sum of their creative powers that created Early Renaissance sculpture. It is clear that the sculptors were principally concerned with grasping reality in all its varied manifestations; and it is equally evident that the influence of antiquity played only a secondary role. Unlike the case of Nicola Pisano, whom antique models inspired to open his eyes to nature, we might now say that it was their grasp of reality that reopened the sculptors' eyes to classical tradition. At the same time, we cannot say that there was an *Italian* Early Renaissance in the early 15th century; we should speak only of a Florentine Early Renaissance. Central and southern Italy played very little part here, while the northern half of the peninsula still lay entirely under the spell of International Gothic and had closer relations with the North than with Florence. A glance at Venetian works from the circle of Bon and the Master of the Mascoli Altar or at contemporary Lombard sculpture, such as the statue of *Pope Martin V* in Milan Cathedral (*84*), suffices to reveal the fundamental differences with Florence.

The only decisive contribution to the foundation of Early Renaissance sculpture outside Florence came from southern Tuscany, with the work of the Sienese Jacopo della Quercia (c.1374–1438). His sources lie both in International Gothic and in classical antiquity, and he is one of the great artists of the early 15th century who managed to fuse these two poles into a unity. His most mature work is the relief sculpture on the main portal of S. Petronio, Bologna (*72*). Tradition has it that even Michelangelo was lastingly affected by the way curving lines and precise articulation of the body are not mutually exclusive in this work; each gains its true expressive force from the other. The monumental effect of the figures, despite their small scale, is obtained by the reduction of all accessories.

North of the Alps, the early 15th century was the golden age of the "soft style" in International Gothic. The main subject is the *Schöne Madonnen*, or "beautiful madonnas" (75), which were widely represented in the late 14th century. The contrast with contemporary Florentine sculpture could hardly be greater in terms of realistically conceived figures. Yet we must not forget that the tendency to bring out the third dimension was a common feature of this Northern stylistic phase as well. The flowing folds *embrace* the body, and the drapery itself, rather like that in the figure of *St. John* by Ghiberti (78), also becomes more voluminous, relating to the creation of a spatial shell in contemporary architecture. That the artists north and south of the Alps frequently took up related artistic problems in the early 15th century is also evident from the similar "pictorial" space in Madern Gerthner's relief of the *Adoration of the Kings* (70), and Ghiberti's *David and Goliath* from the "Door of Paradise" (71).

In any case, the North was not exclusively under the spell of the "soft style" during this period. As in Italy, where the current of International Gothic reached its full flowering at the same time as the Early Renaissance, north of the Alps we also find a trend toward realistic effects and an emphasis on the corporeal. The workshop of Claus Sluter (77) carried on the traditions of the Parler workshop, although no direct relations existed between the two, and from here, presumably under some direct influence, the line of development led to the works of Hans Multscher in the 1420s and 1430s, notably the *Crucifixion*, the Kärgnisch figures, and the figures in Ulm Town Hall.

South of the Alps, the direction of sculpture in the later 15th century was to some extent determined by historical events. Toward the middle of the century the wave of artists' travels began, and, in its wake, the forms of the Tuscan Early Renaissance spread throughout Italy. If formerly it was only individual masters from Florence—and usually not the first-rate ones, either—who traveled to northern and central Italy, now the great Florentine sculptors, painters, and architects were summoned to honors elsewhere. Donatello was active in Padua for ten years (from 1443); Antonio Rossellino and, later, Benedetto da Maiano worked on large-scale commissions in Naples; Filarete, Mino da Fiesole, and, toward the end of the century, Antonio Pollaiuolo made decisive contributions to the spread of the Early Renaissance in Rome; Agostino di Duccio worked in Modena, Rimini, Perugia, and other towns; from 1482 on, the most important Italian sculptor of the second half of the century, Verrocchio, worked in Venice.

These travels were certainly partly in response to those in power in the central and northern Italian art centers who wished to have a part in the achievements of the new style. But the changed state of patronage in Florence doubtless made the offers from abroad seem more tempting than they had been in the early Quattrocento. The age of commissions for monumental statues, evidence of a general civic pride—represented in particular by the work on Orsanmichele and the extensive statuary for the façade and campanile of the cathedral—had passed. Florentine patrons from rich merchant families, competing with the

brilliant court of the Medici, aimed at courtly refinement. From the midcentury on, Florence could no longer offer commissions to equal those greeting Donatello in Padua and Verrocchio in Venice—great bronze equestrian statues (*106, 108*) and an extensive cycle of sculptures for an altar, presumably part of a large rood screen, as H. Schröteler recently pointed out. Instead, other genres came into demand in Florence, among them the portrait bust and, largely inspired by the decorated frame of Ghiberti's "Door of Paradise" (*59, 76*), small bronzes, which became favorite collectors' items.

Hand in hand with the changed attitude of the patrons and the shift of emphasis in art came a change of style. Its most striking feature is the desire for greater decorativeness and the dominance of line, which sometimes became extremely refined, at the expense of rendering volume. A similar development also occurred north of the Alps at this time, and both can be considered to a degree a re-Gothicization. Simultaneously, major artists began to concern themselves with creative problems hardly conceivable in the early Quattrocento. In this context, too, there are striking parallels north and south of the Alps. One of the main sculptural themes in the second half of the 15th century is the animated figure projecting into space. Masters such as Verrocchio (*93*) and, in particular, Pollaiuolo (*94*) in Italy, as well as Nicolaus Gerhaert, Michael Pacher, and Erasmus Grasser in the North, worked on this. Space "penetrated and animated by embodied lines of movement" (W. Pinder) is exemplified by Grasser's *Moorish Dancer* (*95*) and Pollaiuolo's small bronzes (*94*). The rendering of movement also posed new artistic problems, the solution of which would become one of the major aims of European sculpture in centuries to come: how to free the figure from the single, closed, "pictorial" viewpoint. The problem of the plural viewpoint is just as

92 DONATELLO, DAVID. Probably c. 1435. Bronze. Museo Nazionale del Bargello, Florence. Intended for a fountain in one of the Medici gardens, this is the first free-standing nude since antiquity.

93 ANDREA DEL VERROCCHIO, DAVID. Before 1476. Bronze. Bargello, Florence. In 1476 the figure was sold to the Signoria in Florence by the Medici. Verrocchio deliberately invites comparison with Donatello (*92*) here. Although the structural principle is similar, Verrocchio's work can only be understood by contrast with the earlier statue. He articulates the sharply contrasting details very precisely,

heightens the role of line, and, above all, relieves the strict frontal viewpoint by the twist of the torso.

94 ANTONIO POLLAIUOLO, HERCULES AND ANTAEUS. c. 1480. Bronze. Bargello, Florence. The figures are variously interrelated with one another and with space.

95 ERASMUS GRASSER, MOORISH DANCER. c. 1480. Wood. Stadtmuseum, Munich. In terms of the interpenetration of figure and space, we see a concern with artistic problems that also interested sculptors south of the Alps at this time (*93, 94*).

96 DONATELLO AND MICHELOZZO, TOMB OF POPE

JOHN XXIII. 1425–27. Florence Baptistery. The Gothic wall tomb is here translated into Renaissance form. The two colossal architectural columns of the baptistery serve to condense the horizontally superimposed zones.

97 PIETRO LOMBARDI, TOMB OF PIETRO MOCENIGO. c. 1475. SS. Giovanni e Paolo, Venice. The Florentine wall tomb created by Bernardo Rossellino (98) is linked to a typically Venetian niche arrangement.

98 BERNARDO ROSSELLINO, TOMB OF LEONARDO BRUNI. c. 1445. S. Croce, Florence. The earlier additive articulation of the wall tomb (96) now gives way to a monumental *al antica* tomb. Rossellino has created a prototype that became the rule far beyond the limits of Florence and lasted until the 16th century.

99 DESIDERIO DA SETTIGNANO, TOMB OF CARLO MARSUPPINI. c. 1455. S. Croce, Florence. Desiderio borrowed the over-all structure and articulation of the Bruni tomb (98). But his treatment of detail is more free and decorative, typical of the change of style toward the mid-century.

100 BENEDETTO DA MAIANO, SCENES FROM THE LIFE OF ST. FRANCIS. 1470–75. Pulpit in S. Croce, Florence. In these reliefs, Benedetto has adopted the style of Ghiberti. The decorative whole is animated by the very delicate colors.

101 NICOLAUS GERHAERT OF LEYDEN, TOMB OF EMPEROR FREDERICK III. Begun 1467. St. Stephen, Vienna. The relationship between the main figure and the setting, the smothering of every free surface with figures and arms, the restless movement of line, and numerous details recall Pollaiuolo's papal tomb in Rome (102), although the Italian tomb is more clearly articulated than this Northern one.

102 ANTONIO POLLAIUOLO, TOMB OF POPE SIXTUS IV. 1484–92. Grotte Vaticane, St. Peter's, Rome.

103 VEIT STOSS, ASSUMPTION. 1477–89. *Altar of the Virgin*, church of Our Lady, Cracow. The almost Baroque animation of the drapery parallels Italian tendencies. But in the South, as in the case of Verrocchio (104), the flowing robes are always determined by the organic structure of the body.

104 ANDREA DEL VERROCCHIO, CHRIST AND DOUBTING THOMAS. 1465/66–83. Bronze. Orsanmichele, Florence. The niche was built 1420–25

for Donatello's *St. Louis*. Verrochio managed to integrate the group with the existing architecture perfectly. The "tripartite vertical articulation correlates with the triple zoning of the niche wall and coordinates figures and architecture" (G. Kreytenberg).

105 MARTIN AND GEORG VON KLAUSENBURG, ST. GEORGE. 1373. Courtyard of Hradčany Castle, Prague. The astonishing movement in space recalls contemporary architecture, for instance, the rhythm of the triforium zone in Prague Cathedral, under the direction of Peter Parler (after 1353).

106 DONATELLO, GATTAMELATA. 1448–53. Bronze. Piazza di S. Antonio, Padua.

107 LEONARDO DA VINCI, EQUESTRIAN STATUETTE. c. 1505. Bronze. Art Museum, Budapest. This small, very animated work reflects Leonardo's growing preoccupation with monumental equestrian statue. (Compare earlier equestrian statues *105, 106, 108*.)

108 ANDREA DEL VERROCCHIO, COLLEONI. 1479/80–88. Bronze. Piazza di SS. Giovanni e Paolo, Venice. While Donatello's equestrian statue can be fully grasped in profile, Verrocchio's work no longer has one main viewpoint but must be observed from different angles.

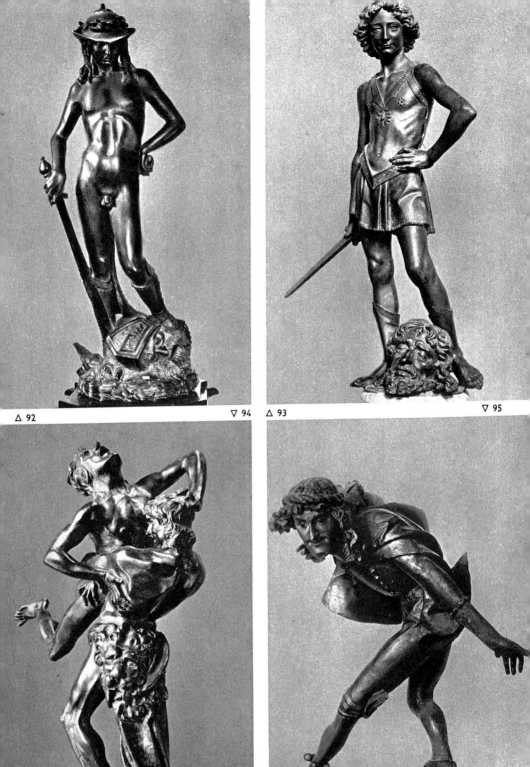

△ 92 ▽ 94 △ 93 ▽ 95

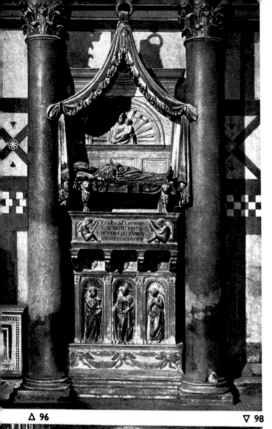

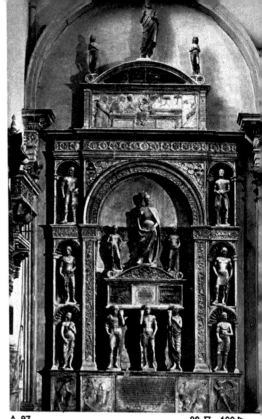

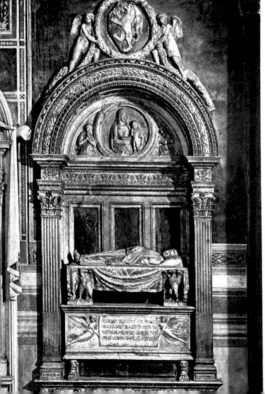

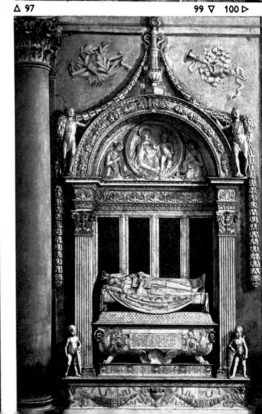

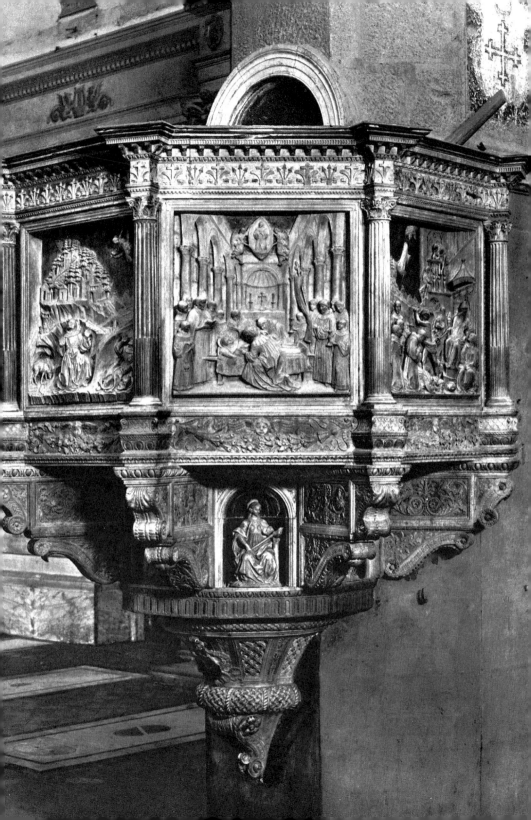

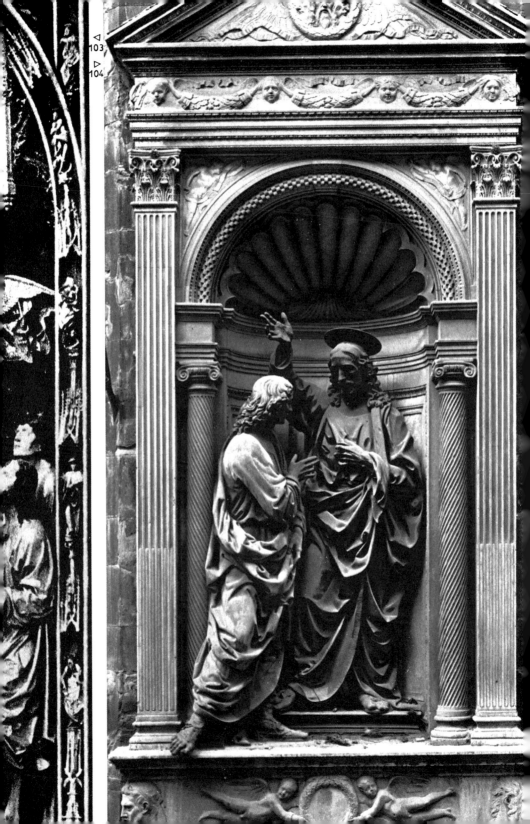

103
104

△ 105

△ 106

▽ 107

▽ 108

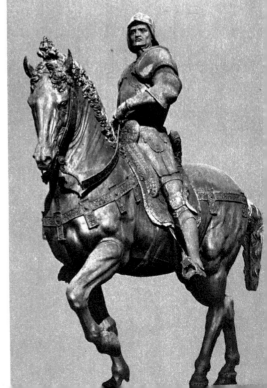

decisive a part of Verrocchio's art as it is of the works of Nicolaus Gerhaert and the free-standing figures by Michael Pacher. The change becomes clearly visible if we compare Donatello's equestrian statue, the *Gattamelata* (*106*), with its severely compact and fully expressive profile view, and Verrocchio's *Colleoni* (*108*), which becomes fully legible only if one walks around it; or if we compare Hans Multscher's statues of *Sts. Florian and George* from the Sterzing Altar, 1456–59, with the corresponding figures of Michael Pacher's St. Wolfgang Altar (*111*) of 1471–81. Italian sculpture under Verrocchio even went a step further. As in contemporary painting, the sculptor aimed at communication between the sculpture and its beholder. In this respect, Verrocchio's *Christ and Doubting Thomas* in Orsanmichele (*104*) started a tradtion that extends to the present. The time was not yet ripe for similar solutions in the North; but there, too, involvement with the viewer was a concern, as can be seen from Nicolaus Gerhaert's busts in the chancellery of Strasbourg.

The great achievement in sculpture north of the Alps in the late 15th century was the evolution of the carved altarpiece (*103, 111–14*). Its forerunners go back to the 14th century; in Oberwesel and Marienstatt (c.1331 and c.1335), there are still carved retables whose over-all effect derives from the interplay of skillfully carved tracery and small-scale figures. Carving first became associated with painting in the later 14th century, when the side panels were extensively sculptured on the inside, while only painted on the outside (St. Claire Altar, Cologne Cathedral, c.1360; Master Bertram's altar for the church of St. Peter, Hamburg, c.1380.

In the Netherlands, toward the end of the century, the carved central shrine was combined with painting on the inside of the wings, to form a pictorial unity. It is typical of this association between carving and painting that the carved shrine no longer depicted individual figures arranged in several rows but a single scene with a number of figures—paintings transposed into carving (altarpiece for the Chartreuse de Champmol, 1394–99, with carvings by Jacques de Baerze and panel paintings by Melchior Broederlam). Flemish carved altarpieces with crowded scenes on the shrine became a favorite export item in the course of the 15th century. They no doubt gave strong impetus to the development of the German carved altarpiece. But what was new in German-speaking regions in the late 15th century was the monumentality of the shrine; rows of statues or painted scenes were life-size. We can see how close some of the formal vocabulary came to contemporary tendencies in Italian art by comparing the Cracow *Altar of the Virgin* by Veit Stoss (*103*) with *Christ and Doubting Thomas* by Verrocchio (*104*). Common to both is the almost Baroque pathos of the crumpled and broken folds, the emotional animation of the line, and the torsion of the figures in space, although in Verrocchio's case this is based on organically structured bodies—a problem which did not concern the North until the High Renaissance.

In Italy all the experience acquired by extensive study of detail during the second half of the century crystallized, toward 1500, in sculpture, as in painting, in a new conception of form. The many small-scale components gave way to large, unified forms. The late works

of Benedetto da Maiano, such as the *Virgin Enthroned* and *St. Sebastian* (1497, left uncompleted on his death), are precursors of the High Renaissance in this regard. In some ways the ideals of the early Quattrocento seem to have been revived again, although on the basis of a new knowledge of nature. It is worth noting that at this moment new commissions for monumental cycles gave the artist added impetus—in this respect, too, the brief age of the High Renaissance recalls the first decades of the Quattrocento. The tomb of Julius II in Rome (*115*), a cycle of apostles for Florence Cathedral, the sculptures in the Medici Chapel, Florence, and the project to adorn the façade of S. Lorenzo with statuary were commissions of a scale unknown in the preceding decades. Antiquity now played a decisive role as a source of inspiration. What the contemplation of the Roman ruins was to architecture, the treasure of antique sculpture that was now excavated systematically in Rome became to sculpture. At this time, the nucleus of the vast Vatican collection came into being; the *Laocoon*, a Hellenistic sculpture group of tremendous influence, was found in 1506, and in 1515 Pope Leo X named Raphael superintendent of the antique buildings of Rome.

Michelangelo's marble *David* (*109*), executed 1501–4, is an outstanding example of the new attitude. Antiquity and the study of nature, the real and the ideal, type and model, detail and whole are integrated perfectly. Also in the first decades of the new century, Andrea Sansovino, like Michelangelo a Florentine by birth, created a new type of monumental wall tomb in Rome (S. Maria del Popolo), inspired by the model of antique triumphal arches.

North of the Alps, the rich Late Gothic linear style became extremely refined toward the end of the century. The *House of Sacraments* by Adam Kraft in the church of St. Lawrence, Nuremberg, was executed 1493–97; between 1501 and 1505, Tilman Riemenschneider created his great altarpieces in Rothenburg (*112*) and Creglingen. But at the same time, and sometimes in the work of the same master, we also sense a tendency to condense and clarify the composition and structure of the figures, as in Adam Kraft's relief for the Nuremberg Municipal Weighing House (1497) or the monumental nude figures of *Adam* (*110*) and *Eve* by Riemenschneider (1491–93).

This prepared the way for the great influx of Renaissance forms. Adolf Daucher, the foundry of the Vischer family (*133*, *134*), and the workshop of Loy Hering (*118*) became focal points of the new formal language. The merchant towns of Nuremberg and Augsburg, which had reached the peak of their prosperity, gave out large commissions which contributed to the spread of the new ideas. Working directly from the model, as is recorded of the younger members of the Vischer workshop, is likely in very few cases.

The techniques of print making—woodcut and copper engraving—developed almost simultaneously in the mid-15th century and provided a new medium for diffusing art forms. The style of the mature and late Dürer, clarified by the impressions gleaned from his journeys to Italy, made a great contribution to the spread of Renaissance forms north of the

Alps, and he exerted a strong influence on sculptors' workshops (*123*). The overwhelming effect of the new artistic experiences is also evident in the late works of masters belonging to the older generation: Riemenschneider's tomb of Lorenz von Bibra in Würzburg Cathedral (completed 1522) and his *Lamentation* in Maidbronn (1526); the Bamberg *Altar of the Virgin* by Veit Stoss (1520–23), the work of a man over seventy (*113*).

However, another current of Late Gothic sculpture, untouched by the Italian forms, spilled over directly into Mannerism north of the Alps. It is represented by masters such as the Bavarian Hans Leinberger (high altar, Moosburg, 1515; *St. James the Elder*, c. 1520 [*116*]), the north German Benedikt Dreyer (St. Michael, Lübeck, 1510), the northern Rhenish workshop of Heinrich Douvermann (altars in Xanten and Kalkar, between 1515 and 1535), and the Saxon Hans Witten ("Tulip Pulpit," Freiberg Cathedral, c. 1520). The efforts to achieve an at times drastic realism and plastic modeling of details is linked in this last phase of Late Gothic sculpture to an effusive and often unbridled exuberance of line. With the great contemporary northern Rhenish altars by Master H. L. (Niederrotweil, 1514–18 [*114*]; Breisach, 1526) and their distortion and ornamentation of the figure, we have crossed the threshold to Mannerism.

As in architecture, so too in sculpture the age of the High Renaissance is limited to a narrow span of time. And again it was the same master whose early works were the culmination of the entire development initiated in the 15th century, namely, Michelangelo, who

109 MICHELANGELO, DAVID. 1501–4. Marble. Height 4.34 meters. Galleria dell'Accademia, Florence. Until 1873 the figure stood in the Piazza della Signoria in Florence; then it was replaced by a copy. The 26-year-old Michelangelo used a block of marble from the cathedral works, originally destined for a statue above the choir and on which Agostino di Duccio had begun work in 1466.

110 TILMAN RIEMENSCHNEIDER, ADAM. 1491–93. White sandstone from the Main. Height 1.89 meters. Mainfränkisches Museum, Würzburg. The monumental "balanced" nude figure was now adopted in the North. Beside Michelangelo's *David* (*109*), however, we can see that the sense of articulate form was far less developed; the differentiation between weight-bearing leg and free leg is still largely achieved by means of a uniform Gothic arc that embraces the entire figure.

111 MICHAEL PACHER, CORONATION OF THE VIRGIN. 1471–81. High altar, St. Wolfgang. The scene, flanked by the figures of Sts. Wolfgang and Benedict, fuses with the rich ornamental forms

of the canopy into a uniform linear network. The treatment of light and shade gives an impression of indeterminate depth.

112 TILMAN RIEMENSCHNEIDER, LAST SUPPER. 1501–5. *Altar of the Holy Blood*, St. Jacob, Rothenburg. By comparison with Michael Pacher's work, the individual figures are more strongly articulated despite the autonomy of line, and the spatial effects are clearer. The effect of fenestration in the background suggests both a general spaciousness and a real interior space.

113 VEIT STOSS, NATIVITY. *Altar of the Virgin*, Bamberg Cathedral. Signed and dated 1525. The work shows the influence of the Renaissance forms penetrating from the South, hence the articulation of the individual figures and the clarity of the composition. Note also the compact round arch closing the scene above, in place of the richly carved canopy seen previously. The upper part of the work is not complete. Two round arches were to spring from the column to the left and right (sketch in the Archeological Institute of Cracow University gives what was presumably the original plan).

114 MASTER H. L., CORONATION OF THE VIRGIN. 1514–18. High altar, St. Michael, Niederrotweil. The solid organic structure of the body recently transmitted by the Italian Renaissance is dominated in the work of Master H. L. by an autonomous line contradicting the natural form.

115 MICHELANGELO, MOSES. c.1513–16. S. Pietro in Vincoli, Rome. The figure was created for a grandiose uncompleted project, the tomb of Pope Julius II. The sense of passionate emotion is expressed not so much through the physiognomy as through the dramatic contrasts in the torsion of the body. In this respect Michelangelo's work develops and heightens the principles of Donatello (82).

116 HANS LEINBERGER, ST. JAMES THE ELDER. c.1520. Height c.2 meters. Bayerisches Nationalmuseum, Munich. Almost contemporary with Michelangelo's Moses (115), Leinberger's figure also has a solid body and torsion within the pose, but the individuality of the various parts of the body does not emerge through the robes.

117 JACOPO SANSOVINO, MADONNA DEL PARTO. c.1520. S. Agostino, Rome.

118 LOY HERING, ST. WILLIBALD. 1514. Eichstätt Cathedral. This is a masterpiece of the German High Renaissance in its clear structure, compact outlines, and expressive physiognomy.

119 PIETRO FRANCAVILLA, MOSES. c.1585. Niccolini Chapel, S. Croce, Florence. The facial expression and the general composition are unmistakably influenced by Michelangelo's Moses (115). But, in true Mannerist fashion, spontaneous movement and violent contrast have now become the major concern.

120 MICHELANGELO, APOLLO. c.1530–35. Bargello, Florence. Sometimes also interpreted as David. The frontal viewpoint is united with a movement in space that requires the beholder to move round the figure.

121 PIERINO DA VINCI, RIVER GOD. c.1550. Louvre, Paris. Michelangelo is the main source of Pierino da Vinci's style. Beside the Apollo (120), his figure is less solid. At the same time, the pose shows a tendency toward artificiality, in particular with its complex, intertwined movements.

122 GERMAIN PILON, RESURRECTION. c.1580. Louvre, Paris. By the very skillfull rendering of movement, Pilon manages to convey the theme of the Resurrection in a nonstatic manner; at the same time, the structure and surface treatment have the classical balance typical of French 16th-century art.

123 CHRISTOPH WEIDITZ, ADAM. c.1540. Pear wood. Height 32 cm. Kunsthistorisches Museum, Vienna. There is an accent on such details as the stomach muscles and knees and a perfect mastery of the contrapposto position of the body.

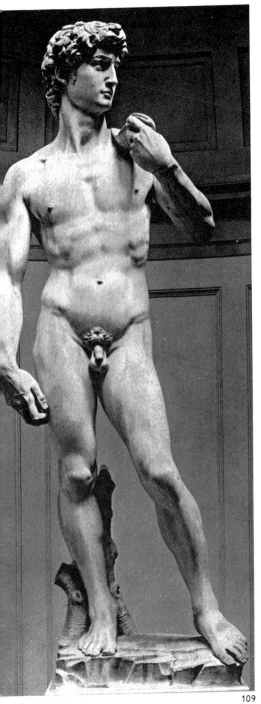

111

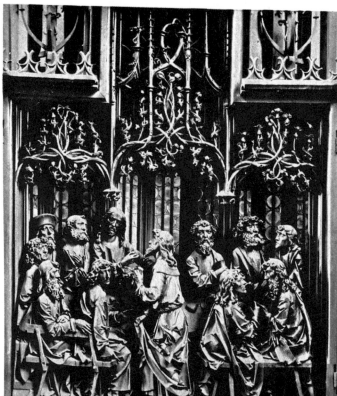

112

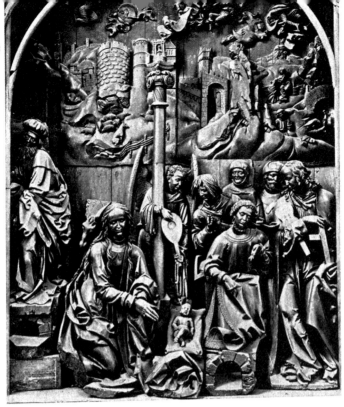

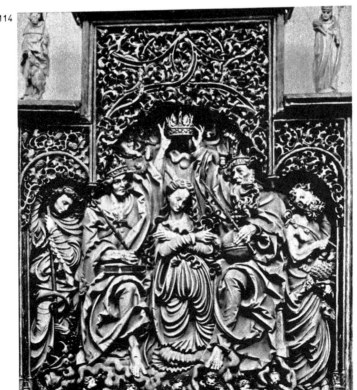

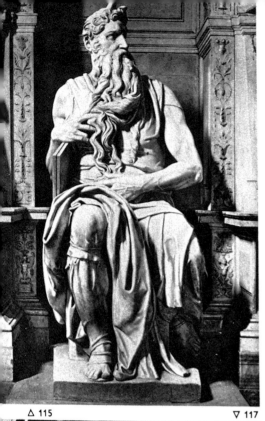

△ 115 ▽ 117 △ 116 ▽ 118 119 ▷

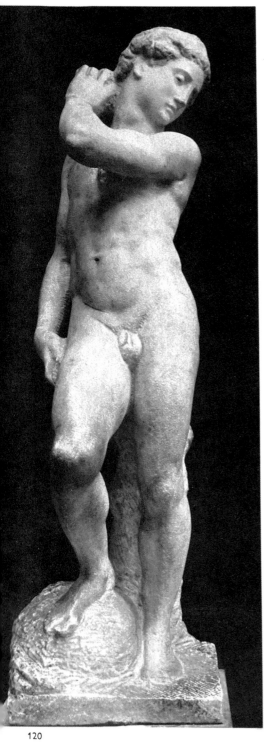

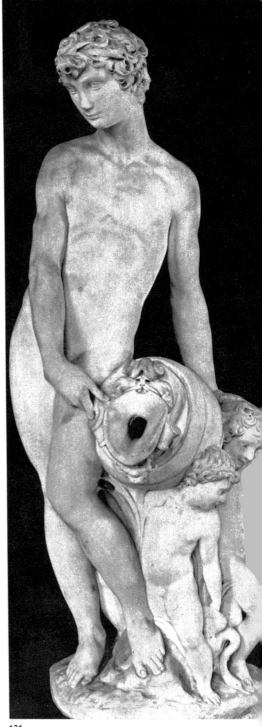

120

121

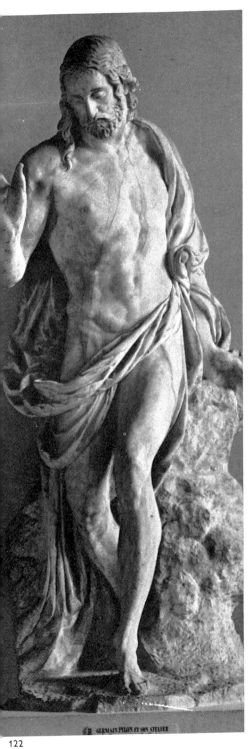

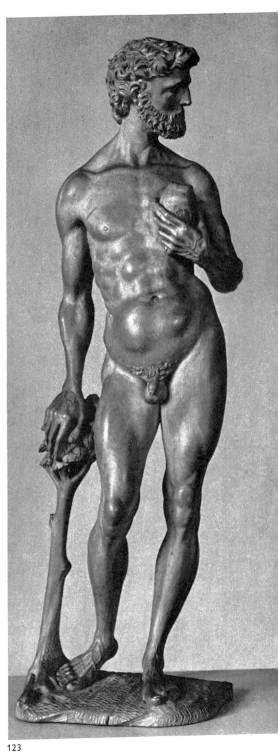

GERMAIN PILON ET SON ATELIER

122

123

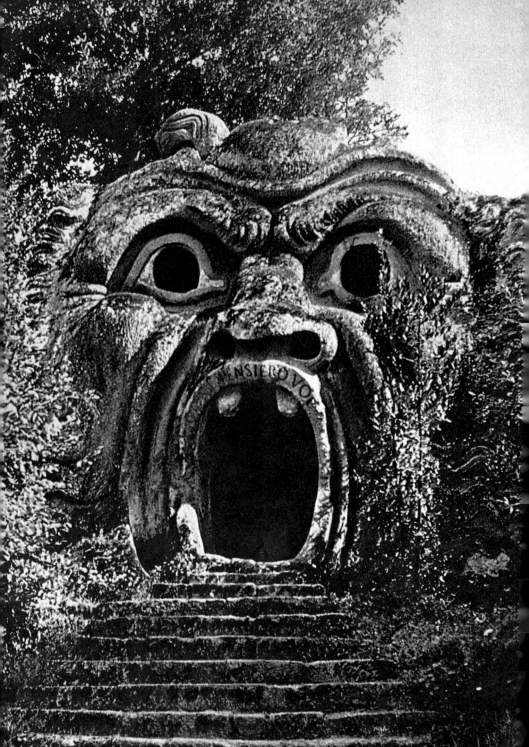

led the way into the new era (*120*). We already find him treading new paths in the second decade of the new century. His *Slaves* and the *Moses* for the Tomb of Julius II (*115*) have a heightened movement and expressiveness hitherto unknown. The perfect equilibrium in which the world seemed to have caught its breath for a moment has been destroyed for the sake of rendering visible spiritual tensions and passions. This trend led to the sculptures in the Medici Chapel and the later Pietàs. The High Renaissance proved to have been no more than a short transitional phase. "At the same time the form that represented the ideal for him—Michelangelo—does not so much show nature reduced to the sublime and beautiful as materially heightened in certain respects" (Burckhardt). The work of Michelangelo —and above all the inexhaustible repertoire of his movement studies which he used as a means of heightening expression—forms one of the bases of Mannerist sculpture, which was often exaggerated masterfully under his successors (*119*), but at times resulted in a rigid formalist *maniera*.

Yet it would be a distortion to follow Vasari's idea and see the sculpture of the Cinquecento only as the legacy of Michelangelo. Like other art forms, its manifestations are extremely varied, if not contradictory, often within the work of one and the same artist. The common thread in Mannerist sculpture despite the multiplicity of forms, is, again, the destruction of the norms set by the classical art of the High Renaissance. The rich variety of super-cool classicizing forms taken up by Mannerist sculptors, lacking the animation they had in the years around 1500, were sometimes transformed into exaggeratedly expressive distortions of nature. The return to the late 15th century is unmistakable. Both north and south of the Alps, the sensitive, Late Gothic line often served as a means of outlining the elongated figures; and the disintegration of the large, unified form into a wealth of smaller-scale forms, exemplified in the modeling of the body of *Perseus* by Benvenuto Cellini (*125*), has its forerunners in the bronze casts of the late 15th century. The problem of the plural viewpoint in sculpture, which first preoccupied the artists of the last third of the Quattrocento, and which was taken considerably further by Michelangelo, became that of the multiple viewpoint, one of the major concerns of figurative sculpture. Masterpieces such as *Rape of the Sabine* (*127–30*) by Giambologna (Giovanni da Bologna, 1529–1608) allow the beholder to apprehend the group only by circling around it—the spiral motion of

124 MOUTH OF HELL, Park of Monsters, Bomarzo (also described as the "Sacred Wood," according to inscriptions). c.1580. Created as the park of the Palazzo Orsini. The attribution is uncertain; perhaps Ammanati. Nature and art fuse here, and the boundaries between architecture and sculpture are effaced. The park is a specifically Mannerist work in its emphasis on the weird and eerie.

125 BENVENUTO CELLINI, PERSEUS WITH THE HEAD OF ANDROMEDA. 1545–54. Loggia dei Lanzi, Florence. Characteristically, the group depicts a fleeting moment. The masterly "balance" of the body is linked to a specifically Mannerist dissection of the surface.

126 HUBERT GERHARD, ST. MICHAEL. 1588. Bronze. Façade of St. Michael, Munich. The Mannerist figures of the Archangel and Lucifer are skillfully interlocked in space.

127-30 GIOVANNI DA BOLOGNA, RAPE OF THE SABINE. Signed and dated 1583. Loggia dei Lanzi, Florence. The torsion of the Mannerist figures removes any impression of the static. There is no principal viewpoint; thus, the structure of the group can only be experienced fully from a multiple viewpoint—that is, by walking around it.

131 MICHELANGELO, BATTLE OF THE CENTAURS. 1492. Casa Buonarroti, Florence. This early work of Michelangelo borrows from the bronze relief on the same theme by his master Bertoldo di Giovanni (Museo Nazionale, Florence), but Michelangelo has more recourse to the models of antique battle sarcophagi.

132 VINCENZO DANTI, MOSES AND THE BRAZEN SERPENT. c.1570. Bronze. Bargello, Florence. The restless composition is dominated by swirling, ebullient lines. The rational depiction of space, brought to increasing perfection in the Quattrocento, is absent here. The relief modeling, inspired by Donatello's *rilievo schiacciato*, is not regular but gradated, interrupted by isolated plastic accents.

133, 134 PETER VISCHER THE YOUNGER, THE MIRACLE OF THE ICE BLOCKS. c.1515. Base of the shrine of St. Sebald, St. Sebald, Nuremberg. According to the legend, the saint lit a fire from blocks of ice and this miracle converted a hardhearted Nuremberg wagoner. Peter Vischer the Younger spent nine years in Italy (1501–9), and the impressions he gained there are reflected both in the purity of his composition and in the clear articulation of the figures.

135 PETER FLÖTNER, ATE AND LITAI. Lead panel. Diameter 15.4 cm. Bayerisches Nationalmuseum, Munich. The romantic mood and such details as the trees bring this relief of a mythological scene close to the so-called Danube School. The extension of the background by means of extremely delicate relief gradations proves a knowledge of Italian Quattrocento sculpture (Ghiberti and his followers). (Compare *71*.)

136 GIOVANNI DA BOLOGNA, RAPE OF THE SABINES. 1583. Bronze. Relief on the pedestal of *127*. Loggia dei Lanzi, Florence.

137 GIOVANNI DA BOLOGNA, ECCE HOMO. 1570–85. Grimaldi Chapel, Genoa University. The source of Giambologna's reliefs is the style developed by Ghiberti in his "Door of Paradise" (*71*). But now, in typical Mannerist fashion, abrupt perspectives open up, different levels of modeling are juxtaposed, and the composition is largely asymmetrical. But Giambologna's two reliefs illustrated here also show the range possible within this framework: *Rape of the Sabines* (*136*) has an architectural perspective anticipating Tintoretto, while *Ecce Homo* has skillfully coordinated parallel relief levels.

138 BENVENUTO CELLINI, PERSEUS FREEING ANDROMEDA. 1545–54. Bronze. Relief on the *Perseus* group (*125*). Bargello, Florence (copy in the Loggia dei Lanzi).

139 JEAN GOUJON, LAMENTATION. 1545. Louvre, Paris. French relief sculpture of the 16th century was more interested than Italian in establishing a clear, comprehensible relationship between figure and ground. Here, a sensitive and elegant linear style determined the contours and draperies of the elongated figures.

140 ADRIAEN DE VRIES, NAIADS AND TRITONS. 1596–1602. Fountain of Hercules, Augsburg. The influence of Giovanni da Bologna, under whom de Vries trained, is combined with a traditional Netherlandish restraint.

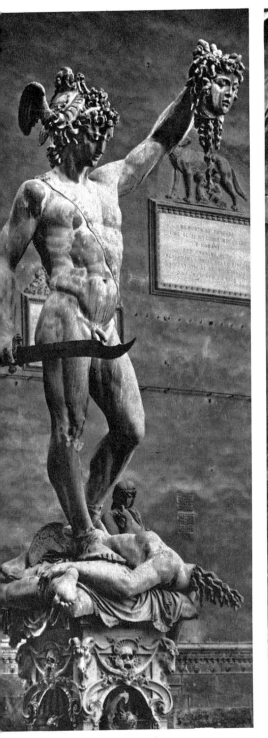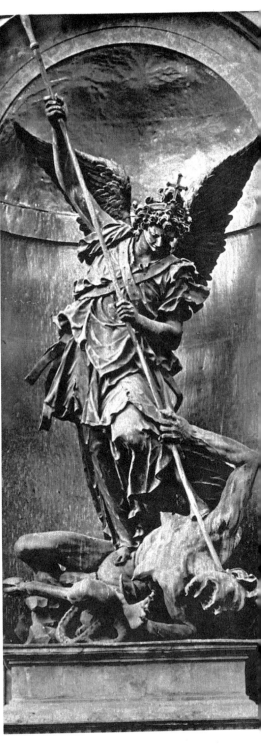

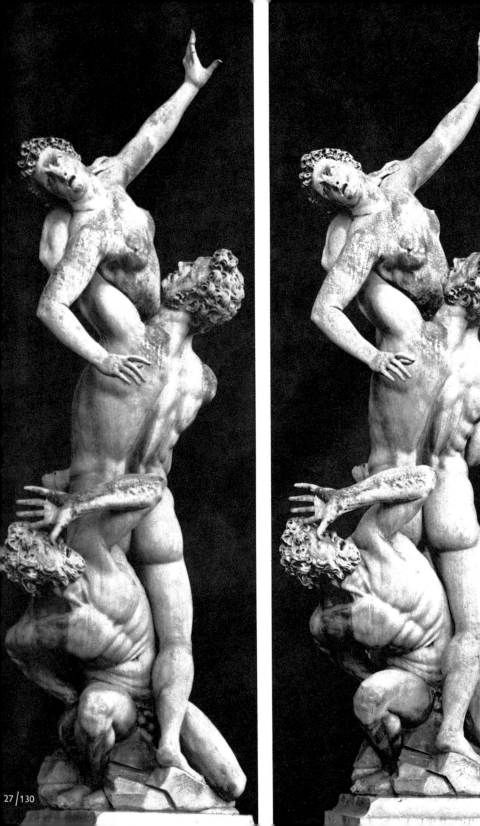

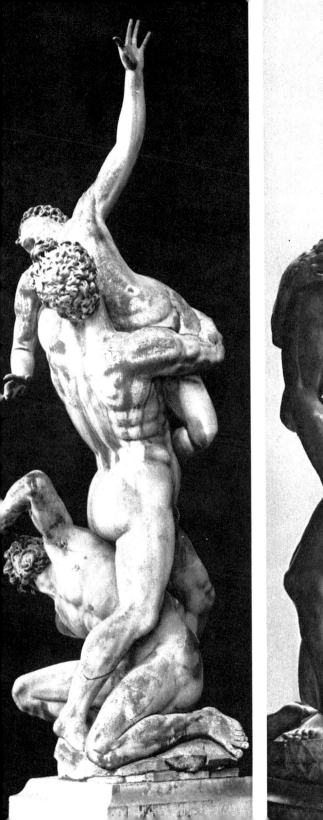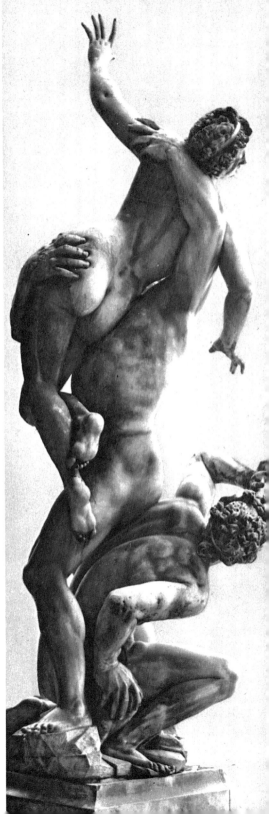

△ 131

▽ 132

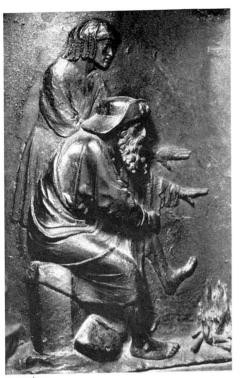
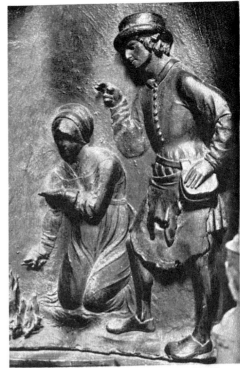

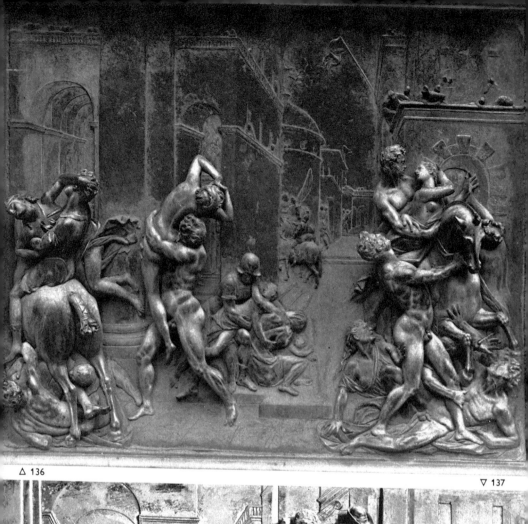

△ 136

▽ 137

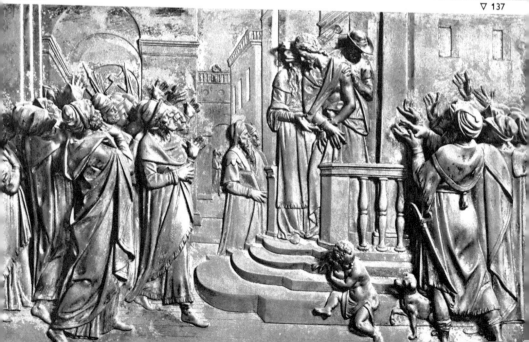

△ 138　　　　　　　　　　　　　　　　▽ 139

the tower of figures also animates the surrounding space. The victory over the static, taken to the point of virtuosity, was also a new problem for the creative artist, important in terms of the future, and again it was resolved in masterly fashion by Giambologna in his bronze *Mercury*.

North and south of the Alps, a tendency toward preciosity, as seen in Cellini's unique salt-cellar (Kunsthistorisches Museum, Vienna), created for François I between 1540 and 1543, promoted certain art forms whose foundations had been laid in the 15th century: small-scale bronzes, small-scale sculptures, and medals (*123*, *131–39*). But there was also a tendency to efface the limits between nature and art—another feature of Mannerist sculpture that would be of great significance in the Baroque era. Grottoes copied from nature served as pretexts for statue cycles (Boboli Garderns, Florence). In the great parks of the mid-16th century—Pratolino near Florence; Bomarzo, south of Orvieto (*124*), or the Villa Lante near Viterbo—sculptured monsters assume incredible shapes and combine with surrounding natural forms. A similar sensibility produced the figures ejecting water from their mouths or breasts; the limits between *objet d'art* and functional object are dissolved (*140*).

As the boundaries between nature and art become hazy, it follows that the attributes of the different art forms will also become interchangeable. Relief sculpture in Florence, Venice, the Netherlandish workshops, and south German art centers now made generous use of pictorial media scarcely conceivable at the time of Ghiberti and Donatello. And the boundaries between architecture and sculpture also became unclear. Monsters in the great parks are large enough for the spectator to pass through; and they become buildings by the addition of steps.

Many features of Mannerist sculpture were as though designed to exercise the talents of Northern artists; the passion for the abnormal, the love of the fantastic, the restless and complex movements, the pre-eminence of line, the preference for small format. Accordingly, Mannerism took root north of the Alps in a way that was impossible for the Early and High Renaissance tendencies (*122*, *126*, *139*, *140*). And, presumably, it is not chance that in 16th-century European sculpture the outstanding creative figure was an artist of Northern origins and Southern training: Giovanni da Bologna, born in Boulogne-sur-mer, who moved to Italy in 1554 or 1555 and there manifested all or nearly all the tendencies of Mannerist sculpture in works of the highest rank (*127–30*, *136*, *137*).

140

PAINTING

Vasari realized that Giotto ushered in a new era in European art. He saw Giotto's work as the embodiment of the first phase of the *rinascita*, the rebirth of good art, which, in his view, could only derive from an intensive study of nature. The naturalism of Giotto's art was already praised by the writer Boccaccio, born in 1313. Indeed, the three-dimensional expression of forms in space, thanks to which the figure achieves independence in the pictorial structure, the scenic unity in compositions determined by human sensibilities and emotions, and the realistic representation of architectural and landscape details are all characteristic features of Giotto's works. They distinguish his œuvre sharply from Duecento (13th-century) painting. Art historians have realized that Vasari's view of Giotto as a realist brings out only one side of his true importance. It is only when we also observe the deliberate and very skillfully planned composition—the reciprocal interplay and contrasting of the figures and landscape and architectural elements—and the reduction of detail to the measure necessary to clarify the event that we can appreciate some of the greatness of Giotto's art (*142*).

Following the 16th-century trend to glorify great individuals, Vasari considered the rebirth of Italian painting around 1300 the personal achievement of Giotto alone, and many art historians have adopted this view up to the present day. It was also Vasari who first linked the name of Giotto with the most important surviving cycle of frescoes created around the turn of the century south of the Alps: the *St. Francis* frescoes in the upper church of S. Francesco, Assisi (*143*). As in Giotto's work, we find a new awareness of reality, and technically, too, the frescoes of the life of St. Francis are related to the ascertained works of Giotto by an epoch-making innovation. In both cases *giornate* were introduced—each day, damp plaster sufficient for just that day of painting was applied to the wall. This meant very great gain in the permanence of the frescoes, because it greatly restricted the use of colors applied *al secco* (after the plaster had dried). From an artistic point of view, however, the frescoes in Assisi are very different from all the works that can definitely be attributed to Giotto. Compared to the frescoes in Padua (*142*), there are not only considerable differences between the individual frescoes, which suggests the collaboration of various relatively independent masters, but the paintings in Assisi (*143*) reflect reality more naïvely, without the meditative spirit that makes Giotto stand out from all his contemporaries. The dramatist Giotto, with his reductive compositions, stands apart from the born narrators in Assisi, who openly confess their love of the ornamental detail and decorative effect.

It is another question whether the Assisi workshop may have been influenced by Giotto. Our inadequate knowledge of Giotto's early work prevents us from giving a definite an-

swer. And to attribute the frescoes in Assisi to disciples of the Paduan Giotto is impossible if we consider the third center of Italian painting at the time, Siena. Here Duccio di Buoninsegna (c. 1255–c. 1318) executed his *Maestà* for the high altar of the cathedral between 1308 and 1311 (*144*). Without question he broke with the tradition of the Duecento less abruptly than Giotto and the masters of Assisi; but the angular, gold-heightened linear style of his figures should not close our eyes to the free, crowded composition of the enthroned Virgin between angels and saints and the astonishing animation in the scenes on the reverse and the predella panels, for instance, the *Entry into Jerusalem*. Not unlike the masters of Assisi in his narrative powers, Duccio shows himself to be at a more advanced stage of development than the Assisi masters in his attitude toward nature.

141 PIETRO CAVALLINI, BIRTH OF THE VIRGIN. 1291. Mosaic. S. Maria in Trastevere, Rome. The scenes along the lower edge of the vault of the apse are important precursors to the work of Giotto. The figures are marked by a hitherto unknown substantiality and clearly articulated movement. There is a new concern with spatial effects. Instead of a gold ground as a neutralizing spatial foil, the framing architecture serves not merely as an accessory; it is linked to the figures in such a way as to heighten the action. Note, for instance, the accentuation of the main figure by the projecting cornice on the left, the way the frontal figure near the central axis and the servant on the right edge are juxtaposed with the architectural columns, and the curving lines of the curtain that emphasize the gestures of the women.

142 GIOTTO, MEETING AT THE GOLDEN GATE. 1305–10. Fresco. Arena Chapel, Padua. The realism of the scene extends to individual details, such as the differentiation between the ashlar blocks and the smooth, whitewashed masonry. The group of figures passing through the gate, whose curve follows the line of the bridge, gives the effect of spatial depth. But we must not overlook the fact that the façade of the gate arrests the sense of depth by means of its slightly contrary direction and almost parallel planar lines, nor that space is rendered chiefly by means of the three-dimensional bodies, not by a systematic perspective structure. The composition itself removes the need

for a frame to demarcate it and set it apart. Joachim's encounter with Anna is conveyed with a directness that almost conceals the fact that the faces are types rather than individuals.

143 ST. FRANCIS PREACHING TO POPE HONORIUS III. c. 1300. Fresco. Southern nave wall, upper church of S. Francesco, Assisi. Compared to Giotto (*142*), the composition is less strict, and the grouping of the figures looks more haphazard and natural. The evident love of realism, much less deliverate than with Giotto, is reflected above all in the architecture, which makes use of clements of medieval church architecture (considered modern at the time). The marble inlays in the spandrels of the foreground arches and the steps of the papal throne, the capitals, and the drapery on the walls reveal a decorative tendency unknown in Giotto's work. The loosely grouped, asymmetrically disposed figures (in particular, the two seated figures front left and far right) show a feeling for solid form very close to Giotto and an elegant, fluid, linear style indebted to the Gothic.

144 DUCCIO DI BUONINSEGNA, MAESTÀ (Virgin Enthroned Between Saints and Angels). 1308–11. Front of the panel made for the high altar of Siena Cathedral. Museo dell'Opera del Duomo, Siena. The predella and reverse of the panel show scenes from the life of the Virgin and of Christ. Duccio's *Maestà* occupies a position in Sienese painting similar to that of Giotto's frescoes in Padua (*142*) to Florentine

113

painting. Duccio's great achievement, in addition to his delicate palette, was the mastery of large-format painting (2.14 × 4.26 meters) without the aid of a strict symmetrical figurative plan. The adjacent and tiered rows of figures acquire a certain freedom, thanks to their varied movements and gestures. The Virgin is no longer severely frontal, and the contrary motion of mother and child relates the lines of movement throughout the entire scene.

145 SIMONE MARTINI, GUIDORICCIO DA FOGLIANO. Signed and dated 1328. Fresco. Palazzo Pubblico, Siena. The strict, statuesque effect of the silhouette of the Sienese condottiere is in attractive contrast to the detailed rendition of the camp and the two castles. The colors of the armor and of the trappings of the horse form a counterpoint to the harmony of the blue and ocher landscape.

146 AMBROGIO LORENZETTI, EFFECTS OF GOOD GOVERNMENT. c.1340. Fresco. Palazzo Pubblico, Siena. The native Sienese love of narrative is paramount in Lorenzetti's portrayals of the effects of good government (of which only this painting survives). The left half of the fresco, devoted to prosperity in the city, is a masterly rendering of perspective and a faithful depiction of a late medieval Italian town, with its abundance of patrician towers. The brick in the architecture and the well loggia in the foreground suggest that the town is Siena. The right half of the fresco shows the effects of prosperity in the country and gives a view of the distant hills of Tuscany.

147 BARNA DA SIENA, CHRIST ON THE MOUNT OF OLIVES. c.1350. Collegiata, S. Gimignao. This masterpiece of midcentury Sienese painting combines the severe pictorial structure of Giotto with the Sienese talent for realistic, ornamental detail.

148 ALTICHIERO DA ZEVIO, BEHEADING OF ST. GEORGE. Completed 1384. Oratorio di S. Giorgio, Padua. The style of the figures and the way in which the composition is emphatically related to the right angles of the frame point to the influence of Giotto. But the detailed portrayal of landscape and the silhouette of the town reveal the affinities with Northern painting that made northern Italy a center of International Gothic around the turn of the century.

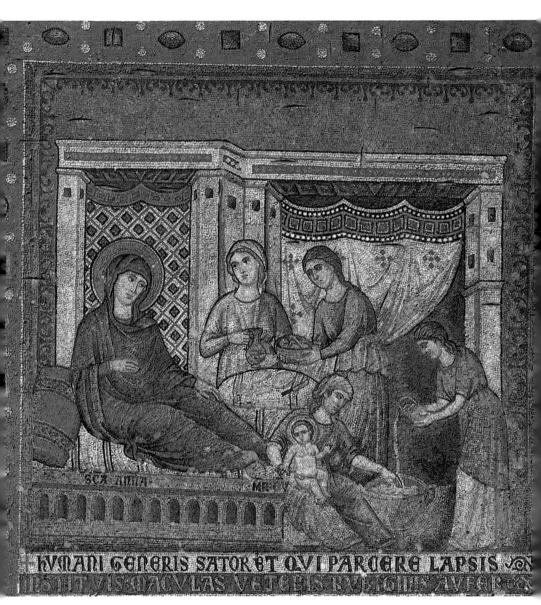

SCA ANNA MRIA

HVMANI GENERIS SATOR ET QVI PARCERE LAPSIS
INSTITVIS MACVLAS VETERIS RVBIGINIS AVFER

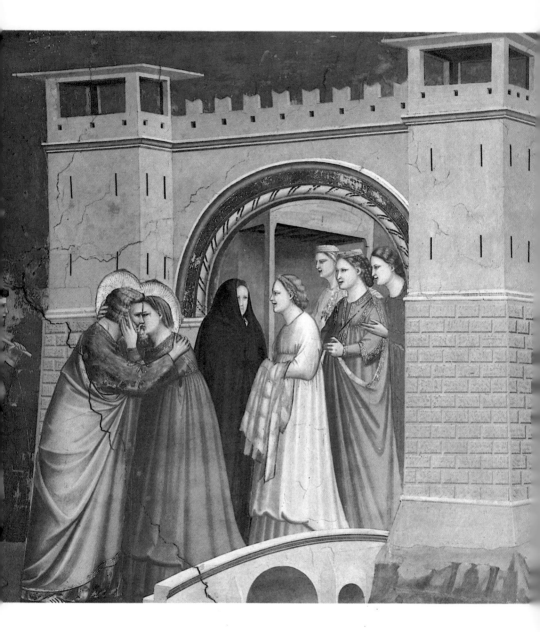

142

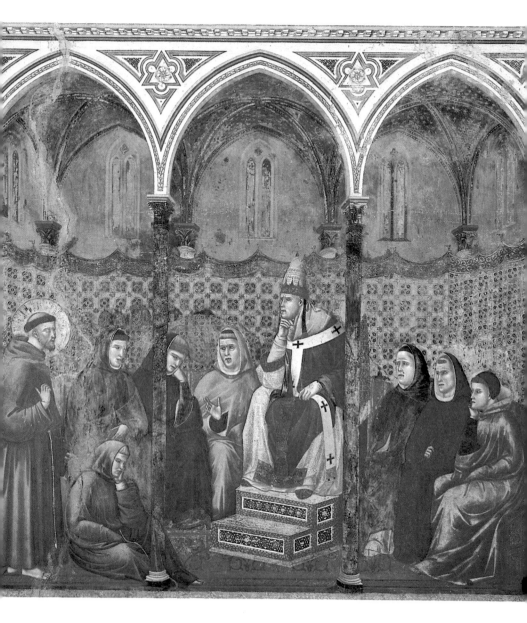

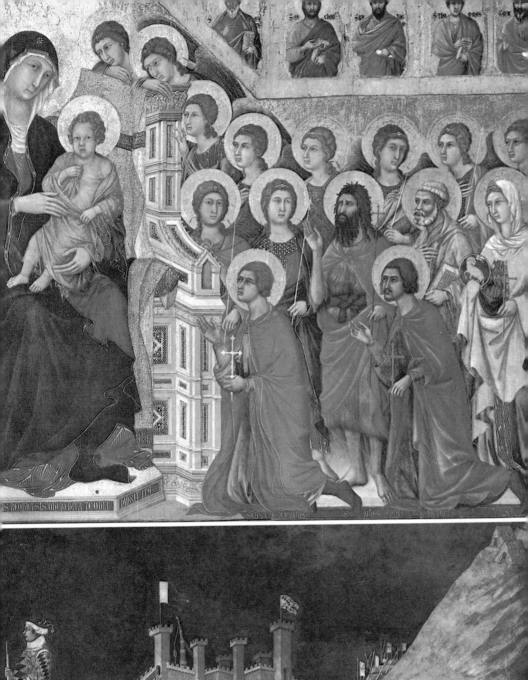

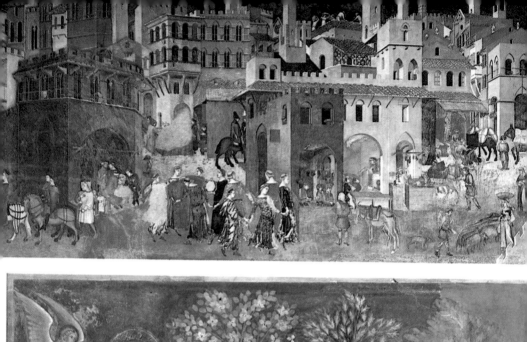

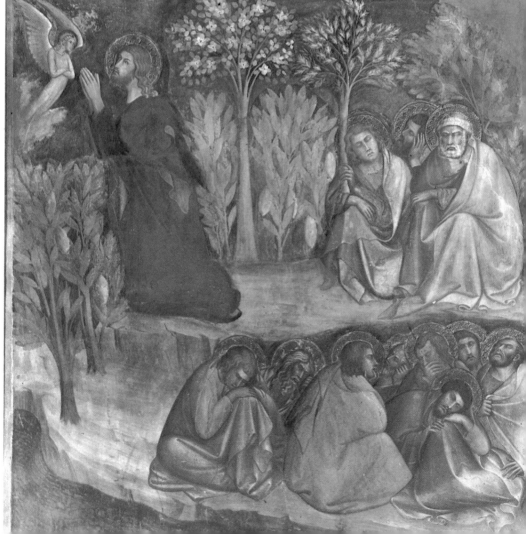

If we compare Giotto and Duccio, the fundamental difference between the Florentines and the Sienese becomes apparent. Giotto's passionate desire to give figures and objects a three-dimensional appearance heralds the inherent sculptural tendencies that were to characterize the whole of Florentine painting until Michelangelo, while the Sienese are notable for their extremely refined linear style and color gradations.

Giotto, Assisi, Siena—it is only the sum of the currents operating here that can give us an accurate idea of the first phase of the *rinascita* in European painting. There were precursors, such as Giotto's presumed teacher Cimabue, and, above all, the Roman painter Pietro Cavallini, who signed and dated the mosaics in the apse of S. Maria in Trastevere, Rome, in 1291 *(141)*. The solidity of Cavallini's figures, the construction of several levels of space, and the enhancement of the action by means of architecture and landscape are features of Cavallini's work that must have made a strong impression on Giotto. It is worth noting that Vasari calls the older Cavallini a pupil of Giotto in order to stress Giotto's pre-eminence. If we knew more about Cavallini's lost fresco cycles, they might tell us more about the derivation of Giotto's style and the date of the St. Francis cycles in Assisi.

Giotto's œuvre exerted an enormous influence throughout the 14th century, but only one side of his art was followed up—its relation to reality. His closest pupils and followers, such as Taddeo Gaddi and Bernardo Daddi, concentrated on elaborating and enriching the realistic detail, while the new art of pictorial construction—bringing out the main content by a reduction of individual details—that is so much admired today was for the time being incapable of development.

By contrast, Sienese painting in the first half of the 14th century flourished in a way that had no equal among the Florentine successors to Giotto. Simone Martini (c. 1284–1344) drew his initial inspiration from the linear and tonal style of Duccio, but managed to overcome the remnant of Byzantine tradition, the *maniera greca* of the Duecento, entirely in favor of greater truth to nature. His *Maestà* fresco in the Palazzo Pubblico in Siena (c. 1315), the panel of *St. Louis of Toulouse* of 1317 (Museo di Capodimonte, Naples), the cycle of the *Legend of St. Martin*, presumably dating from between 1322 and 1326, in the lower church of Assisi, which is a milestone in the achievement of an over-all compositional organization of the frescoed walls, and the fresco of *Guidoriccio da Fogliano*, dated 1328, in the Palazzo Pubblico, Siena *(145)*, with its strong contrast of two colors, the monumental, silhouettelike effect of the horseman, and the careful depiction of the town, castle, and army camp, are

◁ 149 MASTER BERTRAM, EXPULSION FROM PARADISE. c. 1380. Kunsthalle, Hamburg. Panel of the so-called Grabow Altar, created for the church of St. Peter, Hamburg, but in the town church of Grabow since 1731. The violently animated and twisted figures of Adam and Eve are projected from the flat gold ground. The disposition of the figures in space is reinforced by the foreshortening of the architecture. The attempt to articulate the bodies and to make the figures and architecture three-dimensional points to influences from Italian painting, presumably transmitted via Prague.

important works in an art that shows traces of the study of Giotto's pictorial system, among other influences. Comparable only to Giotto in his brilliant career, Simone Martini settled at the papal court of Avignon in 1339. Although his activity there is known to us only in broad outline, his work and that of his successors had a lasting influence on French painting in the second half of the century. It also contributed toward making Avignon one of the most important contacts between Italian and Northern painting.

The brothers Ambrogio (c. 1290–1348) and Pietro Lorenzetti (c. 1280–1348) of Siena were almost the same age as Simone Martini. Their work reveals an intensive study of the art of Giotto, which did not, however, impair their inherent Sienese talent for animated lines, rich colors, and love of narrative. On the contrary, Ambrogio's frescoes of *Good and Bad Government* in the Palazzo Pubblico, Siena, executed c. 1340, portray the town with an attention to detail that points far beyond the age of the Early Renaissance (*146*). The adjacent highly animated and varied landscape, with its continuous spatial recession, was a prototype of Sienese Quattrocento painting; its effects are still apparent in the work of Paolo Uccello and Piero della Francesca.

The plague referred to as the Black Death in 1348 seemed to have put an abrupt end to the golden age of Sienese painting. But after this break, presumably immediately after the midcentury, one more work appeared linking the Sienese love of narrative and the principles of Giotto's pictorial construction in unique fashion: the cycle of frescoes in the Collegiata of S. Gimignano that Lorenzo Ghiberti attributed to the legendary Barna da Siena (*147*).

Painting north of the Alps in the early 14th century did not undergo any comparable changes regarding the mastery of nature. Panel painting in Cologne (altarpiece, St. Claire, c. 1330) and Westphalia (altarpieces in Hofgeismar, c. 1310–20) is characterized by slender, almost flat figures, often placed against highly ornamental gold ground with little perspective, and which seem to hover rather than stand in their richly flowing draperies. But from the fourth decade of the 14th century, the first influences from Italian painting, called by Max Dvořák the "new Gospel" of art, began to penetrate to the North. France was directly confronted with the new artistic problems because of the presence of Simone Martini and his successors (hunting scenes in the Chambre du Cerf, and Matteo di Giovanni da Viterbo's fresco cycles in the chapels of St-Jean and St-Martial, all in the papal palace at Avignon, from 1343); meanwhile, in the southern German-speaking regions, details in specific works give evidence of the first contacts with Italian painting under Giotto and his contemporaries: for instance, the perspective modeling of such details as the sarcophagus in the *Noli me Tangere*, one of the scenes in the Verdun Altarpiece in Klosterneuberg, created by an anonymous Viennese master in the 1340s. (The composition as a whole lacks these spatial effects and the figures are flat.)

With the shift of political emphasis to Bohemia under Emperor Charles IV (1346–78), Prague became a new art center, next to Avignon the major port of entry for influences

from Italian painting. The Hohenfurth Altarpiece (National Gallery, Prague) from the midcentury is inconceivable without reference to the works of the Giotto school. The systematic structure of pictorial space goes considerably further than the preliminary attempts found in Viennese painting two decades earlier. Just how these ideas were transmitted has not yet been clearly established; but we perhaps have a clue in the fact that the Italian painter Tommaso da Modena was working for Charles IV around 1350. In the works of Master Theoderic of Prague, such as the *Crucifixion* in the chapel of Karlstein Castle (c. 1360–65), the figures have also acquired a solid form and begin to inhabit a kind of "body space." This artistic ambience also produced the sculpture of the Parler workshop.

In painting, as in sculpture, the influence of Bohemian art during the last third of the century can hardly be overestimated. It reached both the west (high altar, parish church, Schotten in Hesse, c. 1370) and the north of Germany, where the work of Master Bertram (*149*) shows a curious fusion of the influences of Italian painting, transmitted via Bohemia, and of the work of Simone Martini.

In its central Italian birthplace, Early Renaissance painting did not produce any outstanding creative innovations in the late 14th century. Panel painting and frescoes, some of high quality, continued along the lines established early in the century. The love of realist detail and experiment with perspective were dominant, but artists were unable to construct

150 MASACCIO, TRINITY WITH THE VIRGIN AND ST. JOHN. 1425 or 1426. Fresco. S. Maria Novella, Florence. For the first time in modern art, the third dimension is projected accurately onto a plane, thanks to the laws of linear perspective recently rediscovered by Brunelleschi. This projection, together with the somewhat over-life-size scale of the figures, produces entirely novel spatial effects. In the architectural setting and the coffered barrel vault, Masaccio used *all'antica* forms that may also have been transmitted by Brunelleschi.

151 MASTER OF FLÉMALLE, ST. BARBARA. Signed and dated 1438. Right wing of the Werl Altarpiece (named after the donor, Heinrich Werl). Prado, Madrid. The rendering of a boldly foreshortened space has become as characteristic of Flemish painting as of Masaccio (*150*). Tiled floor, bench, hearth, rafters on the ceiling, shutters, and so forth, emphatically stress depth, which is extended by the view through the window. But while the Florentine master reflects and organizes the results of his new perceptions, the Northern artist proceeds intuitively. The differences, despite basically

similar aims, also emerge in the treatment of the figures. In both cases, there is a striving for solid form, but Masaccio articulated the body beneath the robes under the influence of sculpture, while Northern artists let the rich, ample folds of drapery convey the underlying solidity of the body.

152 LUKAS MOSER, STS. MARTHA, LAZARUS, MAXIMIN, AND CEDONIUS AT THE GATES OF MARSEILLES. Above: Mary Magdalene appears to the princely couple. Signed and dated 1431. Right panel of the exterior of the *Magdalen* Altarpiece. Parish church, Tiefenbronn. The figures have a plastic modeling and personalized heads. Note also that, as with the Master of Flémalle (*151*) and the Van Eyck brothers (*156*), Moser's painting is realistic down to the last detail—the robes, masonry, and roof tiles. The Tiefenbronn Altarpiece is the masterpiece of southwest German painting before the advent of Konrad Witz and Hans Multscher. (Recent attempts to reveal the inscription as a forgery and to attribute the altarpiece to the Provençal followers of Simone Martini agree neither with technical nor stylistic analyses.)

153 MASTER FRANCKE, NATIVITY. Panel from the exterior of the *St. Thomas à Becket Altar* commissioned in 1424 by the Hamburg merchants who traveled to England. Kunsthalle, Hamburg. At the time of the highly realistic Flemish and southwest German style, a wave of International Gothic permeated the central and lower Rhine region and northern Germany. This altarpiece is marked less by attempts at realism than at rendering a sense of the miraculous. Master Francke is not interested in the logical interrelation of the details in systematic space. He works with unexpected colors, such as the dark glowing red of the starry sky. Figures, landscape, and sky are interwoven by areas of light, whose correlate is mysterious patches of darkness.

154 STEFANO DA VERONA (DA ZEVIO), MADONNA IN THE ROSE GARDEN. c.1420. Museo Civico, Castelvecchio, Verona. The panel shows the Virgin and Child, Mary Magdalene, and a wealth of almost incorporeal angels among flowers and birds in a garden that has little suggestion of space despite its trellislike fence. There is no fore- or background, only an above and below; the figures are interwoven into a kind of tapestry of ornamental flowers and flowing lines.

155 PIERO DELLA FRANCESCA. BATTISTA SFORZA. c.1470. 47 × 33 cm. Uffizi, Florence. Left panel of a diptych; the right panel is a portrait of her husband, Federigo da Montefeltre. The view of a distant landscape behind the foreground hill, the precise, delicately painted detail, and the sophisticated glazing technique reflect Netherlandish influences, which Piero must have absorbed at the court of Urbino.

156 JAN VAN EYCK, ROLIN MADONNA. c.1435. Louvre, Paris. Painted for the collegiate church, Autun. "The interior and landscape are fused into a most convincing spatial unity in this composition. In no other work by Van Eyck is the perspective so effective in its uninterrupted run from the close foreground to the furthest extremity of the space" (H. Beenken).

157 FRA ANGELICO, CORONATION OF THE VIRGIN. 1436–43. Convent of S. Marco, Florence. This fresco reveals Fra Angelico as a master of monumental composition. There is a notable absence of detail. Circle and semicircle are the constituent elements: The Dominican monks form a semicircle—in space and on the picture surface—echoed by the semicircular grouping of Christ and the Virgin, which closes in a circle, with the whole framed by a semicircular arch. This skillful articulation of the planar surface and the relationship between the flat and the three-dimensional were not taken further until the appearance of Raphael at the peak of the High Renaissance (*177–79*).

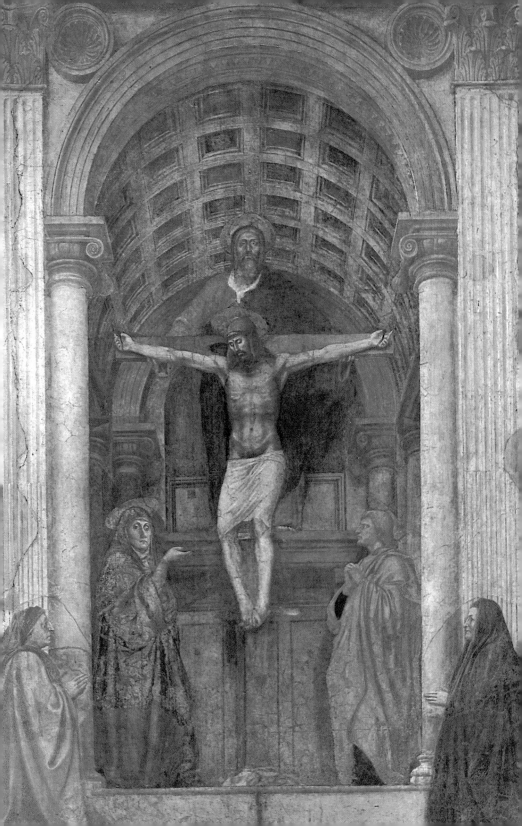

156

convincing compositions of the two.

The most important contribution to Italian painting in the last third of the Trecento came from northern Italy, with Altichiero's frescoes in Padua (Capella di S. Giacomo, S. Antonio; Oratorio di S. Giorgio [148]). He achieved a wonderful synthesis of the formal language of the Giotto school with the Lombard love of decoration, largely derived from the tendencies of Northern Late Gothic, in his perfectly balanced and compact compositions.

North of the Alps, Bohemia remained the center of European painting in the last decades of the 14th century, too; for instance, with the work of the Master of Wittingau (altarpiece from Wittingau Monastery, c. 1380, National Gallery, Prague). If we seek works pointing to the future in the period around the turn of the century, we must turn our attention primarily to the Franco-Flemish region. For the study of reality in Italian painting had spread over great parts of France and Flanders, largely thanks to the School of Avignon. Here, toward the end of the century and under the influence of the courts of Paris and Dijon, the joy in naturalistic detail was combined with a passion for displays of magnificence and splendor. Characteristically, small-format work was preferred. Manuscript illumination flourished in Paris, Bourges, and Dijon, and some of the best works in panel painting were in book format (the so-called *Small Bargello* diptych by the School of Paris, c. 1390). The famous Books of Hours were created in Burgundy in the early 15th century; they had no equals in their time, either in the multiplicity of courtly, refined ornament or in the loving devotion to realistic detail. The outstanding examples are the *Très Riches Heures du Duc de Berry* (c. 1416, Musée Condé, Chantilly), the *Grandes Heures de Rohan* (c. 1420, Bibliothèque Nationale, Paris) inspired by it, and the *Heures de Milan et Turin*, created between 1415 and 1420, on which the Van Eyck brothers probably worked (parts in the Museo Civico, Turin; others burned in the Biblioteca Comunale, Turin, in 1904).

The Franco-Flemish region became the nucleus of International Gothic, which, largely because of the predilection for small-format, portable works, soon spread throughout Europe. It reached Westphalia (Konrad von Soest, altarpiece, Protestant church, Bad Wildungen, 1412; his *Altar of the Virgin*, St. Mary, Dortmund, c. 1420) and northern Germany (Master Francke, *St. Thomas à Becket Altar*, 1424, Kunsthalle, Hamburg [153]), and its influence also penetrated to the upper Rhine (Master of the Little Paradise Garden, c. 1410, Städelsches Kunstinstitut, Frankfurt) and southern Germany (Pahl Altar, c. 1410, Bayerisches Nationalmuseum, Munich; Kremsmünster Altar, c. 1400, Österreichische Galerie, Vienna). It also spread to northern Italy, thanks to masters such as Giovannino de' Grassi and Michelino da Besozzo from Lombardy, Stefano da Zevio from Verona (*154*), and the Venetians Jacobello del Fiore and Giambone. Traveling artists such as Gentile da Fabriano, born before 1370, and Pisanello, born about 1395 in Pisa but trained under Stefano da Zevio in Verona (*199*), brought the whole of northern and central Italy under the influence of International Gothic.

The best achievement in Florentine painting in the early 15th century also showed the effects of this trend; for instance, the frescoes and panel paintings of Lorenzo Monaco. And a masterpiece of the "soft style" in Italy was the altarpiece of the *Adoration of the Magi* by Gentile da Fabriano, painted in 1423 (Uffizi, Florence), commissioned by Palla Strozzi for S. Trinità in Florence. For the rest, Florentine painting in the first quarter of the 15th century is characterized by a kind of decadent, late Giotto style. It is worth emphasizing that painting in Florence until about 1425 can offer no innovations comparable to sculpture. Painting was the last to be touched by the rebirth of the arts. Masaccio (1401–c. 1428) laid the foundations for the entire Quattrocento in a space of scarcely five years. In 1425 or 1426, Masaccio painted the fresco of the *Trinity with the Virgin and St. John* in S. Maria Novella, Florence, with the donor figures kneeling at the sides in front of architectural elements (*150*). The architecture, composed of individual classical forms, gives a clear view into a painted, barrel-vaulted room that appears to be a real recession in the wall. For the first time in painting since the decline of late antiquity, the third dimension has been successfully reproduced on a flat surface by means of accurately calculated perspective. Moreover, the expressive force of the portrayal is not only the result of the convincing architectural illusion, but derives equally from the apparent interpenetration of picture space and the real space in which the beholder stands. Since the donors are kneeling in front of the lateral columns and the other figures, they appear to exist in front of the painted picture, that is, in real space. The beholder is thus drawn into the picture. At the same time, by uniting all the figures into a steeply rising pyramid, Masaccio gives the plane its legitimate value, too. The optical break through the wall and the preservation of planar surface are balanced. Masaccio's rendering can stand as the incunabulum of all future illusionist painting until the Baroque.

Mantegna exerted a decisive influence on Venice, above all on his brother-in-law Giovanni Bellini (c. 1431–1516), in whose work all the tendencies of the Venetian Early Renaissance crystallized (*171*). From about 1460 his study of Mantegna is evident in his striving for plastic figures and for an anatomical grasp of structure, as well as in the rather calligraphic sharpness of his linear style. Two decades later, Bellini reached a new stage in his development. Although the modeling and articulation of his figures is no less precise, the line becomes less severe and is finally replaced by modeling in light and shade, so that his landscapes, flooded with light, seem more natural. This change was the result of an event that had as lasting an influence on Venetian painting as Mantegna's transmission of the formal language of the Early Renaissance: Antonello da Messina's stay in Venice in 1475-76 (*174*). Antonello (c. 1430–79), the only painter of European importance in southern Italy in the 15th century, had trained in Naples. There he came under the influence of Netherlandish painting and exercised his talent for still-life detail, and there he also acquired his technical knowledge. By applying color in transparent layers, he achieved a luminosity and an astonishingly substantial effect previously unknown in Italy. Later, when he came to

know the works of Piero della Francesca, Antonello developed a masterful handling of light. Through these abilities, Antonello led Venetian painting to an awareness of its native talents during his relatively short stay in Venice. His influence extended from Bellini to Giorgione (*190*), Titian (*180*), and Veronese (*195*). It was Giovanni Bellini who crossed the threshold to the new century as he crossed from Early to High Renaissance concepts. In his superb late compositions, in which he constructed deep space with masterly assurance, there is a natural coherence between freedom of design and structural balance. His idealized figures of saints, who seem raised above the earthly sphere, are still directly related to human perception (*171*). There is a perfect equilibrium between the precise line and the rich modeling. Bellini stands for the "very old and yet the best in painting," as Dürer realized with astonishment during his second journey to Italy in 1505-7.

Sandro Botticelli (c. 1444–1510) was the dominant figure in Florentine painting in the last decades of the 15th century (*167*). The most striking features of his art are related to those in contemporary sculpture (Pollaiuolo, *94*; Verrocchio, *93*): increased animation and an inexhaustible fantasy in the delineation of outline and internal structure, which, in the case of Botticelli's most important pupil, Filippino Lippi (c. 1457–1504), sometimes led to a rather mannered style. With Botticelli, Florentine painting of the late Quattrocento anticipated *one* variety of Mannerism. The interest in antiquity played a major part here; but, like Mantegna at the same time, the Florentines did not use it as a direct source for their art. What antiquarian interests were to Mantegna and his circle, the influence of literature in-

158 PAOLO UCCELLO, SIR JOHN HAWKWOOD MEMORIAL. Signed and dated 1436. Fresco. Florence Cathedral. The virtuoso rendering of the pedestal, seen both from a slight angle and from below, is clear evidence of Uccello's keen study of perspective. To demonstrate his mastery of foreshortening, Uccello also showed divergent viewpoints for the pedestal and the horseman. He did not use a side- or low-angle viewpoint for the heraldic figure of the condottiere, but a squarely frontal one. The horse and rider are both forcefully modeled and outlined clearly and firmly against the dark ground. Uccello's intent—to render an equestrian sculpture in paint—is another example of the reliance of early Quattrocento painting on sculptural models.

159 ANDREA DEL CASTAGNO, FARINATA DEGLI UBERTI. c. 1450. Fresco. Museo di S. Apollonia, Florence. Castagno painted a cycle of *Uomini famosi*—famous names in Florentine history, poets, and Old Testament figures—for the Villa Pandolfini in Legnaia, near Florence. The resemblance to painted sculpture is immediately evident, as in all Castagno's work. The sculptural quality is enhanced by the figure's seeming to step out of his architectural framework, of which only a fragment is indicated: the figure crosses the threshold from picture space to real space.

160 KONRAD WITZ, SABOBAY AND BANAIAS. c. 1435. Kunstmuseum, Basel. Panel from the *Mirror of Salvation Altar* for St. Leonard, Basel. According to the *Speculum humanae salvationis*, a late medieval book of devotions, the knights Abisai, Sabobay, and Banaias brought King David the water from the cistern of Bethlehem (Abisai kneels before David on the adjacent left panel). This scene was the Old Testament counterpart to the Adoration of the Kings. As in the work of Castagno (*159*), figures resembling painted, free-standing statues were the major artistic aim.

161 STEFAN LOCHNER, MADONNA OF THE ROSE BOWER. c. 1445. Wallraf-Richartz-Museum, Cologne. The jewellike details, the delicate figures and robes, the contrast between the garden and gold ground, and the contrasting

scales of the figures should not make one forget that the tonal and formal structure of this work is highly deliberate and, moreover, that the disposition of the figures in a semicircle, the numerous overlaps, and the perspective of the polygonal bank of grass reveal an evident delight in spatial effects. In unique fashion, Lochner combines the realistic tendenci es of his native southwest Germany with the ideals of Cologne painting indebted to Late Gothic. How greatly he is also indebted to the Renaissance becomes clear by comparing Stefano da Verona's *Madonna in the Rose Garden* of a generation earlier (*154*).

162 BENOZZO GOZZOLI, PROCESSION. Detail from the *Adoration of the Kings*. 1458–60. Fresco. Chapel of the Palazzo Medici, Florence. In some respects this fresco is highly realistic. Two brilliant episodes in Florentine history —the removal from Ferrara to Florence of the council that was to unify the Eastern and Western Churches (1439) and the ceremonial banquet Piero de' Medici gave for Pope Pius II and Galeazzo Sforza in 1459—are reflected here in a wealth of portraits and costumes that could be verified by a mid-15th-century beholder. On the other hand, the abundance of ornamental detail, for which Benozzo was well trained by his work as a goldsmith, shows the revival of the principles of International Gothic. These frescoes are a good example of the transition in Florentine art from the bourgeois ideals of the first half of the century to the courtly tendencies of the later Quattrocento. The steep landscape in the background is inspired by Ghiberti's "Door of Paradise" (*71*), on which Gozzoli had collaborated as an apprentice.

163 ROGIER VAN DER WEYDEN, MEDICI MADONNA. 1450. 53 × 38 cm. Städelsches Kunstinstitut, Frankfurt. The choice of saints—Peter and John on the left, Cosmas and Damian on the right—suggests that Rogier van der Weyden executed this small panel for the Medici during his journey to Italy in the jubilee year of 1450. The strict composition follows the *Sacra Conversazione* as evolved by Domenico Veneziano (*164*) shortly before in Florence. But the differences between North and South emerge all the more clearly in the figures. Domenico's

forcefully modeled John the Baptist, with his clearly articulated limbs, is very different from Rogier's slender figure, with its angular contours.

164 DOMENICO VENEZIANO, SACRA CONVERSAZIONE (Virgin and Child with Saints). 1445–50. Uffizi, Florence. Painted for S. Lucia dei Magnoli, Florence. Left: Sts. Francis and John the Baptist; right: Sts. Zenobius and Lucy.

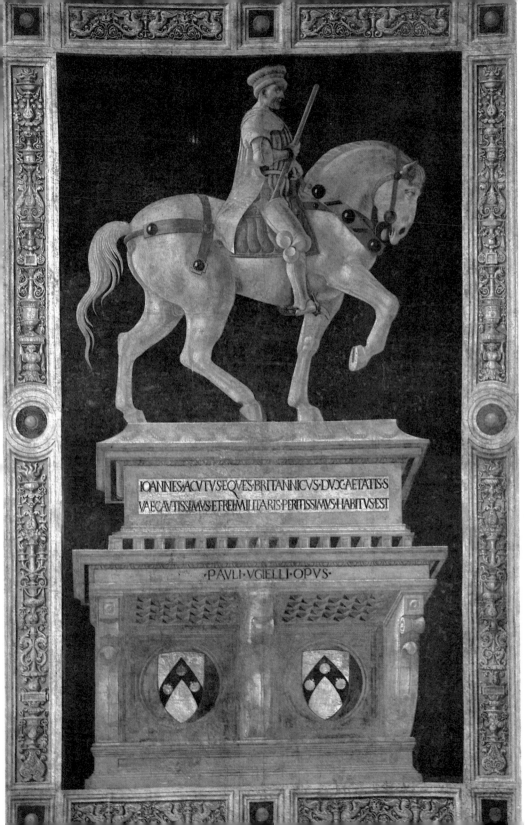

IOANNES·ACVTVS·EQVES·BRITANNICVS·DVX·AETATIS·S
VAE·CAVTISSIMVS·ET·REI·MILITARIS·PERITISSIMVS·HABITVS·EST

·PAVLI·VCIELLI·OPVS·

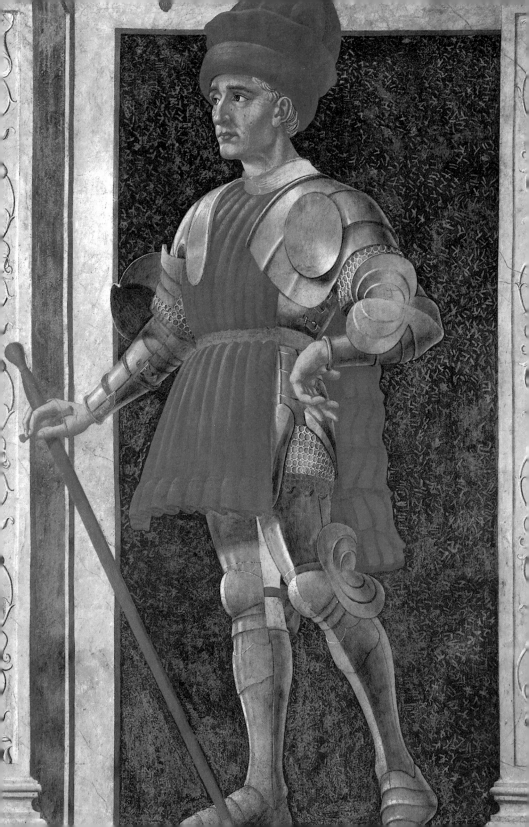

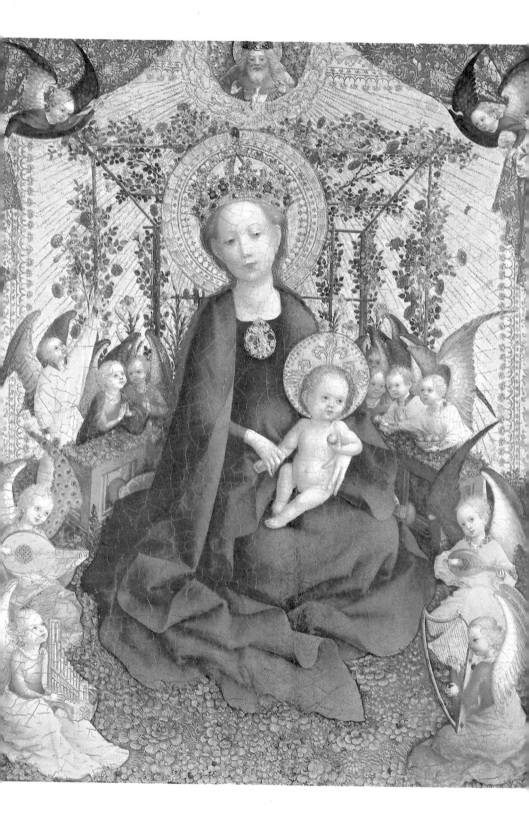

spired by the Humanists was to Florence in the late Quattrocento. It was this that inspired the choice of subjects, which were often depicted in a complex iconography difficult to decipher.

Toward 1500, Italian painting is characterized by an abundance of different, at times contradictory, and at times complementary, trends. The animated line could be used as a means of heightening expression (Botticelli), or it could achieve a virtuoso brilliance, a bold striving for effect (Filippino Lippi). At the same time, the Umbrian school (led by Perugino) and Venetian painting (chiefly under Giovanni Bellini) concentrated on modeling figures and objects by means of light and color. In addition to the talent for astonishing illusionist effects (Melozzo da Forlì and Mantegna), there is the teaching of Piero della Francesca on the structural importance of the planar surface. The realistic depiction of detail, scarcely conceivable in the early part of the century, is linked to a masterly portrayal of the extremely animated human body (seen, for instance, in the work of Signorelli). Moreover, there are examples of boldly arranged, crowded, representational compositions (Ghirlandaio, *183*). The iconographic range of the early Quattrocento was extended to include a wealth of mythological and secular themes.

Around 1500, and against all expectations and likelihood, these apparently unrelated trends fused into a synthesis that was the culmination of the Renaissance. Leonardo's early work is the first to represent this development. In 1496–97 he completed the *Last Supper* for the refectory of S. Maria delle Grazie, Milan (*184*). In Venice, the late works of Giovanni Bellini and the masterpieces of the young Giorgione (*190*) were created in the first decade of the new century. But it was Rome that became the nucleus of High Renaissance painting, with Michelangelo's Sistine ceiling (*176*), 1508–12, and Raphael's *stanze* of the Vatican, begun in 1509 (*177, 178*).

The work of Raphael can be considered as the perfect embodiment of High Renaissance painting (*175*), the full and visible achievement of the synthesis. Born in Urbino, Raphael (1483–1520) may have become familiar with the works and theories of Leon Battista Alberti and Piero della Francesca in his early youth. He learned the painterly treatment of contours and developed his talent for landscape in Umbria, in Perugino's workshop. During his years in Florence, his drawing gained precision and he learned how to represent the animated human body. At the same time, the early works of Fra Bartolommeo became models

◁ 165 PIERO DELLA FRANCESCA, MADONNA OF THE EGG. 1470s. Brera, Milan. Originally an altarpiece. The kneeling donor is Federigo da Montefeltre. Here Piero demonstrates his mastery of perspective, both linear and atmospheric. However, his suggestion of deep space, achieved mathematically, is countered by the planar walls flanking the apse, by the bunched arrangement of the figures, and by the hanging egg (iconographically, a symbol of fertility), which appears to be suspended over the Virgin's head, while at the same time attached to a shallow shell on the back wall. This interplay between space and plane exerted a strong influence on the next generation—for instance, on Raphael's *School of Athens* (*177*) and Bramante's illusionistic choir in S. Maria presso S. Satiro (*18*).

166 HIERONYMUS BOSCH, HAY-WAIN. Center panel of a triptych. c.1490. Prado, Madrid. Between Paradise on the left panel and Hell on the right, Bosch shows man the betrayer and man the betrayed. The haycart is the focus of the composition and the numerous groups of figures are unified by means of light and shade.

167 SANDRO BOTTICELLI, ADORATION OF THE KINGS. c.1475. Uffizi, Florence. Painted for the Medici. The idealism of the composition, typical of the Italian Early Renaissance, emerges clearly by comparison with Hugo van der Goes's Portinari Altarpiece (*168*). The row of lifelike portraits in the foreground anticipates Botticelli's future achievement as a portraitist. The strong luminous colors recall Botticelli's apprenticeship under Filippo Lippi.

168 HUGO VAN DER GOES, NATIVITY. Uffizi, Florence. Central panel of the Portinari Altarpiece, donated for the high altar of S. Egidio, Florence, in 1474 or 1475 by Tommaso Portinari, who directed the trade center of the Medici in Bruges from 1465 to 1480. Comparison with works from the Florentine Quattrocento shows the differences between North and South very clearly. The Portinari Altarpiece does not seek idealized forms; its heightened expressiveness derives from unusual physiognomies and gestures. It does not seek to integrate the isolated detail into the composition, but, rather, to bring out the individuality of both figures and objects.

169 LEONARDO DA VINCI, VIRGIN OF THE ROCKS. c.1500. National Gallery, London. The pyramidal structure of the figure group, in which spatial and planar values are perfectly balanced, is set against a view into space with marked atmospheric effects. Rejecting the firm, dominant contour line characteristic of Florentine Quattrocento painting, Leonardo developed a method of painting with fluid transitions that has been called *sfumato*. In terms of composition, Leonardo stands at the threshold of the High Renaissance; in terms of painting, this work points far into the 16th century.

170 ALBRECHT ALTDORFER, JOHN THE EVANGELIST AND JOHN THE BAPTIST IN THE WILDERNESS. c.1510. Alte Pinakothek, Munich. The "atmospheric,'surreal' handling of distance" (R. Ruhmer) is close to Leonardo (*169*).

171 GIOVANNI BELLINI, STS. NICHOLAS AND PETER. 1488. Left panel of the Frari Altarpiece. S. Maria Gloriosa dei Frari, Venice.

172 ALBRECHT DÜRER, STS. PAUL AND MARK. Right wing of the so-called *Four Apostles*, presented by Dürer to the town council of Nuremberg in 1526. Alte Pinakothek, Munich. The sculptural quality of the figures and, above all, the brushwork reveal the influence of Bellini (*171*) in this late work.

173 ANDREA MANTEGNA, ST. SEBASTIAN. Late 15th century. Cà d'Oro, Venice.

174 ANTONELLO DA MESSINA. ST. SEBASTIAN. 1475. Gemäldegalerie, Dresden. A comparison of this work with *173* indicates the wide range of northern Italian painting in the late Quattrocento. In addition to the same subject matter, they have almost identical compositions, and there is a common search for plastic values in the figures, but Mantegna worked primarily with sharp lines of demarcation, whose rhythm is reinforced by the arrows that disrupt the contours and the pointed tips of flying drapery. Antonello, intent on the harmonious integration of the different elements, abandoned linear outlines in favor of painterly transitions that link both the individual parts and the whole figure to their setting. The body is articulated not with lines but by means of light and shade.

175 RAPHAEL, MARRIAGE OF THE VIRGIN. 1504. Brera, Milan. Painted for S. Francesco, Città di Castello. This panel is evidence of Raphael's break with the Quattrocento workshop of his teacher Perugino. The action is very vivid and animated, while the composition is idealized and analyzed down to the last detail—disposition of the figures, architecture, landscape, and shape of the frame. There are numerous internal interrelationships.

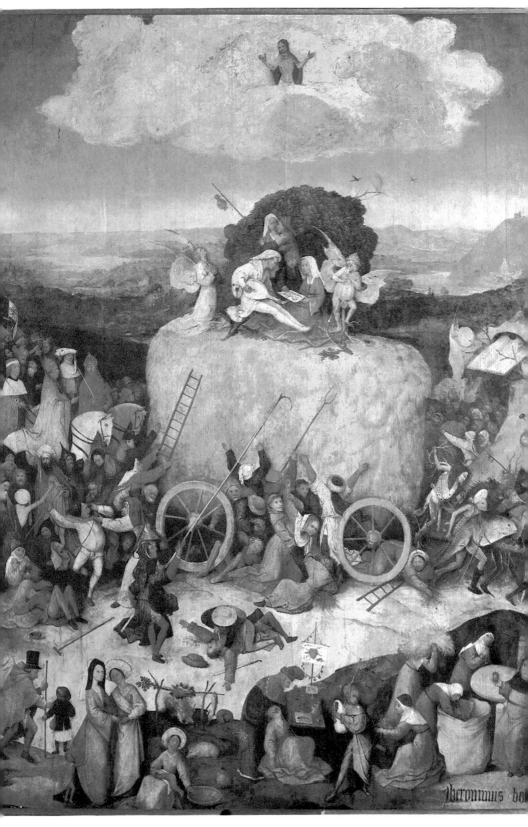

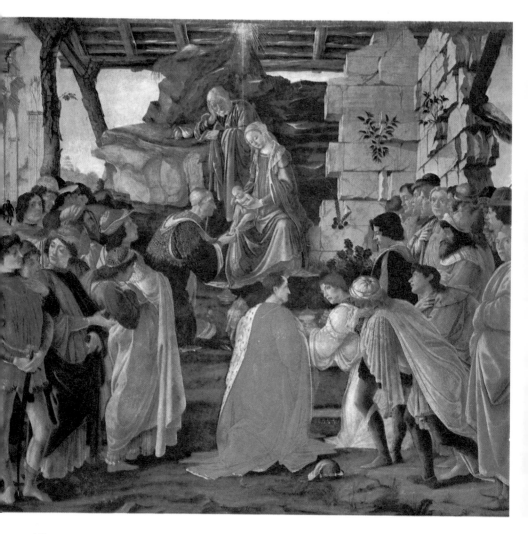

167

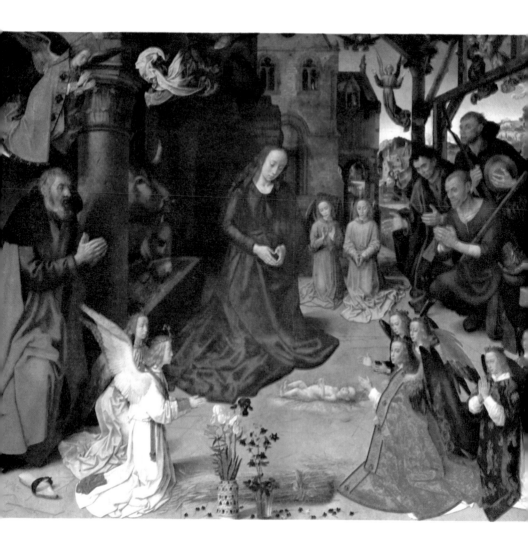

168

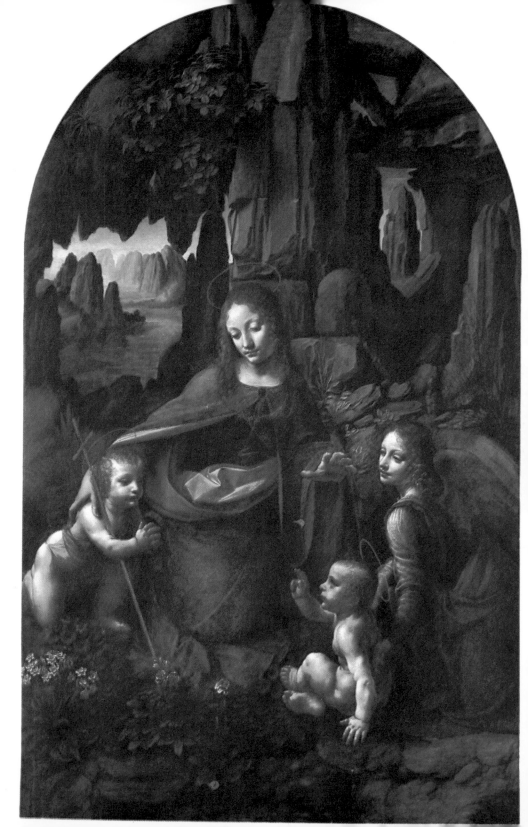

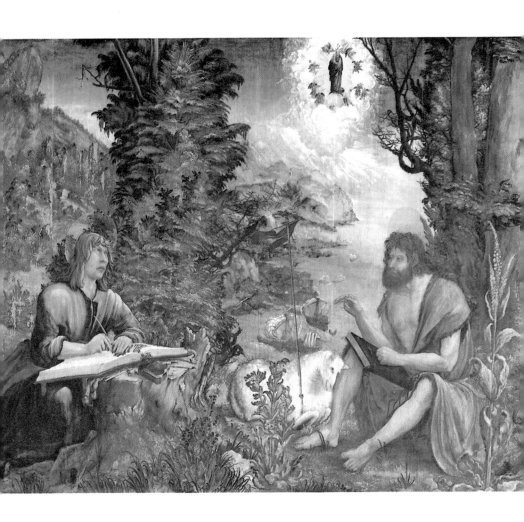

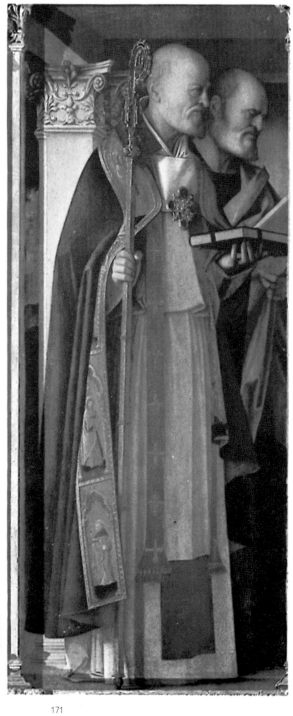

171

172

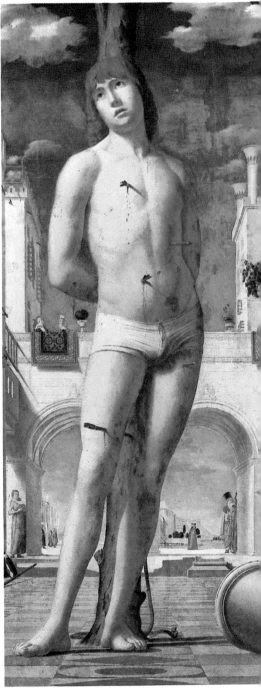

173

174

for his boldly constructed monumental compositions. In Rome, under the inspiration of classical monuments, he composed his greatest works—his frescoes there.

The "inevitability" of Leonardo's *Last Supper* (*184*) and Raphael's *School of Athens* (*177*) may at first conceal from view the artistic skill of the painters—the way in which Leonardo balanced out the tensions between the represented space and the planar surfaces, or how Raphael transformed unfavorable, badly lit and asymmetrical areas of wall, broken up by windows and doors, into truly ideal formats. It almost conceals how Raphael's apparently casual grouping of the figures was in fact considered down to the last detail, prepared in a long series of studies, and how the complicated iconographical material in the *stanze* was included without strain.

The late works of the same masters who led Renaissance painting to its zenith herald the breakthrough into a new style. Its general characteristics are the overthrow of the balance between linear and painterly effects in favor of the latter (in particular, Leonardo and Giorgione) and an increased dynamism and animation (above all, Raphael). In painting, too, it was the generation of the High Renaissance that crossed the threshold to the Late Renaissance—to Mannerism.

North of the Alps, around the turn of the century, the influence of the Italian Renaissance became widespread, after isolated earlier contacts, including, in German painting, Michael Pacher's encounter with northern Italian painting (possibly the works of Mantegna). Dürer's stays in Italy in 1494–95 and 1505–7 were to have a far-reaching impact. In the North, the young Dürer (*201*) was very much influenced by the highly developed techniques of graphic art and by the extremely linear style of such masters as Martin Schongauer (*200*). His exposure to Italian art, especially during his second stay in Italy, resulted in clearer and more restful forms, in the grasp of the figure as a three-dimensional solid (*202*), and, under the influence of Venetian painting, in the introduction of new painterly techniques (*Four Apostles*, *172*).

The reproductive potential of the woodcut and the copper engraving diffused the formal language of the Renaissance rapidly. Moreover, journeys to Italy began to form part of the apprenticeship of many painters. The Augsburg artist Hans Burgkmair (1473–1531) is recorded as having crossed the Alps in 1495, and probably again later. His pupil Hans Holbein the Younger (*189*) may have visited Lombardy in 1518. Albrecht Altdorfer probably traveled to Italy before 1526.

But even apart from direct contacts with Italian art, there was, around the turn of the century, a tendency toward classicism, toward large, balanced forms, and the integration of realism and idealism. This phenomenon marked the whole of European art, as demonstrated by the mature works of Gerard David (c. 1460–1523), whose figurative style characteristically recalls Jan van Eyck. Among the somewhat younger masters of Netherlandish painting, a personal acquaintance with Italian art was the rule; Jan Gossaert (also called Mabuse, c. 1478–c. 1533/36), who perhaps trained under David and was certainly influenced by

75

Dürer, and who was in Rome 1508–9, is at the head of the Netherlandish Romanists who brought Netherlandish painting under the influence of the Italian Renaissance.

The early 16th century, one of the great periods in German painting, was marred by an expressive use of color and light. In this respect, it was related to contemporary Venetian art. German talents could be seen on the one hand in the painters of the Danube School, with their romantic love of nature, such as Albrecht Altdorfer (*170*) and the young Lucas Cranach, and on the other hand in the "anticlassical" art of Matthias Grünewald (*191*).

Immediately after the *Trinity* fresco, if not at the same time, Masaccio was working on the frescoes in the Brancacci Chapel of S. Maria del Carmine, Florence, which were presumably begun by his teacher Masolino. As in the figures in the *Trinity*, Masaccio aimed at a precise plastic ideal. The statuesque power of the figures recalls the art of Giotto, and if Giotto had any true successor, it was Masaccio. The articulation of the body and draperies, however, show the strong influence of the early works of Donatello; that of Nanni di Banco is even more apparent (*Quattro Coronati* [*80*]). Masaccio's affinities to sculpture are not ideal, as in the case of Giotto, but direct. The reciprocal influence between the two art forms was reversed now. In the 14th century, painting very often served as a source of inspiration to sculptors, while now it was sculpture that pointed toward new directions for painting. Donatello and Nanni di Banco can be placed beside Giotto as the true teachers of Masaccio. The scenes in the Brancacci Chapel are marked by a unity of composition unknown since the time of Giotto. The figures, the landscape, and the architecture are all related, and each enhances the other. But unlike early 14th-century painting, the figures now move about freely on a wide stage; they no longer create the illusion of space by their own solid volume. By painting individualized heads and showing animated gestures, Masaccio achieved a variety and at the same time an inner coherence in the group; this particular creative talent would not be seen again until the end of the century, with Leonardo's *Last Supper*. The landscape and architectural backgrounds have acquired the character of portraits as well, without loss in detail or individual features.

In the 1420s, International Gothic gave way in the North and in Flemish and southwest German painting to a forceful realism that informed figures, spatial effects, and landscape equally. The so-called Master of Flémalle, born in Tournai (and sometimes identified with Robert Campin or the young Rogier van der Weyden [*151*]), the brothers Hubert and Jan van Eyck (*156*), the Swabian Lukas Moser (*152*), and Hans Multscher from the Allgäu were in the forefront of this new trend. As in the work of Masaccio, elegant line is replaced by three-dimensional modeling, by the effort to achieve true perspective and the tendency toward naturalistic landscapes and architecture. This "discovery of the world and of man" also characterizes the masterpieces of painting north of the Alps around 1430. Soon after Masaccio executed the frescoes in the Brancacci Chapel, Lukas Moser finished his *Magdalen* Altarpiece (1431) and Jan van Eyck completed the *Altarpiece of the Mystic Lamb* (1432). The 1420s and 1430s brought the panel paintings of the Master of Flémalle, and 1437 is the

date of Hans Multscher's Wurzach Altarpiece (Staatliche Museen, Berlin), executed in his workshop. Thus, Early Renaissance ideas are seen in painting at about the same time south and north of the Alps. But despite this general coincidence of dates, there are a number of differences. While artists north of the Alps approached the world of nature intuitively, the Italians immediately strove for a rational understanding of what they saw. The "empirical perspective" of the masters north of the Alps differs from Masaccio's mathematically proved perspective. And unlike the Flemish and southwest Germans, who devoted their talents to portraying the manifold and varied, the Italians selected, systematized, and rationalized their compositions. Accordingly, Masaccio still sought out the typical and general within the individual and unique, while the masters north of the Alps chose the individual and atypical. It is not surprising, in view of this divergent attitude, that in the North the new genre of the portrait, especially in the hands of the Master of Flémalle and, in particular, Jan van Eyck, achieved wider and earlier importance than in Italy. Finally, a typical feature of Flemish painting is the attention paid to purely painterly values and effects, in comparison with the Italians at the same date. Thanks to a new mixed medium of oil and tempera, which Jan van Eyck evidently introduced (Vasari called him the "inventor" of oil painting), it became possible to superimpose layers of fine glazes to give the surface a shimmering, transparent glow—which in turn enhances the lovingly depicted detail.

176 MICHELANGELO, LIBYAN SIBYL. 1511. Fresco. Sistine Chapel ceiling, Rome. In his cycle of sibyls and prophets, Michelangelo raised the favorite theme of Florentine painting—the painted "statue"—to new artistic heights. His figures in motion, particularly the later ones on the west part of the ceiling, are immensely substantial and expressive. The influence of his cycle on 16th-century painting and sculpture is so great that it can hardly be assessed.

177 RAPHAEL, SCHOOL OF ATHENS. 1510–11. Fresco. Stanza della Segnatura, Vatican, Rome. The scene depicts the spiritual world of antiquity as imagined by the High Renaissance. In the center are Plato and Aristotle; at their feet, Pythagoras on the left, Euclid on the right. The architecture reflects Raphael's study of the monuments of ancient Rome.

178 RAPHAEL, EXPULSION OF HELIODORUS FROM THE TEMPLE OF JERUSALEM. 1512–14. Fresco. Stanza d'Eliodoro, Vatican, Rome. The scene symbolizes the attempts of Pope Julius II,

enthroned at the left edge, to restore the papal states to the church. Comparison with the *School of Athens* (*177*) clearly shows how narrow was the peak of the High Renaissance. The principle of composition is the same, but the balance between realism and idealism is absent in the Heliodorus fresco. Here, the central axis opens into an abruptly foreshortened funnel-shaped depth; and, instead of strong luminous colors, there are muted tones and a flickering alternation of light and shade.

179 RAPHAEL, TRANSFIGURATION. 1517–20. Pinacoteca Vaticana, Rome. Lower part completed by Giulio Romano. Separated by only a few years from the *stanze* paintings, Raphael's last work is evidence of an almost violent progression along the lines suggested in the Heliodorus fresco (*178*). Raphael is not only the embodiment of the High Renaissance; his late work, as here, points beyond Mannerism to Early Baroque.

180 TITIAN, ASSUMPTION. 1518. S. Maria Gloriosa

dei Frari, Venice. In its dynamic composition, this work of Titian's occupies the same place in Venetian painting as Raphael's *Transfiguration* (*179*) in Roman. "In relation to the apostles standing below with hands upstretched and conceived like a pedestal in motion, the rising Mary is conceived as the source of light, a radiant frontal figure directly acting upon us" (E. Hubala).

181 ALBRECHT DÜRER, ALL SAINTS. 1511. Kunsthistorisches Museum, Vienna. The classical balance of the composition reflects the formal powers Dürer drew from his exposure to Italian art.

182 ANDREA DEL CASTAGNO, LAST SUPPER. c. 1450. Fresco. Museo di S. Apollonia, Florence.

183 DOMENICO GHIRLANDAIO, LAST SUPPER. 1480. Fresco. Refectory of the Ognissanti, Florence.

184 LEONARDO DA VINCI, LAST SUPPER. 1496–97. Fresco. Refectory of S. Maria delle Grazie, Milan. Castagno's fresco (*182*), with its bold perspective, strongly realistic figures, and the scenic integration of the apostles by the inclinations of their heads and gestures is the main precursor of Leonardo's masterpiece. Ghirlandaio's fresco (*183*), by contrast, strives less for a vivid rendering of the drama than for decorative effects and an astonishing fusion of picture space and real space (created by the vaulting). Leonardo assimilated all the preceding experiments and created an equilibrium between realism and idealism that would also mark Raphael's frescoes in the Stanza della Segnatura a decade later. (See *177*.)

185 ANDREA MANTEGNA, LODOVICO GONZAGA AND HIS FAMILY. Completed 1474. Camera degli Sposi, Castello, Palazzo Ducale, Mantua.

186 GIORGIO VASARI, THE DEEDS OF POPE PAUL III. 1546. Salone dei Cento Giorni, Palazzo della Cancelleria, Rome. The destruction of the boundaries between real and picture space foreshadowed in the work of Mantegna (*185*), following Masaccio (*150*) and Castagno (*182*), became a major artistic aim for Vasari as well. In this work, however, the illusion of space confuses rather than clarifies the compositions.

187 MELOZZO DA FORLÌ, THE ANGELS WITH THE INSTRUMENTS OF CHRIST'S PASSION. c. 1480. Cupola, sacristy of St. Mark, Sanctuary of the Holy House, Loreto. This fresco, executed with Melozzo's workshop, in particular Palmezzano, is the first example of an illusionist cupola after Mantegna's fresco on the ceiling of the Camera degli Sposi (*185*). The shallow vault is optically transformed into a steeply rising pyramidal tower, implying exterior space as well.

188 CORREGGIO, ASCENSION OF CHRIST. 1520. Fresco in the cupola over the crossing of S. Giovanni Evangelista, Parma. This fresco goes much further than Melozzo's (*187*) in opening up the upper limits of the space. By the use of bold light effects and figures moving freely in the picture space, in a manner inconceivable before Michelangelo's Sistine ceiling figures (*176*), Correggio seeks "new solutions to the contemporary problem of mass movement" (W. Bodmer).

189 HANS HOLBEIN THE YOUNGER, MADONNA OF BURGOMASTER MEYER. 1525–30. Darmstadt Castle. The panel shows a search for "solid corporeality" and at the same time "that increasing humanization of the divine that was the general fate of art—that is, the attitude of the time" (W. Pinder). The theme of the Mother of God worshipped by donors is close to the idea of the Madonna della Misericordia, with her protecting mantle.

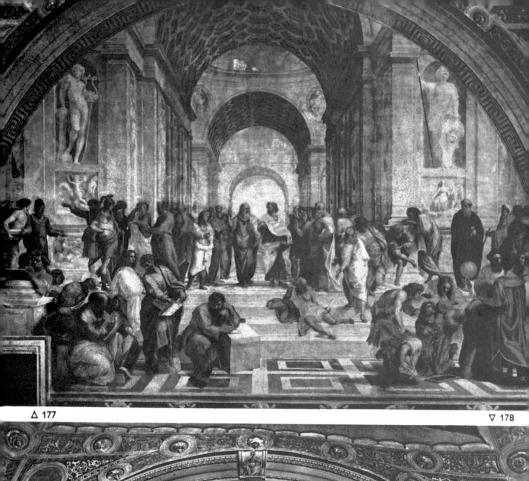

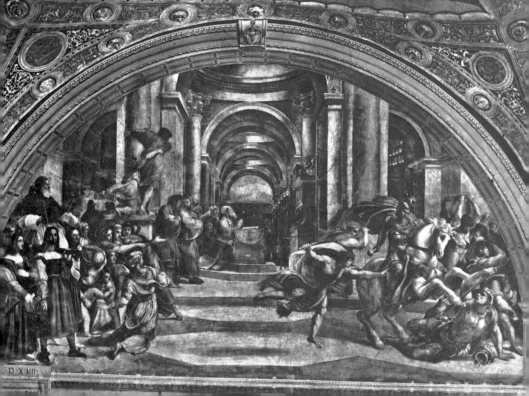

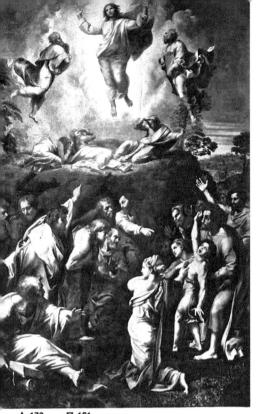

△ 179 ▽ 181 △ 180

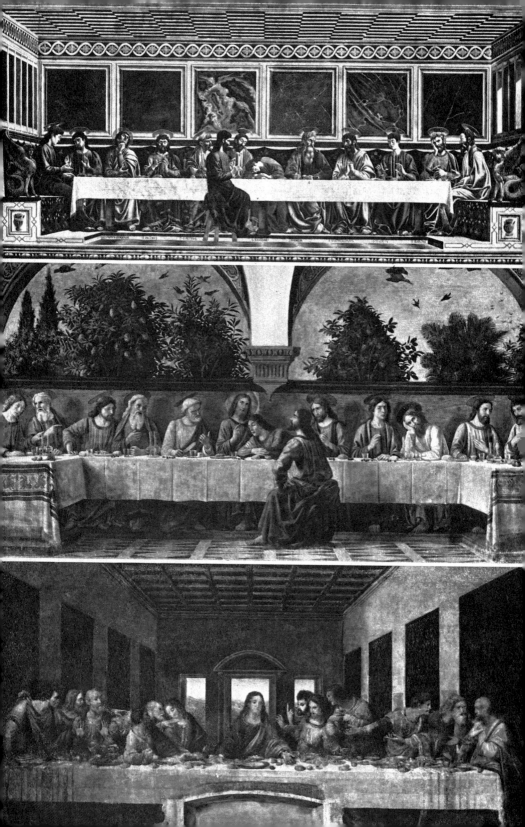

187

Neither Masaccio nor the Van Eyck brothers left successors. Instead, what characterized the following generation was concern with individual artistic problems, which were solved in new ways. This is especially clear in Florentine painting in the second quarter of the century. Paolo Uccello (1397–1475 [*158*]) was particularly preoccupied with the spatial recession Masaccio had achieved by means of mathematical perspective. His fresco of the *Deluge*, datable to around 1450, in the Chiostro Verde, S. Maria Novella, Florence, has the over-all effect of an abruptly foreshortened "spatial funnel," anticipating Mannerist effects. True, the mastery of perspective did not remain an end in itself, but much of Uccello's achievement lies in his integration of figures within the new space. Toward the midcentury, the younger Andrea del Castagno (1423–57) chose to develop the plastic figures created by Masaccio. In his *Uomini famosi* (c. 1450, Museo di S. Apollonia, Florence [*159*]), he achieved in paint an incredible effect of sculpture. These life-size figures not only seem to stand in front of the painted architecture, they sometimes even appear to step out of it. Thus Andrea went beyond Masaccio's fresco of the *Trinity* (*150*) in opening up the picture space into the real space.

It is interesting that the sculptural quality in painting was also an important artistic problem north of the Alps at about the same time. It is a dominant element of the *Mirror of Salvation Altar* by the Swabian Konrad Witz, c. 1435 (*160*) and of the *Annunciation* altarpiece of about 1446 in Ste-Madeleine, Aix-en-Provence, created by an unknown artist now referred to as the Master of the Aix Annunciation (central panel in Aix; sides in Rijksmuseum, Amsterdam, and Musées Royaux des Beaux-Arts, Brussels).

In addition to his forceful modeling of figures and new spatial effects, Masaccio also stands apart from other 14th-century painters by his skill in composition and his new way of rendering atmospheric effects. In this respect, he had an important follower toward the midcentury in Domenico Veneziano (c. 1400–61), who, as his name suggests, came of a Venetian family. His *Sacra conversazione* (*Virgin and Child with Saints* [*164*]), painted between 1445 and 1450, is a landmark in the history of art for his deployment of figures in space. The traditional form of the polyptych, which lasted well into the Quattrocento, isolating the main figure in the central panel from the accompanying saints in the sides, has been replaced here by an encompassing architectural unit under which the figures are arranged in a semicircle curving away from the spectator, into the picture. This panel is one of the first of countless representations of the *sacra conversazione* (Madonna and Child with saints), which would become a favorite theme of the Venetians in the late 15th and the 16th century because of its contemplative character. But Domenico's real achievement lies in his colors. Significantly, it was an artist of Venetian origin who turned away from the strong local (single-hued) colors of the Florentine Early Renaissance. By the addition of oil as a binding agent, Domenico, like the innovators in Netherlandish painting from the time of Jan van Eyck, achieved very fine glazes. The resulting wealth of nuances and gradations of color was unique in Florence in the midcentury. Even more important is that Domenico,

following Masaccio, and showing a typically Venetian concern with form in light, succeeded in rendering the impression of light through paint. This is the first time sunlight is depicted realistically in European painting; Domenico's forerunners and many of his contemporaries still suggested it by touches of gold.

The mid-15th century is not only the period when the style of the Early Renaissance was elaborated north and south of the Alps; it is also the time when artists began to travel. First, this meant the diffusion of the vocabulary of the Tuscan Early Renaissance to other Italian art centers. Uccello was already in Venice in the 1420s. In the 1440s he was in Padua. In 1422, Andrea del Castagno finished a cycle of frescoes in the Capella di S. Tarasio in S. Zaccaria, Venice. From 1443 to 1453, Donatello was working in Padua, establishing himself as the great teacher of all the north Italian painters. Between 1445 and 1455, Fra Angelico (1387–1455) executed extensive fresco commissions in Rome and Orvieto. And contrary to the one-sided and romantic view of Fra Angelico as a Late Gothic artist, he is, in fact, the most complex artistic figure in Florentine painting among Masaccio's followers (*157*).

The interchange of artistic currents between North and South also began at this time. As early as the second quarter of the century, works by Netherlandish masters were being collected at the Aragonese court in Naples, and Flemish artists had probably worked there, too. Naples became the port of entry for Netherlandish painting in Italy, to be joined some decades later by the court of the Montefeltre in Urbino, where the court painter Justus of Ghent exerted a wide influence on his contemporaries in Italy from about 1460 to 1480. The most important Netherlandish painter after the Van Eyck brothers, Rogier van der Weyden (*163*), traveled to Rome in 1450 on the occasion of the Jubilee, and his visit to Ferrara in the same year is also recorded. A few years earlier, between 1443 and 1447, Jean Fouquet (1415–c.1480) had visited Italy and, fifty years before Dürer's Italian travels, had brought the formal language of the Italian Early Renaissance to his native country.

In other respects, the period around the midcentury is of great interest to art history. In Italy, there was a shift of location as far as activity was concerned. In the first half of the century, Tuscany, and in particular Florence, had determined the direction of the Early Renaissance, but now other regions began to assert themselves, and other aims, which had been of only marginal interest, if at all, to Florentine painters, became dominant. New concerns included problems of coloring and landscape. From 1452 onward, Piero della Francesca, who had trained under Domenico, worked on his masterpiece, the fresco cycle in the choir of S. Francesco, Arezzo. In northern Italy, it was the generation born around 1430— Andrea Mantegna (*173*) in Padua, Cosmé Tura and Francesco Cossa in Ferrara, Giovanni Bellini (*171*) and, from Sicily, Antonello da Messina (*174*) in Venice—who spread the formal canons of the Tuscan Early Renaissance under the influence of Donatello, and, at the same time, largely replaced the statuesque figurative ideal of the Florentines by modeling with light and color.

A trend toward courtly elegance appeared in Florence at almost the same moment when Masaccio's problems of representing space by linear perspective and modeling three-dimensional figures were being studied most intensively. Benozzo Gozzoli's fresco cycle begun in 1459 in the chapel of the Palazzo Medici, Florence, is a representative example of this sumptuousness (*162*). With the growing wealth and increasing power of the great patrician families, above all, the Medici, came a withdrawal from the bourgeois in favor of a courtly style. Certain characteristics of International Gothic seem to revive in the cultivated, sensitive linear manner that takes the place of integral modeling and in the predilection for the exquisitely worked detail. The late paintings of Fra Filippo Lippi (c. 1406–69), a pupil of Masaccio, are early evidence of this change of taste. Admittedly, the study of reality is not denied, but the concentration is on detail rather than on revealing the relations between large forms.

Finally, toward the midcentury and almost simultaneously north and south of the Alps, graphic art evolved into an independent art form. On the one hand, we have the woodcut, which came into being in the early 15th century in the North; on the other, and more important, the copper engraving, whose origins are believed to lie in southern Germany, also in the early 15th century. The earliest copper dated engraving is from 1446. The work of the so-called Master of the Playing Cards and the rich output of Master E. S. (*198*) mark the first high points of this technique in Northern art, while the earliest examples of Italian copper engraving come from the workshöps of Antonio Pollaiuolo and Andrea Mantegna. This new art form created an entirely new possibility for the interchange and dissemination of artistic ideas, even between remote regions.

The change that characterized Florentine painting in the second half of the century and, to a large extent, northern Italian painting as well—a movement away from the whole to the study of detail, away from the representation of three-dimensional values to an emphasis on animated line—had already occurred north of the Alps. The great teacher here was Rogier van der Weyden (c. 1400–64 [*163*]), who exerted an almost inestimable influence on Netherlandish art and also on the whole of German painting until late in the century. His increasingly realistic handling of detail was a major contribution to the evolution of the landscape. But it also meant a reduction of corporeal and spatial effects. However, the joy in the manifold and varied benefited narrative talents, such as Hans Memling (c. 1434–95).

190 GIORGIONE, THE TEMPEST. c. 1510. Accademia, Venice. In the history of Venetian painting the work of Giorgione forms the link between Giovanni Bellini and Titian. Landscape acquires a new importance in Italian art. South of the Alps, the aim is not pure landscape, however, as with Altdorfer and Wolf Huber or in Dürer's watercolors of the same period. The point of departure in Italy is still man, whose moods and dreams seem reflected in the landscape. This creates an unstated link between figures and landscapes, as does the treatment

of color based on atmospheric effects. The influence of Leonardo (*169*) has been suggested; but clearly these trends were in the air; they appeared north of the Alps at the same time, without any evidence of Italian influences (*170*).

191 MATTHIAS GRÜNEWALD, ASCENSION. 1512–16. Right panel of the second stage of the Isenheim Altarpiece. Unterlinden Museum, Colmar. The scene is "not merely the Resurrection from the grave that 15th-century painting often depicted, but the Ascension and the Transfiguration at the same time" (A. M. Vogt). In order to render the luminous figure of Christ, Grünewald, like his Italian contemporaries, used new painterly methods in place of the linear definition preferred by the 15th century.

192 JACOPO PONTORMO, VISITATION. c. 1530. Parish church, Carmignano. In spite of their strong, solid volume, the figures assembled in a circle seem to hover in an unreal light. The background architecture, recalling the ideas of *pittura metafisica*, heightens the dreamlike, surreal effect of the scene.

193 PARMIGIANINO, MADONNA OF THE LONG NECK. c. 1540. Uffizi, Florence. The extremely complex movement, the distortion of natural proportions, the destruction of a logical spatial continuum by abrupt foreshortening, and ambiguous viewpoints make this work a perfect example of Mannerism. The sensitive linear style and delicate tonal gradations place Parmigianino among the finest European masters of the 16th century.

194 TITIAN, CROWN OF THORNS. c. 1570. Alte Pinakothek, Munich. Throughout his work Titian remained loyal to the ideal compositions and figures established by the High Renaissance. But here he has also managed to overcome the static without breaking the rules of classical composition. His late work shows the final results of the methods evolved by the late Quattrocento for dissolving outlines by painterly transitions.

195 PAOLO VERONESE, BAPTISM OF CHRIST. Courtauld Institute, University of London.

196 JACOPO TINTORETTO, BAPTISM OF CHRIST. 1576–81. Scuola di S. Rocco, Venice. Comparison of this work with Veronese's (*195*) shows the range of Venetian painting in the 16th century. Apart from all the complexity of movement and disposition, Veronese's scene is dominated by the antique ideal of the human figure, set in a clearly structured landscape. Tintoretto, however, moved his smaller-scale group away from the central axis in the foreground, creating instead a number of compositional combinations and interrelations that lead the eye back to the central focus. The spatial depth, which opens into the picture from front right to left, is counterbalanced by the "weight" of the colors.

197 PIETER BRUEGEL THE ELDER. HAYMAKING. Detail. 1565. National Gallery, Prague. From the *Months* series. Landscape plays an outstanding role in Bruegel's œuvre. Carel van Mander told of the overwhelming effect the Alps had on Bruegel during his journey to Italy in 1554: "When he crossed the Alps, he swallowed up all the mountains and cliffs and spat them out again on canvas and panel after his return." In the course of his development, Bruegel abandoned the small-scale and multiple "world landscapes" in favor of monumental forms. His landscapes are the most important precursors of Baroque landscape painting, of which Rubens is the prime exponent.

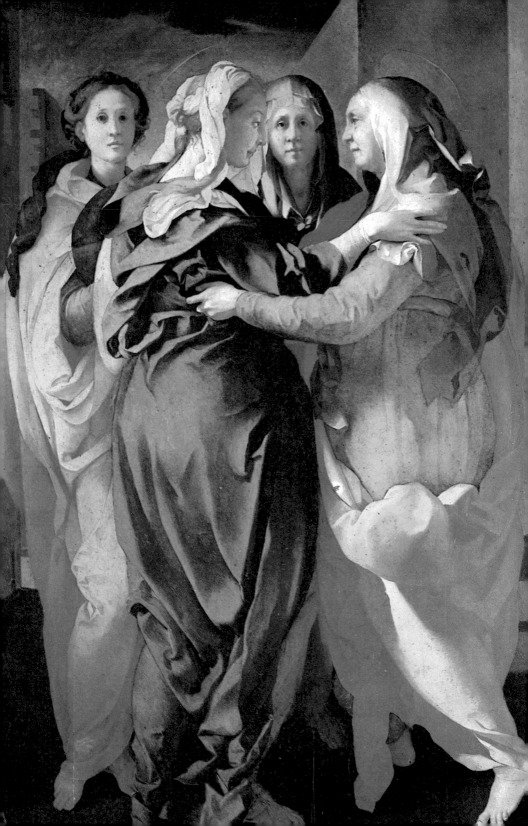

The passion for the unique led to a heightened expressiveness in the work of major masters —including Hugo van der Goes (c.1435/40–c.1495 [*168*]) and Geertgen tot Sint Jans (c.1460/65–c.1495)—which has few equals in Italian painting at the time. And landscape, in particular with Geertgen, gained importance as atmospheric carrier of mood rather than as simple background. Another and highly original side to Netherlandish painting in the late 15th century appears in the work of Hieronymus Bosch (c.1450–1516 [*166*]), whose boundless fantasy puts him at the opposite pole from Memling. Where the latter was concerned with a careful and, at times, anecdotal elaboration in his crowded scenes, Bosch turned to the subconscious. The eerie and the abnormal abound in his works, which were also made up of countless details. Iconographically, Bosch is the precursor of Mannerism, but his work also points far beyond the turn of the century in painterly terms—in the tonal modeling that often takes the place of the contour line, especially in landscapes, and in his bold effects of light and shade.

In the third quarter of the 15th century, Florence gave up its leading role in Italian painting for the first time to masters from other regions. Piero della Francesca (c.1416–92) should be mentioned first (*155, 165*). Born on the borders of Tuscany and Umbria, he may have trained in a Sienese workshop. That is where he probably developed his talent for refined and subtle color distinctions, and his study of Umbrian art may have given him his passion for regularity. The foundations of Piero's painting, with its atmospheric effects, were laid during his collaboration with Domenico Veneziano in Florence (1439–45). At the same time, his exposure to the works of Uccello may have intensified his preoccupation with the problems of representing space on a two-dimensional surface. Piero became the great master of perspective in the second half of the century, and he also wrote treatises on perspective and mathematics. But unlike the Florentine masters who succeeded Masaccio, and unlike the young northern Italians half a generation later, Piero was not primarily interested in an increased illusionism, despite his virtuoso mastery of perspective, but in establishing relationships between planes. The integration of space and plane, which he was the only great painter between Masaccio and Leonardo and Raphael to achieve successfully, is the dominant element of his art, together with his controlled painting style, which reveals his constant analysis of form in light. Piero came into contact with Netherlandish painting during his stay at the court of the Montefeltre in Urbino, and Northern influence is apparent in his late work—in his painstaking treatment of the exquisitely painted detail, in his refinement of the technique of glazing, and in certain of his compositional principles (*155*).

Piero exerted a wide influence on Italian painting in the last third of the century, especially through his profound understanding of perspective. By contrast, his successors aimed chiefly at a heightened illusionism. This applies to Melozzo da Forlì (1438–94), who completed his *Resurrection* in the apse of SS. Apostoli, Rome, in 1480 (surviving fragments in the Quirinal and Vatican museums) and the cupola of the sacristy of St. Mark, Sanctuary of the Holy House, Loreto (*187*), around 1480, assisted by his workshop. Here he used per-

spective to transform the shallow vault into a steeply rising pyramidal tower, around the illusionary windows of which angels seem to hover—an astonishing 15th-century anticipation of future dome and ceiling paintings. We find a similarly bold fusion of picture space and real space, almost at the same time, in the work of the northern Italian Andrea Mantegna (c.1431–1506). In his frescoes in the Camera degli Sposi in the Castello, Palazzo Ducale, Mantua (*185*), completed in 1474, Mantegna went a step further by arranging life-size portrait figures in contemporary dress in an illusionist architecture that fuses with the real architecture. As in the case of Andrea del Castagno (*159, 182*), several of the figures seem to step out of the architectural frame and break through the barrier between painted and real space. Mantegna heightened this impression by inserting a simulated stairway down which the life-size figures seem to descend into the room. Mantegna's transformation of space by pictorial means culminated in the illusionist opening in the center of the vault, which appears to open to the sky.

In his youth Mantegna was strongly influenced by the Paduan works of Donatello, and he introduced to northern Italian painting the solid, three-dimensional human figure and the use of sophisticated perspective, including the low-angle view; he also contributed greatly to the diffusion of classical motifs. It is characteristic of this period that the response to classical antiquity came mainly by way of antiquarian interests, which were particularly strong in the Humanist circles around Padua University. Mantegna, himself an eager collector of antiquities, "quoted" from antiquity rather than using classical art as a model.

Thanks to new methods of painting, and also clearly affected by Italian art (*St. Sebastian* of the Isenheim Altarpiece), Grünewald (d.1528) opened the door to a hitherto unknown range of emotions, from profound contemplation to passionate drama.

By around 1500, Florence had given up its dominant position in Italian art to Rome. It had had an important influence on the developments in the early 16th century as the birthplace of the High Renaissance, for the great masters were either Florentines themselves, such as Leonardo and Michelangelo, or, like Raphael, had absorbed decisive impressions in Florence. In the brief golden age of the High Renaissance, Florence had to stand back. But from the second decade of the new century, it gave a valuable impetus to the development of Mannerism. The altarpieces of Andrea del Sarto (1486–1531) are already characterized by a restlessness, contrasting with the former strictly balanced structure, by violently animated figures and flickering colors (*Madonna of the Harpies*, Uffizi, Florence, 1517). The work of Rosso Fiorentino (1494–1540) can only be understood as a conscious rebellion against the norms of classical art. Now the image of nature is distorted, the bodies are built up of geometric areas, and the palette, dominated by cool, strident tones, has no connections with reality. From about 1530, Rosso worked for François I at the French court, where he became cofounder of the School of Fontainebleau with the Bolognese painter Primaticcio (1504–70). A kind of *uomo universale*, he painted frescoes and designed decorations, stuccos, and tableware. The output of this school was important in diffusing the formal lan-

guage of the Renaissance north of the Alps. A painter more strongly influenced by the High Renaissance, Pontormo (1494–1557 [*192*]), may have studied under Leonardo and certainly under Andrea del Sarto. By distorting the proportions, abandoning a logical spatial structure, and using unreal, blurred colors, he often achieved highly spiritual effects. Characteristically, he also borrowed from Dürer's engravings (seen in his frescoes in the Certosa near Florence). His portraits, and those of his disciple Bronzino (1503–72), have a fascinating silhouettelike effect. The forms of the solid figures are often so well integrated into the picture surface that the formerly "negative" ground becomes an active partner of the picture.

In Rome, Mannerism began with Michelangelo and the late Raphael. Giulio Romano (1499–1546), who had already played a major role in the execution of the later frescoes in the *stanze* of the Vatican, transmitted Roman Mannerism to northern Italy. From 1524 he was active at the court of Mantua. In the Palazzo del Tè, he created a total work of art (*39*) that was fundamental to the definition of Mannerism. The design and decoration of this summer villa are evidence of a highly deliberate intelligence, for Giulio managed to unite an academic classicism with a complete break with all the norms of spatial construction, figure portrayal, and organization of the surface.

Northern Italian painting produced a wealth of previously unknown painterly effects, often inspired by Leonardo. Following Melozzo (*187*) and Mantegna, Correggio (1489–1534) transformed the cupolas of the cathedral and of the church of S. Giovanni Evangelista, Parma (*188*), into open spaces of indeterminate dimensions, largely destroying the boundaries between painting and architecture. In his great high altar paintings of the *sacra conversazione*, geometrically balanced compositions are replaced by complex, often contrapuntal movements. At times, the resulting structure, based on highly refined artistic concepts, acquires a pure linear rhythm. Correggio's study of light and shade could produce virtuoso nocturnal effects, which became one of the principles of Mannerist painting both north and south of the Alps, for night was an ideal framework for rendering subconscious, dreamlike moods remote from reality. In many ways the heir to Correggio, Parmigianino (1503–40), born in the same region, surpassed his master in his eccentric treatment of reality. It is characteristic of Parmigianino that he painted a self-portrait in front of a concave mirror, making distortion of reality a kind of artistic principle. With his elegant line and delicate tonal register, Parmigianino is one of the most fascinating figures of Italian Cinquecento painting (*193*).

Venice became the center of European painting in the 16th century with the shift from draftsmanship toward the dominance of painterly effects. But we must hesitate to use the term Mannerism for Venetian Cinquecento painting. Titian (d. 1576) and Veronese (1528–88), and with them a considerable amount of first-class Venetian painting, do not represent any of the familiar categories of Mannerism. For both men, the norms of the High Renaissance remained a perceptible source for artistic development. For them, dynamic composition and complex movement serve to heighten expression but not to distort or alienate

reality. Thematically, too, Titian and Veronese kept their independence with respect to Mannerism. They glorified not the abnormal and nocturnal powers rooted in man's subconscious but the festive side of life (in particular Veronese, with his huge banquet scenes). Only Titian's "variable pictorial concept," which takes the place of the "classical definition of forms of the High Renaissance" (Dagobert Frey), may count as Mannerism. Yet it was Titian especially who opened new paths to future European painting. In his late work (*194*), all the expression is achieved through color—the linear network gives way to an interweaving of colors (*Martyrdom of St. Lawrence*, Church of the Gesuiti, Venice; *Pietà*, Accademia,

nature in art. Apart from figure studies, he drew animals, draperies, free sketches for monumental compositions, and portraits. The nudes illustrated here are obviously freely handled copies from nature.

200 MARTIN SCHONGAUER, DEATH OF THE VIRGIN. c. 1470. Copper engraving. By comparison with Master E. S. (*198*), Schongauer has refined the technique of copper engraving and given the line greater power of expression. Copper engravings were widely circulated and served as models. Schongauer's influence on Dürer, for instance, was enormous, although the two never met. In 1490 Dürer set out for Colmar to see Schongauer, who died before his arrival (1491).

201 ALBRECHT DÜRER, ST. MICHAEL AND THE DRAGON. Woodcut from the *Apocalypse* series, first published in Nuremberg in 1498. Dürer's graphic work in the last decade of the 15th century is an example of the highly expressive Late Gothic linear style.

202 ALBRECHT DÜRER, ADAM AND EVE. 1504. Copper engraving. Compared to the *Apocalypse* prints (*201*), the change in Dürer's style as a result of his encounter with the Italian Renaissance is very clear. The figures of Adam and Eve are a perfect embodiment of the Apollonian figurative ideal of the High Renaissance.

198 MASTER E. S., VIRGIN OF THE LILIES OF THE VALLEY. c. 1450. Copper engraving. More than three hundred engravings survive by Master E. S., the true founder of the engraving technique. His emphasis on substantial form shows his derivation from the traditions of southwest German painting. (See Konrad Witz, *160*.)

199 ANTONIO PISANELLO, STUDY SHEET. c. 1425. Pen on parchment. Museum Boymans-van Beuningen, Rotterdam. Pisanello's drawings, of which he executed an unusually large number for the period, opened the door to the observation of

1

church scene—following the tendency of Northern artists toward the nonidealized, subjective, and unique.

Several of the major European Mannerists, including El Greco, Bartholomäus Spranger, and Giambologna, survived into the new century. But already by the 1590s, the Carracci from Bologna were laying the foundations of the Early Baroque. And in 1600 exactly, the twenty-three year-old Peter Paul Rubens set off for the South. He both transformed and preserved the legacy of the Italian 16th century, making it a fertile source of northern European Baroque.

BIBLIOGRAPHY

Cultural History

Burckhardt, J. *The Civilization of the Renaissance in Italy.* London: Phaidon, 1944; New York: Oxford University Press, 1945.

Chastel, A., and Klein, R. *The Age of Humanism.* London: Thames and Hudson, 1963; New York: McGraw-Hill, 1964.

Levey, M. *Early Renaissance.* Harmondsworth and Baltimore, Md.: Penguin, 1967.

Panofsky, E. *Renaissance and Renascences in Western Art.* London: Paladin, 1970.

– Studies in Iconology: Humanistic Themes in the Art of the Renaissance. 2d ed. New York: Harper and Row, 1962.

Schlosser, J. v. *Die Kunstliteratur.* Vienna: Schroll, 1924. (3d rev. ed. *La letteratura artistica,* Florence: La Nuova Italia, 1964.)

Shearman, J. *Mannerism.* Harmondsworth and Baltimore, Md.: Penguin, 1967.

Vasari, G. *Le vite de' più eccellenti pittori, scultori ed architettori.* 2d ed. Florence, 1568. (Ed. G. Milanesi. 9 vols. Florence, 1878–85; English ed. *The Lives of the Most Eminent Painters, Sculptors and Architects,* ed. G. de Vere, 9 vols. London: The Medici Society; New York: Macmillan, 1912–16.)

Warburg, A. *Gesammelte Schriften.* 2 vols. Leipzig: Teubner, 1932.

General

Amsterdam. Rijksmuseum. *Le Triomphe du maniérisme européen.* Council of Europe exhibition catalogue, 1955.

Battisti, E. *Hochrenaissance und Manierismus.* Baden-Baden: Holle, 1970.

Benesch, O. *The Art of the Renaissance in Northern Europe.* London and New York: Phaidon, 1965.

Blunt, A. *Art and Architecture in France, 1500–1700.* 2d ed., Harmondsworth and Baltimore, Md.: Penguin, 1970.

– *Artistic Theory in Italy, 1450–1600.* Oxford: Clarendon Press, 1940; New York: Oxford University Press, 1941.

Burckhardt, J. *The Cicerone.* London, 1873.

Chastel, A. *The Myths of the Renaissance, 1420–1520.* Geneva: Skira, 1969.

Decker, H. *The Renaissance in Italy.* London: Thames and Hudson, 1969.

Dvořák, M. *Geschichte der italienischen Kunst im Zeitalter der Renaissance.* 2 vols. Munich: Piper, 1927 and 1929.

Gilbert, C. (ed.). *Renaissance Art.* London and New York: Harper, 1962.

Hartt, F. *History of Italian Renaissance Art: Painting, Sculpture, Architecture.* New York: Abrams, 1969.

Holt, E. (ed.). *A Documentary History of Art.* 2 vols. Garden City, N.Y.: Doubleday (Anchor), 1957–58; Vol. I, London: Mayflower, 1958.

Kauffman, G. *Florence: Art Treasures and Buildings.* London and New York: Phaidon, 1971.

Kubler, G., and Soria, M. *Art and Architecture in Spain and Portugal,* 1500–1800. Harmondsworth and Baltimore, Md.: Penguin, 1959.

Mercer, E. *English Art, 1553–1625.* Oxford: Clarendon Press, 1962.

Osten, G. v. d., and Vey, H. *Painting and Sculpture in Germany and the Netherlands, 1500–1600.* Harmondsworth and Baltimore, Md.: Penguin, 1969.

Toesca, P. *Il Trecento.* Turin: Unione Tipografico-Editrice Torinese, 1951. (Storia dell' arte italiana, II.)

White, J. *Art and Architecture in Italy, 1250–1400.* Harmondsworth and Baltimore, Md.: Penguin, 1966.

Wölfflin, H. *Classic Art.* London and New York: Phaidon, 1952.

– *Principles of Art History.* London: Bell; New York, Holt, 1932.

– *Renaissance and Baroque.* London: Fontana, 1964; Ithaca, N.Y.: Cornell University Press, 1966.

Württemberger, F. *Mannerism.* London, Weidenfeld and Nicolson; New York: Holt, Rinehart & Winston, 1963.

Wundram, M. *Frührenaissance.* Baden-Baden: Holle, 1970.

THEORY

Lee, R. *Ut Pictura Poesis: The Humanistic Theory of Painting.* New York: Norton, 1967.

Panofsky, E. *Studies in Iconology.* (Listed above.)

Wind, E. *Pagan Mysteries in the Renaissance: An Exploration of Philosophical and Mystical Sources of Iconography in Renaissance Art.* Rev. ed. Harmondsworth: Penguin; New York: Norton, 1967.

Wittkower, R. *Architectural Principles in the Age of Humanism.* 3d ed. London: Tiranti, 1962; New York: Random House, 1965.

ARCHITECTURE

Ackerman, J. *The Architecture of Michelangelo.* Harmondsworth and Baltimore, Md.: Penguin, 1971.

– *Palladio.* Harmondsworth and Baltimore, Md.: Penguin, 1966.

Blunt, A. *Philibert de l'Orme.* London: Zwemmer, 1958.

Horst, C. *Die Architektur der deutschen Renaissance.* Berlin: Propyläen, 1928. (Propyläen-Kunstgeschichte.)

Hughes, J., and Lynton, N. *Renaissance Architecture.* London: Longmans; New York: McKay, 1962.

Lowry, B. *Renaissance Architecture.* New York: Braziller, 1962; London: Studio Vista, 1968.

Murray, P. *The Architecture of the Italian Renaissance.* 2d ed. London: Thames and Hudson, 1969.

– *L'archittetura del rinascita.* Milan: Electa, 1971.

Summerson, J. *Architecture in Britain, 1530–1830.* 5th ed. Harmondsworth and Baltimore, Md.: Penguin, 1969.

Willich, H., and Zucker, P. *Die Baukunst der Renaissance in Italien.* 2 vols. Potsdam: Athenaion, 1914 and 1929.

Wittkower, R. *Architectural Principles in the Age of Humanism.* (Listed above.)

SCULPTURE

Avery, C. *Florentine Renaissance Sculpture.* London: Murray, 1970.

Hill, G. *A Corpus of Italian Medals of the Renaissance Before Cellini.* 2 vols. London: British Museum, 1930.

Janson, H. *The Sculpture of Donatello.* 2 vols. Princeton, N.J.: Princeton University Press, 1957. (One-vol. ed., Princeton, 1963.)

Keutner, H. *Sculpture: Renaissance to Rococo.* London: Michael Joseph; Greenwich, Conn.: New York Graphic Society, 1969.

Krautheimer, R. *Lorenzo Ghiberti.* Princeton, N.J.: Princeton University Press, 1956.

Mellini, G. *Giovanni Pisano.* Milan: Electa, 1971.

Müller, T. *Deutsche Plastik der Renaissance bis zum Dreißigjährigen Krieg*. Königstein, 1963.

– *Sculpture in the Netherlands, Germany, France and Spain, 1400–1500*. Harmondsworth and Baltimore, Md.: Penguin, 1966.

Passavant, G. *Verrocchio*. London and New York: Phaidon, 1969.

Pope-Hennessy, J. *Italian Gothic Sculpture*. London and New York: Phaidon, 1955.

– *Italian High Renaissance and Baroque Sculpture*. 2d ed. London and New York: Phaidon, 1970.

– *Italian Renaissance Sculpture*. London and New York: Phaidon, 1958.

Seymour, C., Jr. *Sculpture in Italy, 1400–1500*. Harmondsworth and Baltimore, Md.: Penguin, 1966.

Tolnay, C. de. *Michelangelo*. 5 vols. Princeton, N.J.: Princeton University Press, 1943–60.

Wundram, M. *Donatello und Nanni di Banco*. Berlin: De Gruyter, 1969. (Beiträge zur Kunstgeschichte.)

PAINTING

Berenson, B. *The Italian Painters of the Renaissance*. London and New York: Phaidon, 1952.

– *Italian Pictures of the Renaissance: Central Italian and North Italian Schools*. 3 vols. London and New York: Phaidon, 1968.

– *Italian Pictures of the Renaissance: Florentine School*. 2 vols. London and New York: Phaidon, 1963.

– *Italian Pictures of the Renaissance: Venetian School*. 2 vols. London and New York: Phaidon, 1957.

Carli, E., Gnudi, C., and Salvini, R. *Pittura italiana. I: Medioevo romanico e gotico*. Milan, 1959.

De Wald, E. *Italian Painting, 1200–1600*. New York: Holt, Rinehart & Winston, 1962.

Fischel, O. *Raphael*. 2 vols. London: Routledge & Kegan Paul, 1948. (One-vol. ed. London: Spring Books, 1964.)

Freedberg, S. *Painting in Italy, 1500–1600*. Harmondsworth and Baltimore, Md.: Penguin, 1970.

– *Painting of the High Renaissance in Rome and Florence*. 2 vols. Cambridge, Mass.: Harvard University Press, 1961.

Friedländer, M. *Early Netherlandish Painting*. 14 vols. New York: Praeger, 1967.

– *From Van Eyck to Brueghel*. 3d ed. London and New York: Phaidon, 1969.

Friedländer, W. *Mannerism and Anti-Mannerism in Italian Painting*. New York: Schocken, 1968.

McCurdy, E. (ed.) *The Notebooks of Leonardo da Vinci*. 2 vols. London: Cape; New York: Reynal and Hitchcock, 1938.

Meiss, M. *Painting in Florence and Siena After the Black Death*. Princeton, N.J.: Princeton University Press, 1951.

Oertel, R. *Early Italian Painting*. London: Thames and Hudson; New York: Praeger, 1968.

Panofsky, E. *Albrecht Dürer*. 4th ed. Princeton, N.J.: Princeton University Press, 1955.

– *Early Netherlandish Painting*. 2 vols. Cambridge, Mass.: Harvard University Press, 1953.

Puyvelde, L. v. *La Peinture flamande au siècle de Bosch et Brueghel*. Paris: Elsevier, 1962.

Ring, G. *A Century of French Painting, 1400–1500*. London and New York: Phaidon, 1949.

Smart, A. *The Assisi Problem in the Art of Giotto*. Oxford: Clarendon Press; New York: Oxford University Press, 1971.

Stange, A. *German Painting, XIV–XVI Centuries*. New York: Macmillan, 1953; London: Hyperion, 1955.

Weigelt, C. *Painting of the Trecento*. London: Hill; New York: Harcourt, Brace, 1930.

Whinney, M. *Early Flemish Painting*. London: Faber and Faber; New York: Praeger, 1968.

Wölfflin, H. *The Art of Albrecht Dürer*, ed. K. Gerstenberg. London and New York: Phaidon, 1971.

INDEX

Descriptions of the illustrations are listed in boldface type

194